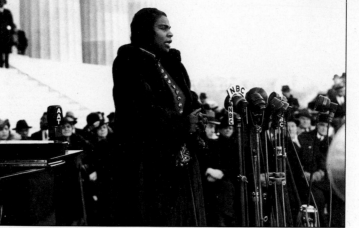

When the Daughters of the American Revolution refused to allow Marian Anderson to perform at Constitution Hall in 1939, she mounted the steps of the Lincoln Memorial and performed for an audience of 75,000. Photograph from the Scurlock Studio, Washington

THE AFRICAN AMERICANS

EDITED BY CHARLES M. COLLINS AND DAVID COHEN
TEXT BY CHERYL EVERETTE, SUSAN WELS AND EVELYN C. WHITE

THE AFRICAN AMERICANS WAS MADE POSSIBLE BY GENEROUS GRANTS FROM

ANHEUSER-BUSCH
COMPANIES

AT&T

Enjoy
Coca-Cola
®

HOTEL ACCOMMODATIONS WERE PROVIDED BY
THE HILTON HOTELS CORPORATION

VIKING
STUDIO
BOOKS

THE AFRICAN AMERICANS, Collins and Cohen

VIKING STUDIO BOOKS
Published by the Penguin Group
Penguin Books USA Inc., 375 Hudson Street,
 New York, New York 10014, U.S.A.
Penguins Books Ltd., 27 Wrights Lane,
 London W8 5TZ, England
Penguin Books Australia Ltd., Ringwood,
 Victoria, Australia
Penguin Books Canada Ltd., 10 Alcorn Avenue,
 Toronto, Ontario, Canada M4V 3B2
Penguin Books (N.Z.) Ltd., 182-190 Wairu Road,
 Auckland 10, New Zealand

Penguin Books Ltd., Registered Offices:
Harmondsworth, Middlesex, England

First Published in 1993 by Viking Penguin,
a division of Penguin Books USA Inc.
This paperback edition published in 1995

10 9 8 7 6 5 4 3 2 1

The photograph of Paul Robeson that appears on page 4 is
 ©Karsh/Woodfin Camp & Associates
The photograph of Dr. Martin Luther King Jr. that appears on page 9 is
 ©Dan Budnick/Woodfin Camp & Associates
The photograph of Muhammad Ali that appears on page 179 is
 ©Neil Leifer
The photograph of Carl Lewis that appears on page 185 is
 ©Gregory Heisler

Library of Congress Cataloging-in-Publication Data

The African Americans / edited by David Cohen and Charles M. Collins:
text by Cheryl Everette, Susan Wels, and Evelyn C. White.
 p.cm.
 ISBN 0-670-84982-0(hc) ISBN 0 14 02. 4918 4 (pbk)
 1. Afro-Americans.
 2. Afro-Americans–Pictorial works.
 I. Cohen, David. 1955-. II. Collins, Charles (Charles Miller)
 E185.A258 1993
 973'.0496073–dc20 93-1574
 CIP

Printed in China by Toppan Printing Company, Ltd.
The text of this book was set in ITC Berkeley Old Style, with initial caps in Coronet
Designed by David Cohen

For information, please write to:
Viking Studio Books, 375 Hudson Street,
New York, NY 10014-3657

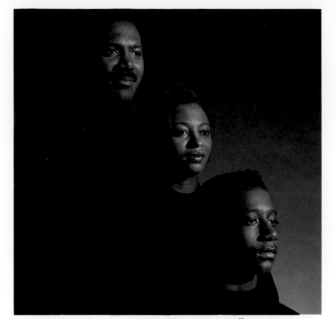

A portrait of achievement: NFL Athlete, Jamie Williams,
Narva Christopher of The Sacramento Bee and honor student Dwight
Huntsman, Jr., of Oakland, California. Photograph by Michael Allen Jones

CONTENTS

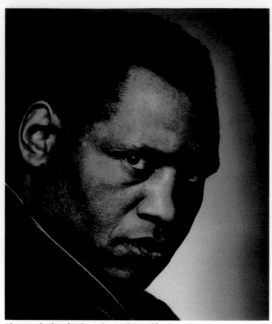

Photograph of Paul Robeson by Karsh/Woodfin Camp & Associates

EDITOR'S NOTE

"We must stop defining ourselves by our most troubled element."
—Sharon Pratt Kelly, mayor, Washington, D.C.

*A*fricans were brought to the New World under the most extreme conditions of human bondage and degradation. When the drafters of the Declaration of Independence declared the American rights of "Life, Liberty and the Pursuit of Happiness," they were not writing about African Americans. When the framers of the Constitution and the Bill of Rights protected the rights of all citizens, they did not include us. As late as 1857, in the Dred Scott decision, the United States Supreme Court stated flat out that the Constitution simply did not apply to Blacks—even free Blacks in the North—because they were not really American citizens in the true sense of the word.

Only a burning desire for justice and a persistent will to succeed against monumental odds have created a place in America for its African people. This place has never been entirely secure; African American rights have never been fully established, and society's esteem for the African American has never been entirely realized.

Nevertheless, the photographs and stories in this volume—historical and contemporary—depict African American contributions across a vast spectrum of American endeavor. This book holds up a mirror to the African American community, illustrating its considerable accomplishments and vital role in American society. It opens a window that allows other Americans to view the rich diversity of the African American experience and the breadth of its achievement. Finally, and perhaps most importantly—it opens doors of self-esteem by presenting young African Americans with positive role models and achievable possibilities in all areas of endeavor.

Our message here is clear. Despite injustice and intolerance—past and present—there can be a comfortable synthesis of African and American cultures and values, and this reconciliation is essential to American society. As a nation we can choose to isolate ourselves in narrowly defined enclaves of race, religion and ideology. Or through greater public understanding, we can learn the unique values, strengths and potential that flow from each constituent element of our nation.

The son of a runaway slave and a citizen of the world who spoke 20 languages, Paul Robeson was a multifaceted talent: All-American, Phi Beta Kappa and valedictorian at Rutgers University, attorney, Shakespearean actor, star of such film classics as The Emperor Jones and Show Boat. Robeson was celebrated abroad as a great singer and actor, and persecuted at home for his political beliefs.

Our challenge is to ward off the deadly threat of cultural, social, economic and political Balkanization. Our goal is to protect vigilantly that common ground where we can nurture a pluralistic, multicultural society that honors its many hues and voices.

It has been a privilege to serve with David Cohen as coeditor of THE AFRICAN AMERICANS. David and I learned many lessons while creating this book. We learned about the rocklike strength of an Oakland grandmother who feeds thousands from the kitchen of her modest home. We learned about kindness and devotion from a crippled 72-year-old volunteer who braves the troubled streets of Detroit each day to give succor to the ill. We learned about love from a Philadelphia teacher who holds a constant vigil for her young charges. We learned about integrity from a great lawyer who worked to establish fundamental equality of all citizens before the law. We learned about self-determination from a talented and determined entrepreneur. From a great tennis star, we learned dignity and grace.

We share these lessons with you, the reader, as examples of what is possible from a people. If the kind acts of a good father in Miami are known, if the brilliant contributions of a Black physicist are appreciated, if the musician's harmony is heard, the painter's colors seen, if the hands of a Black doctor attend your child's birth, then you know there is not a community to be neglected or a person to be wasted. If you can see an image of yourself in just one of these photographs, or if one of these stories is also your story, then the threads that bind us are strengthened.

We dedicate this book to the memory of four good people that we lost during its making: Justice Thurgood Marshall, Reginald Lewis, Arthur Ashe and Marian Anderson. Their achievements, contributions and vision give us confidence and joy in the future of the African American community.

Producing this album has been an exhilarating undertaking, and we are most indebted to the love and patience of our wives, Paula Collins and Devyani Kamdar, and our children, Sara and Julia Collins and Kara and Willie Cohen who have supported our resolve to present this work. We greatly appreciate the devotion and ardor of our photographers, writers, editors and staff in providing the professional support necessary to the scope of this project.

We are particularly grateful to August A. Busch III of the Anheuser-Busch Companies; Donald Keough, Ingrid Saunders Jones, Doug Ivester, Carl Ware, John White and Derilene McCloud of the Coca-Cola Company; Janie Westenfelder, Michael Marion, Joan Purkiss and Linda Dukette of AT&T; Holger Gantz, Robert Moore, David Scypinski and Rob Scypinski of the Hilton Hotels Corporation; Barry Robinson of Prudential Realty; Terry Johnson, Tom Byrnes and Tony Kiernan, who helped us find the funding we needed. Very special thanks also go to John Jacob of the National Urban League and to Dr. Daniel Collins and Vernon Jordan, who provided mentorship, guidance and advocacy for this book project. Michael Jacobs and Michael Fragnito of Penguin USA and Carol Mann, our literary agent, provided the support that permitted our full commitment to this project.

One last thing. As you read through this book, you will probably think of dozens of people who were left out, and you will probably say, "How could they have a book about African American achievement without Lena Horne, Maynard Jackson, Andrew Young or Michael Jordan?" You should know that more people have been left out of this book than anyone could imagine. There is enough depth of talent in this community to fill many volumes of THE AFRICAN AMERICANS. Behind each of the women, men, children, families, organizations and institutions pictured here are countless others whose untold contributions are the foundation upon which we all stand.

Charles M. Collins
San Francisco, California

For Kara, Willie and Lucas, so you will always be tolerant, and so you will only judge people by the content of their character.

David Cohen
Mill Valley, California

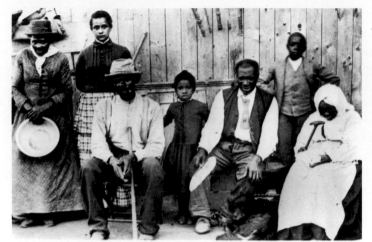

Photograph of Harriet Tubman (far left) from the Bettmann Archives

AFRICAN AMERICANS
BY RIGHT OF BIRTH, BY RIGHT OF TOIL

by John Hope Franklin
James B. Duke Professor of History Emeritus, Duke University

*A*lmost a century ago, the libelous attacks against African Americans were so crude and blatant that even the most optimistic and tolerant among them seemed discouraged. As they looked around them and saw that few, if any, of their so-called "friends" were willing to speak out in their behalf, they took it upon themselves to do so. In a series of essays and books remarkable for their argument and boldness if not for their artistry and felicity, they insisted that they had worked long and hard to make this country rich and strong. Consequently, they could not ignore the efforts of so many who claimed that as a group African Americans were inconsequential, and that as individuals they were worthy only to be hewers of wood and drawers of water.

The Social Darwinists said that African Americans had not "made it" simply because they were not "fit." Their first 40 years of freedom had been a failure, said the distinguished economist John R. Commons. They were beasts, said Charles Carroll, somewhat inelegantly. This alleged failure was widely acknowledged as Northerners of every rank and description acquiesced to the Southern solution to the race problem, characterized by disenfranchisement, segregation, and discrimination.

It must have come as a surprise to many that African Americans struck back with a certain kind of civilized, controlled fury, for it was a gentle, literary fury of refutation. In works written for the general public, such as *Men of Mark; Eminent, Progressive and Rising* by William J. Simmons; *Progress of a Race, Or, The Remarkable Advancement of the American Negro* by J. W. Gibson and W. H. Crogman; and *Afro-American Encyclopædia, or, The Thoughts, Doings, and Sayings of the Race* by James T. Haley, they argued their case. It was Haley who spoke for the others when he said that his book "furnishes the most authentic information concerning the race, and we trust it will awaken a more appreciative spirit of enterprise among Americans."

Even more to the point was W. S. Armistead's *The Negro Is a Man: A Reply to Professor Charles Carroll's Book: "The Negro Is a Beast, or, In the Image of God."* He called the Carroll book "a damnable heresy" and its publishers "a lot of witless asses." Then, there was D. W. Culp's *Twentieth Century Negro Literature, or, A Cyclopedia of Thought on the Vital Topics Relating to the American Negro,* "to enlighten the uninformed white people on the intellectual ability of the Negro." While the impact of these and similar works was dubious, they clearly show that African Americans were sensitive, creative and even confrontational with those who would denigrate their place in the history of the United States.

A fugitive slave, Harriet Tubman returned to the South 19 times to help more than 300 other slaves escape via the Underground Railroad. During the Civil War, she also served as a guide and spy for the Union Army. She was buried with full military honors in 1913.

The time would come—before the middle of the 20th century—when there seemed to be the need once more to herald the services of African Americans to the nation. Following the war to save the world for democracy, many white Americans feared that African Americans, more than 350,000 of whom were in the armed services during the war, would seek the democracy in the United States for which many of them had fought and died in Europe. More than a score of race riots and numerous lynchings occurred in the two years following the war. This suggested to many Blacks how determined white Americans were to keep them in the degraded status that they had endured for many decades. Black Americans sought democracy by pressing for the right to vote, to enjoy equal protection of the law and simply to live and work as other Americans did. They also undertook to show other Americans that they were as loyal and law-abiding as any others and that they possessed the same human impulses that characterized other Americans.

This took the form of pointing with pride to individual achievements of African Americans in particular fields. This time around there were a few white advocates, but the bulk was understandably African American. Representative of the whites was Edwin R. Embree, president of the Rosenwald Fund, who wrote *Brown Americans, the Study of a Tenth of the Nation* and *Thirteen Against the Odds*. Both works contained thumbnail sketches of individual achievers rather than a general account of the experiences of Blacks in the New World. Others, such as Robert E. Park of the University of Chicago, Melville J. Herskovits of Northwestern University and playwrights DuBose Heyward and Paul Green, made efforts to portray African Americans as people and not as objects of exploitation.

Even more important was the veritable outburst of African American writers themselves, bringing forth the most engaging, even sublime expressions. They were no longer arguing that they were human beings; that was a given. They were seeking, successfully, to match their pens and wits with the best of white American poets, essayists, novelists, painters, sculptors and the like. Earlier, there had been *The Souls of Black Folk,* by W. E. B. Du Bois, which struck a new note of independence, intellectual power, and felicity of style. Later there would be the writings of James Weldon Johnson, Claude McKay, Countee Cullen, Nella Larsen, Jessie Fauset and a host of others. Their boldness showed itself in McKay's "If We Must Die," their bitterness in Cullen's "To Make a Poet Black and Bid Him Sing," their subtlety in Langston Hughes' "Brass Spittoons" and their lyricism in Frances E. W. Harper's "Eliza Harris."

They did not argue for their place in the pantheon of American writers and artists; they merely did their work, placed it before the American public and hoped that they would be judged by the same standards by which others were judged. Visual artists did the same thing. Among them were Edward A. Harleston, William Johnson, Aaron Douglas, Augusta Savage and Richmond Barthé. There were also the writers in the scholarly fields, such as E. Franklin Frazier, Kelly Miller, Charles S. Johnson, Sterling Brown, Rayford W. Logan, Kenneth Bancroft Clark and a host of others. While the artists declared that they, too, could sing America, the growing number of scholars pointed to ways to bring about a better America to sing about.

Meanwhile, the advocates, such as Charles H. Houston, Thurgood Marshall, Constance Baker Motley, James M. Nabrit, Spottswood Robinson, Oliver Hill, Robert Carter and others, threw the combined and very considerable weight of their legal powers against the barriers of segregation, "and the walls came tumbling down." Institutions such as the Black church, the NAACP, the Urban League, labor unions, agricultural workers and what W. E. B. Du Bois and Carter G. Woodson called "college-bred men and women" shared a common vision of a better tomorrow for themselves and their offspring, and they worked diligently for it. It was this vision that made the work of the 1950s and 1960s so important, so compelling and such a welcome undertaking.

Today, the situation is different. It is not that racism has been eradicated, or that its multiple offspring of discrimination, segregation and exploitation have disappeared. It is that African Americans have learned how better to cope with the forces that operate against them, and they have learned how to turn the opposing forces into challenges that they can meet fearlessly and with confidence. It also means that African Americans have acquired friendly advocates in high places and low—despite some long-term holdouts—who have had the courage and vision to march with them, sing with them, pray with them and fight with them for a better America.

Consequently, there are more than 40 African Americans in the Congress of the United States, far more than have ever served before. President Bill Clinton appointed four African Americans to his cabinet, and Maya Angelou cast her blessings on Inauguration Day with her poem "On the Pulse of Morning" written for the occasion. Heretofore, not more than one African American had ever served in the president's inner circle. In state legislatures, the number of African American members has steadily increased since the passage of the Voting Rights Act in 1965. More African Americans serve as mayors of cities than ever before, ranging from David Dinkins of New York City to Emma Gresham of Keysville, Georgia. The increased political influence of African Americans manifests itself in the formulation of public policies that benefit the entire population instead of a favored few, and in the enactment of legislation with the objective of extending the blessings of democratic government to all the people.

The rich musical and cultural history of African Americans ranges from the great spirituals and work songs of the 18th and 19th centuries to the joyous exclamations and cadences of lament of the gospel songs of the 20th century. This history extends from the minstrels of yore to various current performing-art forms. The revolution in communications makes available to the national viewing audience Bryant Gumbel in the morning, Oprah Winfrey in the afternoon, Bernard Shaw in the evening, Arsenio Hall toward midnight and Bill Cosby at any time of day or night. Barriers in the world of classical music began to fall with Marian Anderson singing at the Metropolitan Opera, and with Leontyne Price singing romantic roles in a variety of musical masterpieces.

It is, of course, distressing to observe that there are more African American males in houses of correction than there are in college. But there is some solace in the realization that there are more African American males in college than ever before. And if one's faith in education holds firm, there is some reason to believe that the numbers of those in detention will diminish as the diffusion of knowledge reaches those at risk of becoming offenders or the dupes of those who would exploit them. Substance abuse is more rampant than ever before, and even if the numbers of those who currently seek to cope with the problem are inadequate, there are more African American men and women in the scientific and social-scientific fields than ever before who can meet the grave challenge to blunt the effects of this scourge, and with greater public and private support, perhaps to eliminate it altogether.

Over the years, African Americans have experienced moods that almost simultaneously lifted them to the heights of optimism only to be dashed into the depths of despair. Too often that has been what the life of African Americans has been about, a kind of counter-

point that gave meaning to the realism of their sometimes desperate existence and at the same time provided some hope for the future. In 1780, the well-to-do Paul Cuffe of Massachusetts could not vote because he was Black. He was more bemused than outraged when, in response to his refusal to pay his taxes, the town fathers threw him into the Taunton jail. He reminded them of what they had told Britain early in the War for Independence: that taxation without representation was tyranny. Despite the implication in refusing him the franchise (that whites regarded Cuffe as inferior), he continued his work, increased his wealth, became a philanthropist, and remained until his death a substantial benefactor of the Society of Friends.

A half-century later, Frederick Douglass, a fugitive from Maryland slavery who had become one of the most eloquent and effective opponents of slavery, made his own comments on the contradictory nature of American society. Speaking to a Rochester audience on Independence Day in 1862, Douglass said, "I am not included within the pale of this glorious anniversary. Your high independence only reveals the immeasurable distance between us. The blessings in which you, this day, rejoice, are not enjoyed in common. The rich inheritance of justice, liberty, prosperity and independence, bequeathed by your fathers, is shared by you, not by me." It was the fate of Douglass to be remembered more than most of his contemporaries of any race because he saw so clearly the nature of our society and had the courage to speak out against its flaws.

Those flaws still existed long after slavery. In 1896, a Louisiana conductor evicted Homer A. Plessy, an African American, from a train because he was riding in a coach reserved for whites. It mattered not that Plessy had no visible signs of being an African American. The conductor knew him to be one under Louisiana law, and that was sufficient. That was the year the United States Supreme Court declared that racial segregation was legal, as long as the facilities for both races were equal. For the ensuing century, a major preoccupation of African Americans was to argue at every level of the judiciary, in every legislature and to every executive, whether mayor, governor or president, that virtually everything in the United States was separate, but one would be hard put to find anything with equal accommodations or facilities for African Americans.

The late Supreme Court Justice Thurgood Marshall spoke to the point of the difficulties of trying to make things work for equality when the Constitution, under which all people would have equal opportunity to function, did not guarantee a level playing field. He pointed out in 1987 that the Constitution "was defective from the start, requiring several amendments, a civil war, and momentous social transformation to attain the system of constitutional government and its respect for the individual freedoms and human rights we hold as fundamental today." The genius of the American system is that its people have seized the opportunity, from time to time, to "fix" things that the framers did not fix in Philadelphia in 1787. The result has been that new and brighter opportunities have opened up, from time to time, for those on whom the door was closed at the beginning.

The genius of African Americans is that they have neither given up on the American system nor become so cynical that they have not sought to make it work. With an optimism born in hope when only despair was in view, a certainty that their moral position was stronger than that of their adversaries and a determination to use all of their resources to make the system work for all peoples, they have achieved limited success. The same qualities that they have displayed up to this point are essentially the ones they need in order to achieve a status of full equality in the land that James Weldon Johnson reminded them was theirs by right of birth and by right of toil.

John Hope Franklin
Durham, North Carolina

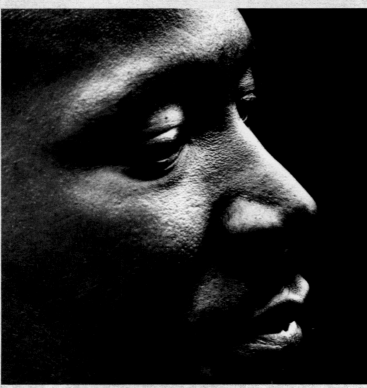

The Reverend Dr. Martin Luther King, Jr., was the leading spokesman for the civil rights movement of the 1960s. Inspired by the principles of Indian states-man Mahatma Gandhi, Dr. King adopted a pro-gram of nonviolent protest and civil disobedience that focused the world's atten-tion on the struggles of African Americans. He received the 1964 Nobel Peace Prize for his efforts to rid America of racism and discrimination. Dr. King, who asked that he be remembered as a "drum major for justice," was slain in April 1968 in Memphis, Tennessee.

Dan Budnick/Woodfin Camp & Associates

SERVICE TO THE COMMUNITY

Perhaps it was Shirley Chisholm, the first Black woman elected to the United States Congress, who said it best: "Service is the rent you pay for room on this earth."

The history of the African Americans encompasses not only a persis-tent struggle against injustice, but remarkable service both to the Black community and to the nation as a whole. Beginning in 1492, when Columbus' legendary Black crewman, Pedro Alonzo Niño, stepped onto the New World shore, men and women of African descent have shaped and enhanced American life.

African American patriots fought in the earliest Boston rebellion against the British soldiers in 1770, and former slave Crispus Attucks was the first casualty of the bloody uprising that led to the Revolutionary War. In the years before the Civil War, Black abolitionists such as Frederick Douglass and Sojourner Truth fought heroically, not only to free Black slaves, but to improve the moral character of the nation as a whole.

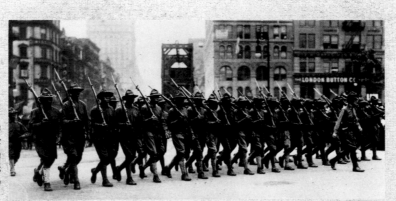

The men of the 15th Negro Regiment were among 367,000 African American soldiers who fought bravely in World War I.

The Bettmann Archives

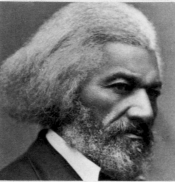

Abolitionist Frederick Douglass was one of America's greatest orators. Born a slave in Maryland in 1817, he taught himself to read at age 12 and acquired more than 10,000 books during his lifetime. An advisor to President Lincoln during the Civil War, Douglass served as marshal of the District of Columbia and U.S. minister to Haiti before his death in 1895.

The Bettmann Archives

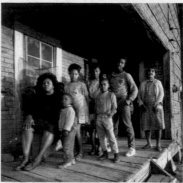

A Mississippi sharecropper who was jailed and beaten for demanding her rights, Fannie Lou Hamer was one of the most inspiring figures of the civil rights movement. A founder of the Mississippi Freedom Democratic Party, Hamer challenged the seating of the all-white Mississippi delegation at the 1964 Democratic National Convention. Her actions led to an unprecedented pledge from Democratic Party leaders to never again seat delegations that excluded Blacks.

Bruce Davidson/Magnum

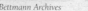
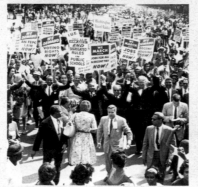

More than 200,000 people participated in the massive March on Washington in August 1963. They gathered at the Lincoln Memorial to hear Dr. Martin Luther King, Jr., deliver his legendary "I Have A Dream" speech, which defined the moral basis of the civil rights movement with its eloquent plea for racial equality.

Consolidated News Pictures

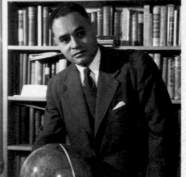

Born in the Detroit slums and orphaned at 11, Ralph Bunche was raised by his grandfather, a former slave. Bunche earned a master's degree and Ph.D. from Harvard. He chaired the political science department at Howard University and was undersecretary general of the United Nations. In 1950, he was awarded the Nobel Peace Prize for mediating the 1948–49 Arab-Israeli conflict.

The Scurlock Studio, Washington, D.C.

When the Civil War brought freedom but not justice, countless African American civil rights leaders, clergy, educators, philanthropists and public servants fought on. Undeterred by the lash of the whip, the lynch mob or the law of the land, they held America accountable to its promise of "liberty and justice for all." Slowly but surely, they vanquished the stumbling blocks of segregation that barred African Americans from America's schoolrooms, courtrooms, hotel rooms, dining rooms, restrooms, emergency rooms, locker rooms and boardrooms.

Each door they pried open led to greater opportunities, not only for African Americans but for every other disenfranchised group in the land. In this way, the African American tradition of service has fulfilled the old exhortation to "lift as one climbs."

Perhaps no other African American gave more effectively and fully to his people and the nation than the late Dr. Martin Luther King, Jr. "Everybody can be great," King said, "because anybody can serve. You don't have to have a college degree to serve. You don't have to make your subject and your verb agree to serve. You don't have to know about Plato and Aristotle to serve. You don't have to know Einstein's Theory of Relativity to serve. You don't have to know the second theory of thermodynamics in physics to serve. You only need a heart full of grace. A soul generated by love."

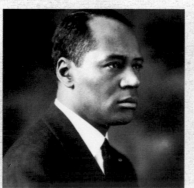

As special counsel for the NAACP and mentor to Thurgood Marshall, attorney Charles Hamilton Houston helped erase color lines in higher education and real estate. Born in 1895, Houston was the son of a Howard University professor. He graduated Phi Beta Kappa from Amherst College and earned a law degree from Harvard, before heading the NAACP's legal assault on racial discrimination.

Scurlock Studio, Washington DC

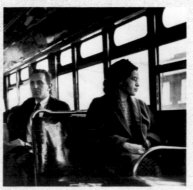

On December 1, 1955, in Montgomery, Alabama, Rosa Parks refused to give up her public bus seat to a white man, in defiance of local segregation laws. Her arrest triggered a yearlong bus boycott that awakened the nation to the emerging civil rights movement and brought Dr. Martin Luther King, Jr., to international prominence.

The Bettmann Archives

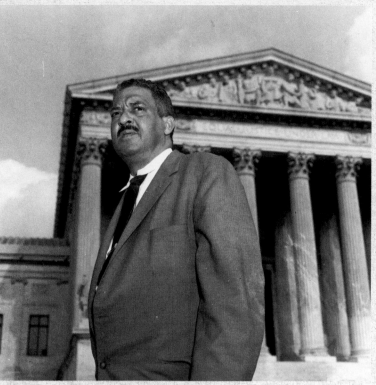

Appointed to the bench in 1967, Thurgood Marshall was the first African American to serve on the United States Supreme Court. As director of the NAACP's Legal-Defense section for more than 20 years, Marshall's greatest victory was the Supreme Court's 1954 decision, Brown v. Board of Education, which officially ended segregation in public schools.

The African American leaders profiled in this section—mayors and governors, cabinet secretaries and community leaders, doctors and generals—all owe a monumental debt to those who came before. To Harriet Tubman, who followed the North Star to freedom but returned to the South time and again for her brothers and sisters; to Rosa Parks, who said, "enough is enough" and wouldn't give up her seat on the bus; to Thurgood Marshall, who first fought to end injustice in our schools and then stood as a beacon of integrity for four decades. As you will see in this section, some African American leaders have climbed nearly to the pinnacle of power and prestige—but in doing so, they stand on the shoulders of giants.

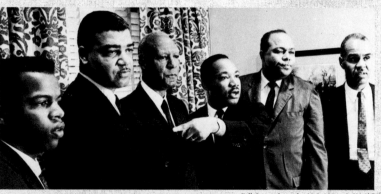

Summit meeting: (left to right) John Lewis of the Student Nonviolent Coordinating Committee (SNCC), Whitney Young of the National Urban League, union organizer A. Philip Randolph, Dr. Martin Luther King, Jr., CORE leader James Farmer and NAACP head Roy Wilkins, at a 1963 conference during which they discussed strategies for the civil rights movement.

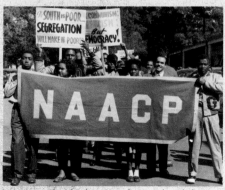

Founded in 1908 by a multiethnic group of activists, the National Association for the Advancement of Colored People was organized to confront racism and fight for equal rights. In its more than 80-year history, the organization has fought to improve schools, housing and job opportunities for African Americans.

Clara McBride Hale's long career caring for sick children began in 1969 when a young woman appeared at her door with a drug-addicted baby. A foster-care mother for more than four decades, Mother Hale took in the infant and then dozens more, as word of her devotion to children spread quickly. The same year, she founded Hale House, a safe, loving environment that has nurtured more than 1,000 young victims of New York City's drug and AIDS epidemics. In 1985, in his State of the Union address, President Ronald Reagan cited Mother Hale as an American hero. "I'm not an American hero," Hale said in response. "I'm simply a person who loves children."

Hale House founder Mother Clara Hale with two of the thousands
of children she nurtured before her death, at age 87, in 1992.
Photograph by Stephen Shames/Matrix

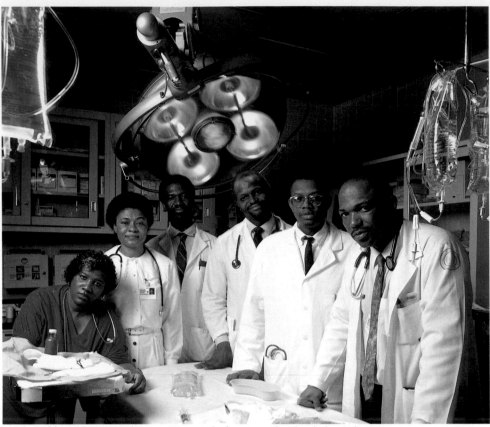

Members of the Harlem Hospital Trauma Team are the first to provide aid to the hospital's serious emergency-room cases. (Left to right) Betty Rivers, R.N.; Salome Eze, R.N.; Craig Braithwaite, physician's assistant; Frank Babb, M.D.; Daniel Powell, M.D.; and Reynold Trowers, M.D., chief of the Emergency Services Department at Harlem Hospital Center. Photo essay by Andy Levin

\mathcal{F}ounded in 1887, Harlem Hospital cares for the residents of its community with a special sensitivity and compassion. The 770-bed facility treats more than half a million patients a year, most of whom are Black or Hispanic and disproportionately poor.

In addition to providing quality health care, the hospital is a vital social, political and economic force in the community. At a time when other medical facilities are cutting back services to the poor, Harlem Hospital operates four community-based methadone mainte-nance clinics and provides medical services to the Fort Washington Center for homeless men. The hospital's mobile van visits nearby neighborhoods, offering residents health-care screenings and prevention tools.

Harlem Hospital has also been an important training ground for women and minority health professionals who are dedicated to providing quality care to those who need it most.

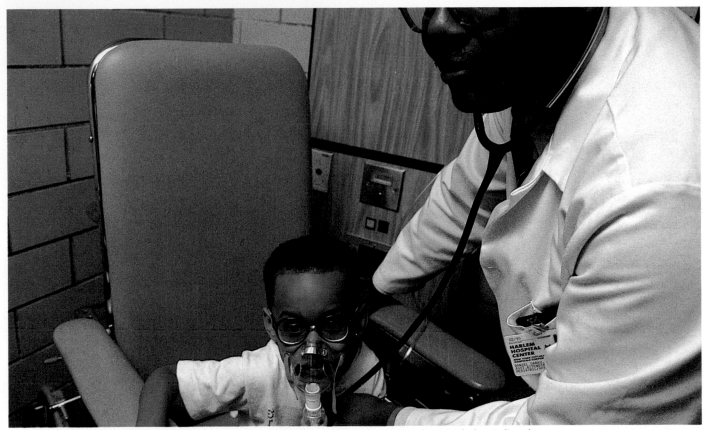

Six-year-old Christopher Jones, an asthma patient, receives treatment from Daniel Darku, M.D., a doctor in the hospital's pediatric emergency room.

Social worker Allison Skeets assesses the needs of emergency patients in the hospital's observation room. She is often the primary link between patients and anxious family members.

Formerly the highest-ranking woman on active duty in the U.S. Army, Brigadier General (Ret.) Clara L. Adams-Ender was commanding general of Fort Belvoir, Virginia, and deputy commanding general of the Military District of Washington.

Born in Wake County, North Carolina, Adams-Ender was the daughter of sharecroppers, the fourth of 10 children. Her father urged her to become a nurse and offered to pay for part of her schooling, but in 1959 Adams-Ender joined the Army in order to raise enough money to finish her nursing education. After earning her bachelor's degree from North Carolina Agricultural and Technical State University in Greensboro, and a master's degree from the University of Minnesota, Adams-Ender became the first woman ever to receive a Master of Military Art and Science degree from the U.S. Army Command and General Staff College at Fort Leavenworth, Kansas.

In the course of her 33-year Army career, Adams-Ender has also served as chief of nursing for Walter Reed Army Medical Center, the largest and most prestigious health-care facility in the Department of Defense. During the Persian Gulf crisis, she was chief of the Army Nurse Corps and director of personnel for the Army surgeon general. Adams-Ender has received the Distinguished Service Medal, Legion of Merit and the Army Commendation Medal, as well as the Roy Wilkins Meritorious Service Award from the NAACP.

Photograph of Brigadier General (Ret.) Clara Adams-Ender,
the highest-ranking woman in the U.S. Army, by C.W. Griffin

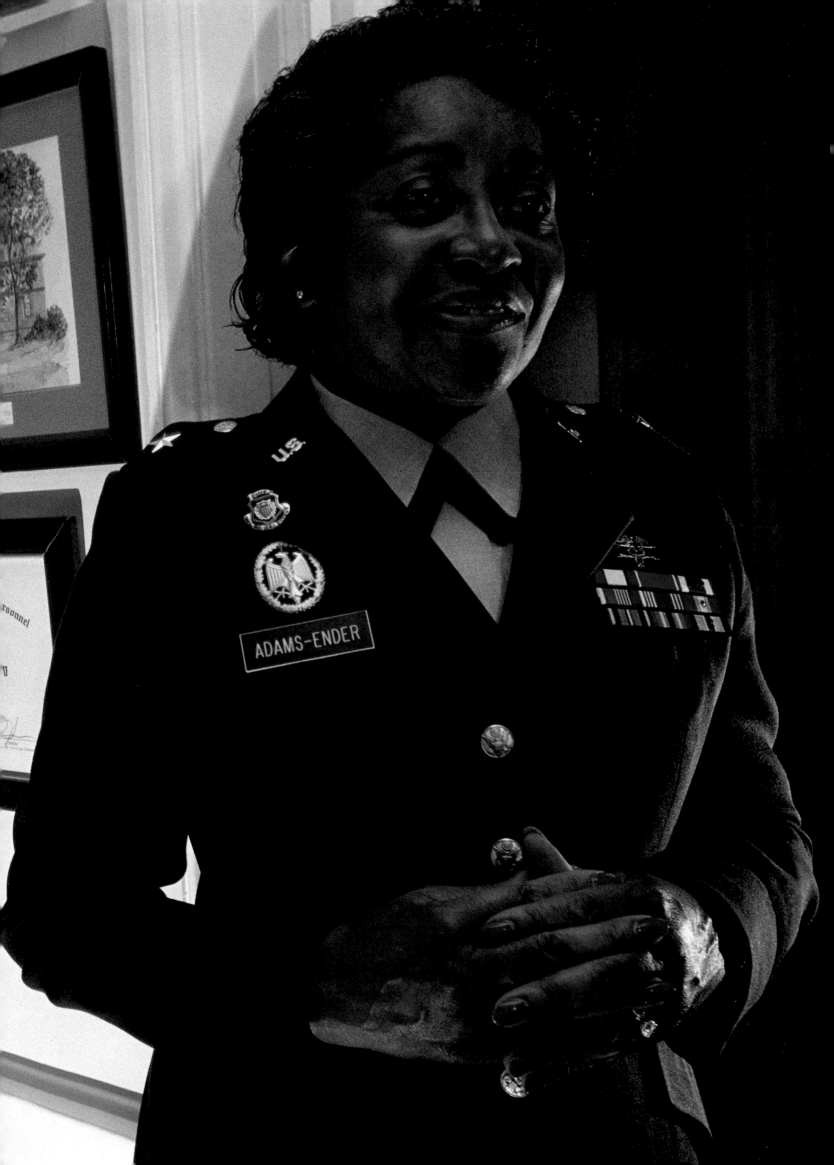

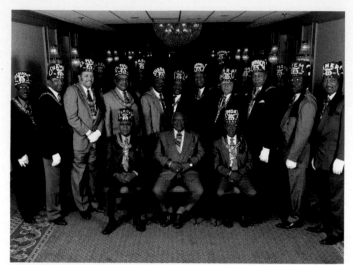

The annual divan meeting of the Ancient Egyptian Arabic Order, Nobles of the Mystic Shrine of North and South America in New Orleans, Louisiana. Photographs by Jeffrey Henson Scales

*F*reemasonry is the African American community's oldest continuous fraternal organization. Many of its precepts and rituals date from the great period of cathedral building in medieval and Renaissance Europe. At that time, masons formed lodges where they could fraternize as they traveled from town to town. The first Grand Lodge was formed in London in 1717, and British colonists brought the organization to America shortly thereafter.

The founder of African American Freemasonry was Prince Hall. According to some accounts, he was a minister, originally from Barbados, who served in the colonial army. Hall petitioned the Massachusetts Grand Lodge to establish a Masonic organization specifically for Black residents of the colonies. When he was denied permission, he applied directly to the Grand Lodge of England, and in 1784 a warrant was issued for African Lodge No. 459 in Boston.

Masonry and other African American fraternal organizations such as the True Reformers, the Knights of the Pythias and the Elks, are dedicated to improving the cultural, economic and social standing of African Americans. Many of the nation's most accomplished Black leaders are Freemasons, including Andrew Young, Jesse Jackson and former NAACP president Benjamin Hooks. The Order of the Eastern Star, an organization for female relatives of the Masons, has hundreds of prominent African American women among its members.

The Masons support a wide range of health, education, emergency-relief, voter-registration and scholarship programs. "We are dedicated community servants," says Imperial Potentate Dr. Arthur T. Shack. "We try to provide a helping hand whenever there is a need."

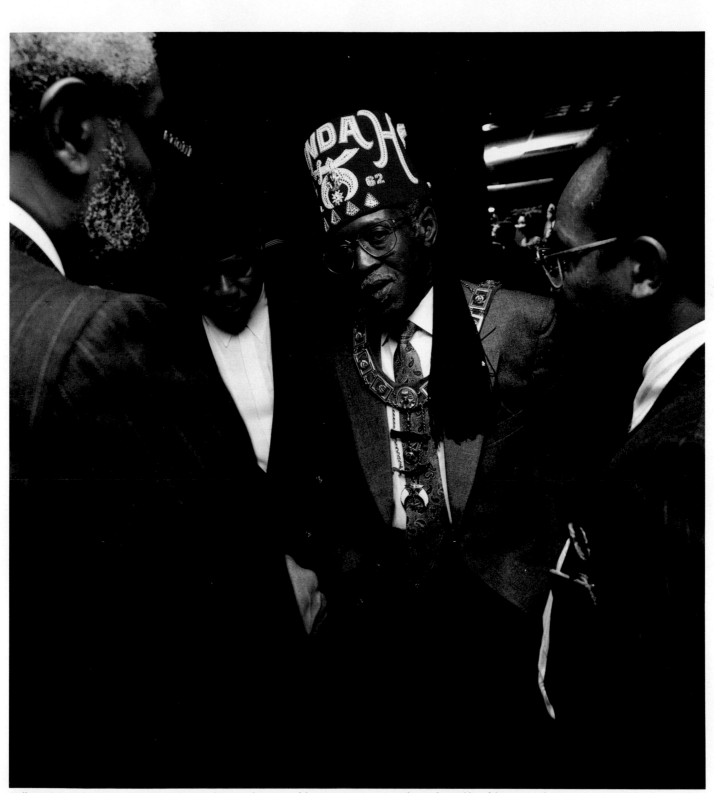

William T. Pratt, Deputy Imperial Potentate, at the annual meeting of the Ancient Egyptian Arabic Order, Nobles of the Mystic Shrine.

Photograph of the National Pan-Hellenic Council at its annual national board meeting in Louisville, Kentucky, by Durell Hall, Jr.

𝒥ounded in 1930 at Howard University, the National Pan-Hellenic Council represents 1.8 million African Americans who are members of the eight historically Black fraternities and sororities—Alpha Phi Alpha, Kappa Alpha Psi, Phi Beta Sigma, Omega Psi Phi, Alpha Kappa Alpha, Delta Sigma Theta, Zeta Phi Beta and Sigma Gamma Rho.

Born in response to discriminatory policies that kept African American students from joining white sororities and fraternities, Black fraternal orders are dedicated to promoting academic excellence and improving community life through a wide range of programs and volunteer services.

Indiana University doctoral candidate Jason DeSousa is the associate executive director of the Pan-Hellenic Council. He says that Black fraternities and sororities on the nation's campuses are engaged in an array of activities ranging from AIDS education and helping the homeless to tutoring inner-city youth.

Photograph of a meeting of the Alpha Phi Alpha fraternity at the University of Michigan, by Andy Freeberg

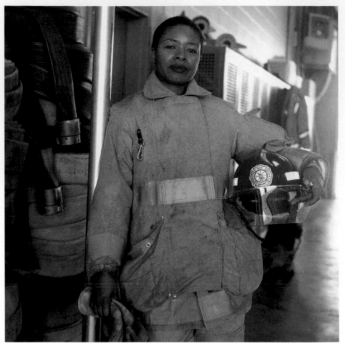

Kathy E. Morris Wilkerson, New Orleans' first female firefighter. Photographs by Jeffrey Henson Scales

\mathcal{A}fter more than a decade on public assistance, Kathy E. Morris Wilkerson, mother of two, successfully completed training to become the first female firefighter in the 101-year history of the New Orleans Fire Department. Wilkerson faced both official resistance to the idea of a female firefighter and a series of grueling physical tests. At first, she could only do two pushups. Now, she's up to 40. Captain Joseph Matthews, president of the Black Association of New Orleans Firefighters, says Wilkerson "will make an excellent firefighter. I would be proud to have her on my unit." Wilkerson says, "I wanted to be independent, not dependent. I'm so thankful that I'll have a chance to serve my community by helping to save lives and property."

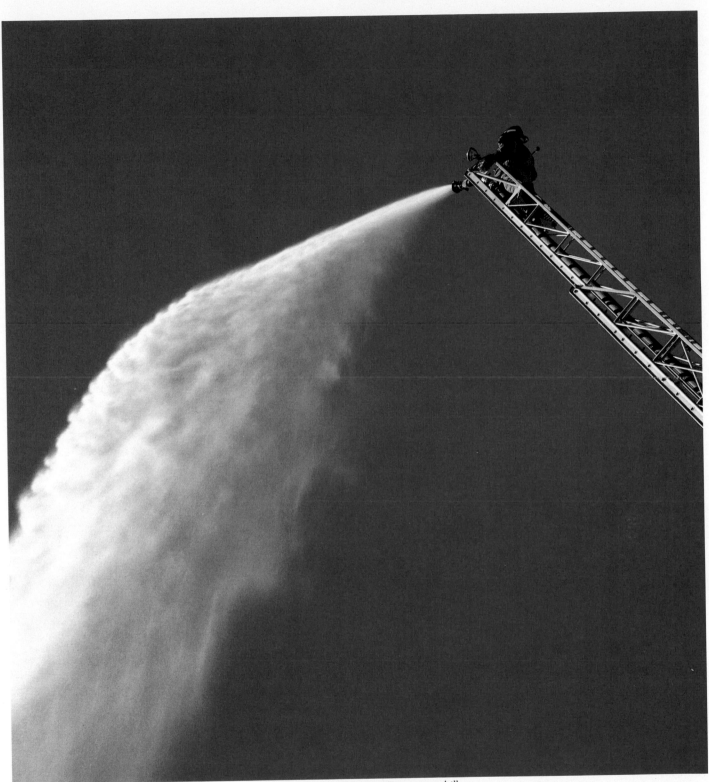

Wilkerson handles a high-pressure hose atop a 100-foot ladder during a New Orleans Fire Department drill.

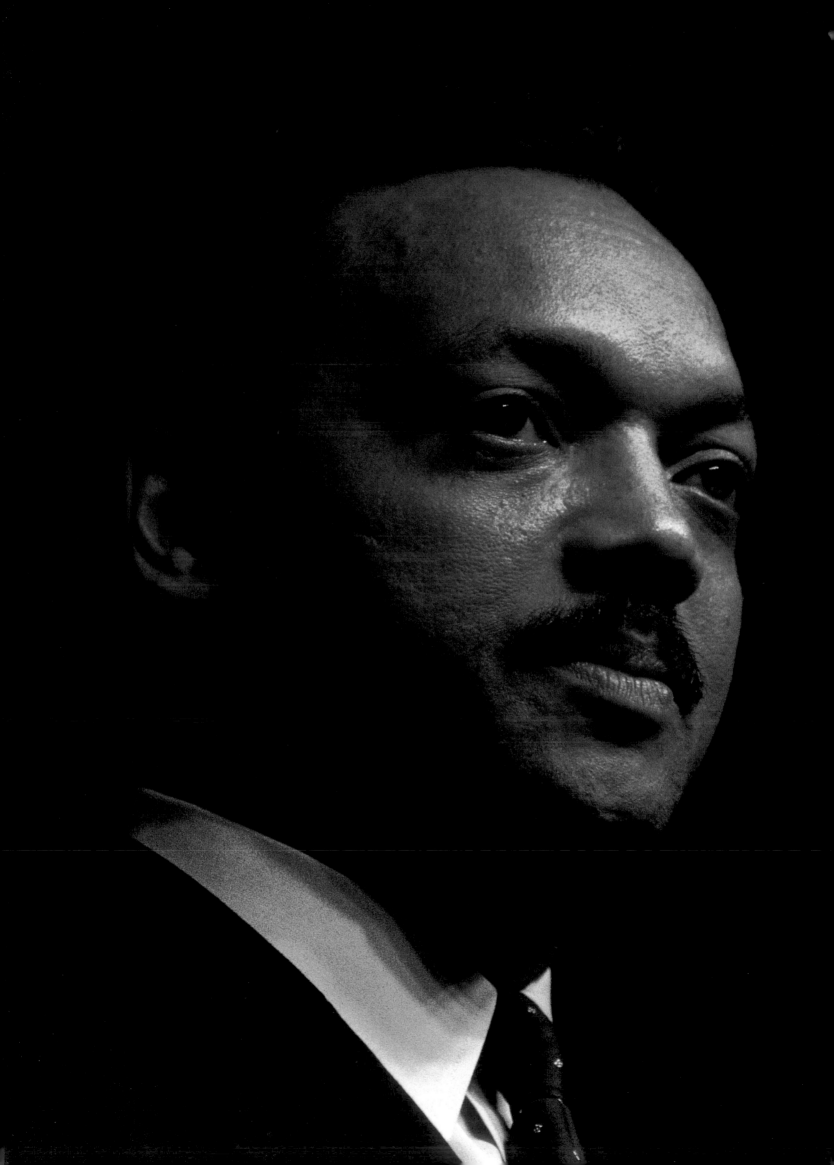

\mathcal{B}orn, in his own words, "to a poor, unwed mother who was herself the child of a poor, unwed mother," Jesse Louis Jackson's life has been characterized by a determined quest for respect and an unshakable dedication to the disadvantaged.

Jackson was raised in a modest home in the segregated South. While studying at the Chicago Theological Seminary in the mid-1960s, he became active in the emerging civil rights movement led by Dr. Martin Luther King, Jr. An impassioned orator, Jackson patterned much of his leadership style after Dr. King, whom he called "my father figure, my brother figure and my teacher."

After King's death, Jackson continued the slain civil rights leader's legacy by becoming a fervent messenger for social change. Lacing his powerful church sermons and political speeches with the inspirational chant "I am somebody," Jackson urges young people across the nation to recognize their capabilities, regardless of the hardships they may have suffered. "Youth are looking for something," Jackson says, "It's up to adults to show them what is worth emulating."

Though he was considered a maverick, well outside the political mainstream, Jackson confounded critics by becoming a major force in American politics in the mid-1980s. In both the 1984 and 1988 presidential races, Jackson's Rainbow Coalition brought record numbers of African Americans and other disenfranchised people into the voting booth. During the 1988 campaign, Jackson won 30 percent of the delegates to the Democratic National Convention. His stirring speech to the assembly in Atlanta received a 15-minute ovation. "The items I have struggled for are in the mainstream of this country's interest," Jackson says. "You cannot name one where I am not in the center of that stream."

Photograph of the Reverend Jesse Jackson by Kenneth Jarecke/Contact Press Images

Photograph of Secretary of Energy Hazel O'Leary by Keith Jenkins

*H*azel R. O'Leary is the first African American to head the nation's Department of Energy. An attorney who graduated Phi Beta Kappa from Fisk University, Secretary O'Leary was an executive at the Minneapolis-based Northern States Power Company prior to her White House appointment. Her previous experience in government includes directing the Federal Energy Administration's Office of Consumer Affairs under President Gerald Ford, and the Energy Department's Economic Regulatory Administration under President Jimmy Carter.

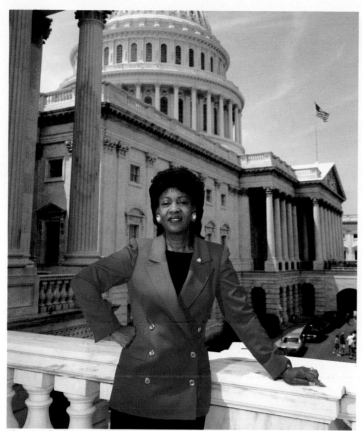

Photograph of Representative Maxine Waters by Anthony Barboza

Schooled in the "unbought and unbossed" tradition of pioneering African American politician Shirley Chisholm, California congresswoman Maxine Waters is considered one of the most powerful African American women in the Democratic Party. One of 13 children born to a single mother in the housing projects of St. Louis, Waters worked in a garment factory and at the telephone company before earning her bachelor's degree in sociology.

Waters made national headlines when she showed up uninvited at a White House summit meeting in the aftermath of the 1992 Los Angeles riots. "I don't have time to be polite," Waters said. "My power comes from the fact that I am ready to talk about Black people."

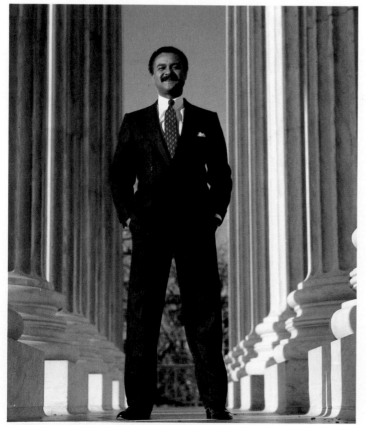

Photograph of Commerce Secretary Ron Brown by Neil Leifer

Commerce Secretary Ron Brown—the first African American to hold the position—is accustomed to the vanguard. He was the only Black student in his elementary school in New York, the first Black fraternity member at Middlebury College and the first Black partner at one of Washington's most powerful law firms. Under Brown's leadership as the first Black chairman of the National Democratic Party, Arkansas Governor Bill Clinton won the White House, ending 12 years of Republican rule. Brown says, "Government should play an active role in dealing with the real problems faced by people in this country."

Photograph of Speaker Willie Brown by Michael Allen Jones
Photograph of Governor Douglas Wilder by Charles Ledford/Black Star

\mathcal{L}ongtime champion of the underdog, California State Assembly Speaker Willie L. Brown, Jr., is one of the most influential leaders in the Democratic Party.

Although today he is known as the best-dressed man in Sacramento, Brown once had to work long hours at a pea-processing plant just to earn enough money to buy school clothes. After high school, Brown moved to San Francisco, where he worked his way through college as a doorman, a janitor and a shoe salesman. He entered California politics in the mid-1960s after earning his law degree. He was elected the first African American speaker of the California Assembly in 1980.

Respected for his sharp political insights and negotiating skills, Brown was national chairman of Jesse Jackson's 1988 presidential campaign. He is also the author of several landmark bills, including legislation that reduces time-consuming delays in the court system, provides compensation for victims of crime and limits health-care costs for the poor.

\mathcal{V}irginia Democrat L. Douglas Wilder—grandson of slaves—became the nation's first elected African American governor in November 1989. A graduate of Virginia Union University, Wilder earned his law degree at Howard University School of Law. A presidential candidate in the 1992 campaign, he is considered by some to be a rising star on the national political landscape.

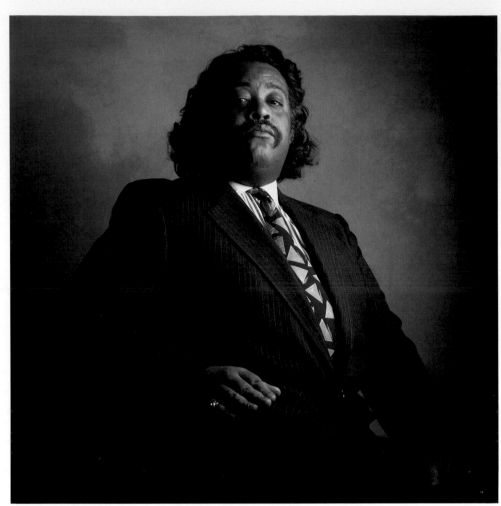

Photograph of the Reverend Al Sharpton by Michael O'Brien

*W*ith his signature rallying cry, "No justice, no peace," Reverend Al Sharpton is a major force in New York City politics and an activist of growing national influence. A Brooklyn preacher who delivered his first sermon at age four, Sharpton has sought to improve the economic and social conditions of New York's African Americans by directing a glaring spotlight on racial conflicts.

Called a provocateur by some, a peacemaker by others, no one questions Sharpton's ability to focus attention on the dire problems of the poor and disenfranchised. Defeated in his bid for a U.S. Senate seat in the 1992 election, Sharpton vows he will run again in 1994. "It's time for me to bring down the volume and bring up the program," Sharpton says.

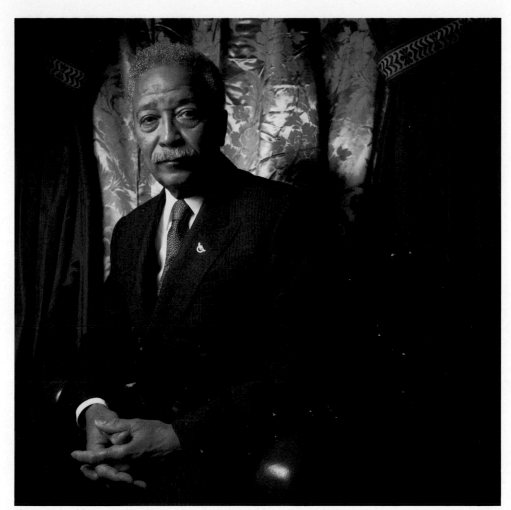

Photograph of former New York mayor David Dinkins by Karen Kuehn/Matrix

*O*n November 7, 1989, David Dinkins became the first African American mayor of America's largest city.

An attorney with a bachelor's degree in mathematics from Howard University, Dinkins launched his historic campaign with a pledge to heal and unify New York. "He is a man for these times," said *New York Newsday.* "His years of experience with urban social issues—from AIDS to housing to education—combined with his sensitivity to the problems of race and class provide him with a consensus-building capacity that will stand him in good stead as a mayor."
During his term of office, Dinkins spoke out forcefully for improved relations between the city's contentious ethnic groups, and brought a sensitive and reasoned voice to the city's often-fractious political landscape.

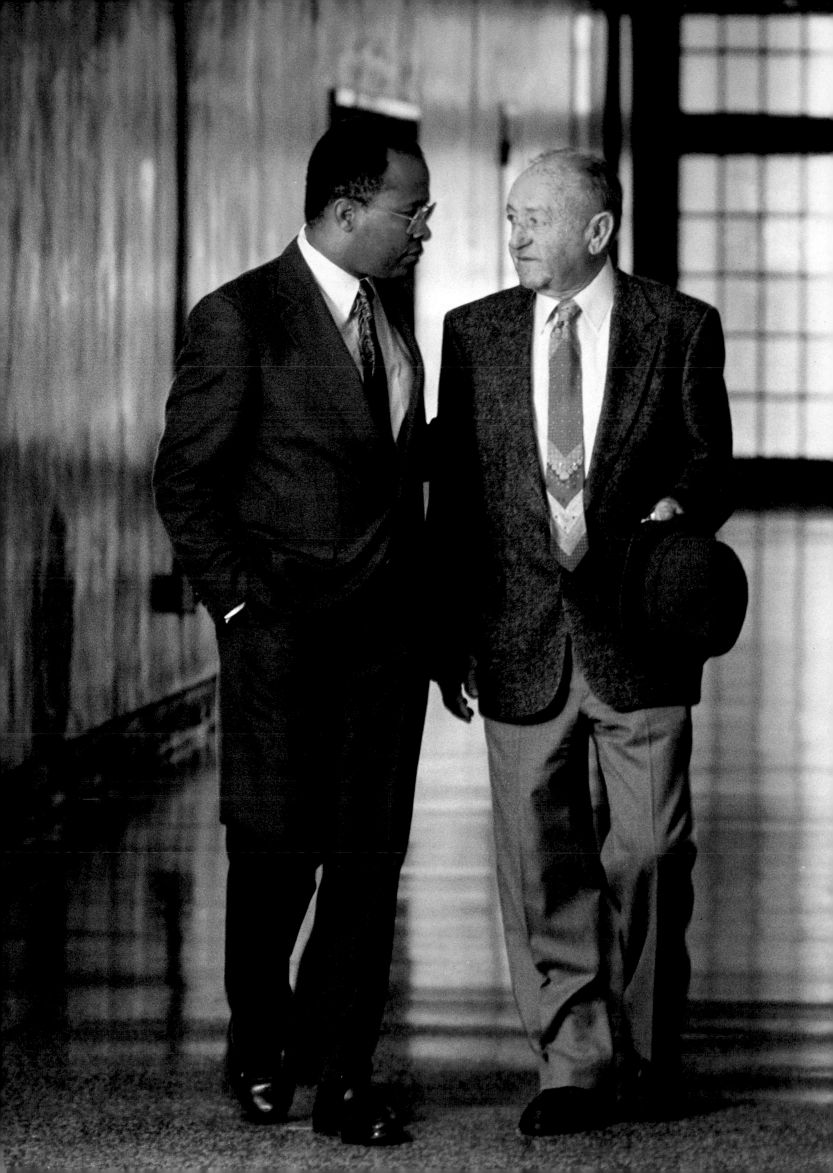

\mathcal{A} Rhodes scholar with degrees from Yale University and Harvard Law School, Kurt Schmoke was elected mayor of Baltimore in 1987. Prior to his election, he served as a member of the White House Domestic Policy Staff under President Jimmy Carter and as an assistant United States attorney.

In his inaugural address, Mayor Schmoke set the agenda for his administration, saying that he wanted Baltimore to become known as "The City That Reads." He has established partnerships between the public and private sectors to create literacy programs and centers. Fiercely committed to improving urban schools, Schmoke passed the largest increase ever in Baltimore's education budget.

Mayor Kurt Schmoke returns to Baltimore City College High School with his old principal, Jerome Denaburg. Photograph by Nick Kelsh

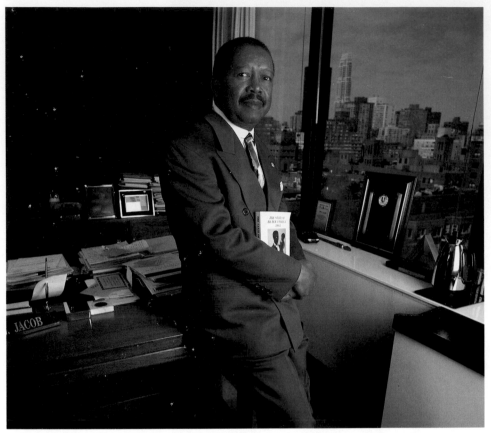

Photograph of John E. Jacob by Jeanne Moutoussamy-Ashe

\mathcal{J}ohn E. Jacob served as president and chief executive officer of the National Urban League from 1982 to 1994. One of the nation's most respected community-based social services and advocacy agencies, the mission of the National Urban League is to assist African Americans in the achievement of social and economic equality. It was founded in 1910 and now has affiliates in 112 cities across the nation.

\mathcal{J}ames A. Joseph is chief executive officer of the Council on Foundations, an organization of 1,300 foundations and other grant makers with assets totaling more than $65 billion. Joseph is also founding chairman of the Association of Black Foundation Executives. Reflecting on his background and commitment to philanthropy, Joseph said, "In the African American community in which I grew up, the rivers of compassion ran deep. We were poor, but when we were hungry, we shared with each other, and when we were sick, we cared for each other. We did not think of what we gave as philanthropy, because sharing was an act of reciprocity in which both the giver and the receiver benefited. We did not think of what we did as volunteering, because caring was as much a moral imperative as an act of free will."

Photograph of James Joseph by Keith Jenkins

Photograph of Randall Robinson by Keith Jenkins

𝒥ounded in 1977, Washington-based TransAfrica works for a more progressive United States foreign policy toward Africa and the Caribbean. Under Randall Robinson's leadership, TransAfrica has pressed the United States government to impose sanctions against South Africa through enactment of the Anti-Apartheid Act of 1986.

Robinson, who holds a law degree from Harvard, has also worked to free Nelson Mandela, initiated an international campaign for a peaceful settlement in Somalia, exposed human-rights abuses in Angola and lobbied on behalf of Haitian refugees.

Photograph of Marian Wright Edelman by Andy Freeberg

𝒦nown as the "children's crusader," Marian Wright Edelman was a respected civil rights activist and lawyer before establishing the Children's Defense Fund, the nation's foremost children's advocacy organization, in 1973. The daughter of a Baptist preacher, Edelman graduated from Spelman College and Yale Law School. She was the first African American woman to pass the bar in Mississippi.

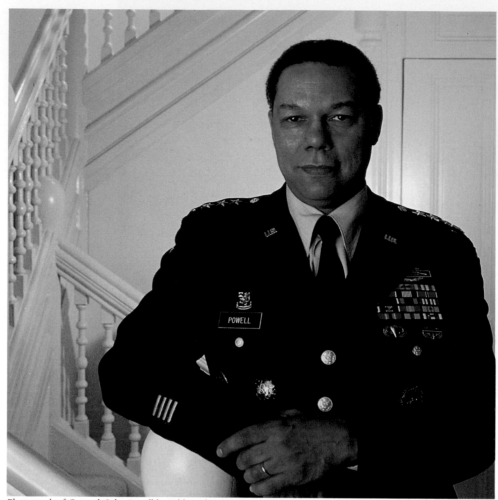

Photograph of General Colin Powell by Eddie Adams/Sygma

𝓘n October 1989, General Colin Luther Powell was named chairman of the Joint Chiefs of Staff, the first Black to hold the nation's top military position. Considered the most politically astute U.S. general since Dwight Eisenhower, Powell is highly regarded as a consensus-seeker sensitive to the vagaries of both international diplomacy and domestic politics. Powell played a key role in the deployment of American troops to Panama in 1989 and the Persian Gulf in 1990–91. Prior to his appointment to the Joint Chiefs of Staff, he served as national security advisor under President Ronald Reagan.

Born of Jamaican immigrant parents in New York City, Powell got his first taste of military life as an ROTC cadet at the City College of New York, where he earned a degree in geology. He later received a master's degree in business administration from George Washington University.

Powell served in Vietnam in 1962 and 1968, and was awarded a Bronze Star for valor and a Purple Heart. He served in the Office of Management and Budget in 1972, was a chief aide to Defense Secretary Caspar Weinberger from 1983 to 1986 and commanded the Army's Fifth Corps in Germany.

Photograph of Dr. Bernard C. Watson by Nick Kelsh

*A*s president and chief executive officer of the William Penn Foundation in Philadelphia, Dr. Bernard C. Watson helped shape a philanthropic enterprise that made grants totaling more than $200 million in the 1980s.

A significant proportion of the foundation's grants supports programs that improve and enrich the lives of the disadvantaged. These include afterschool activities in libraries, teen-pregnancy prevention and a multimillion-dollar program to increase the number of African American students earning college degrees in math, science and engineering. Watson is currently the Chairman of the HMA Foundation, Inc. in Philadelphia, Pennsylvania.

Detroit residents William and Carolyn Smith, the new parents of five adopted sons. Photo essay by Bob Black

Although they had no children of their own, Detroit residents William and Carolyn Smith were foster parents for more than a decade. Then, just as they decided that they needed a break from the demands of childrearing, a newspaper ad radically changed their lives.

"One day my wife walked in the house with this ad from the Michigan Department of Social Services that had a picture of five brothers who needed a home," says William Smith, 41, a self-employed vendor of Afrocentric merchandise. "At first, I thought my wife had lost her mind. Then I thought, hey, someone has got to take care of the kids in our community."

After a year of interviews, training programs and visits, during which the five boys and the Smiths got to know each other, Carolyn and William formally adopted Simuel, 15; Chavez, 13; Nigel, 9; Cedric, 5; and Eric, 4.

"Because of the upheaval in the lives of my sons, this has not been easy," says William Smith. "But my wife and I just sit down with the boys and let them talk about the hard things they've been through. They need to know they are loved and that they finally have a family they can count on."

With the number of Black children in foster-care systems steadily rising, the Smiths say they hope they can serve as role models for other African Americans considering adoption. "A lot of people are sitting around talking about the problems in the Black community but not doing anything about it," William Smith says. "Black folks have got to take some responsibility. These kids want a sense of belonging. They need us."

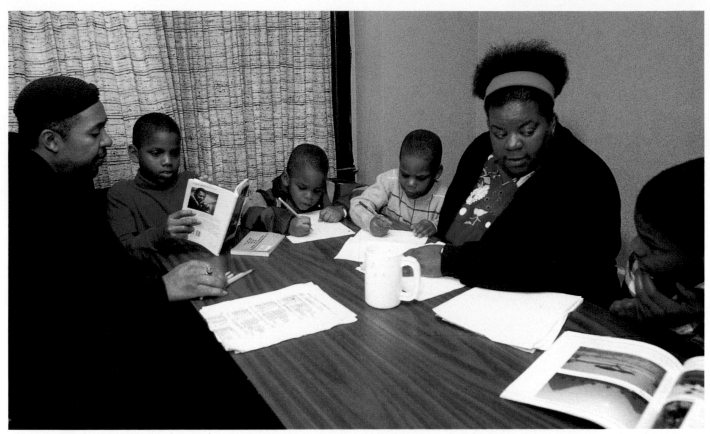

The Smiths provide guidance during a homework session.

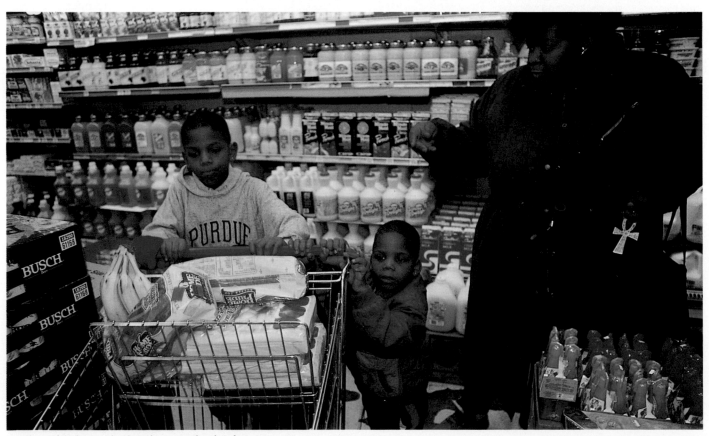

Carolyn Smith shops with adopted sons Nigel and Cedric.
Next page: William Smith teaches his son, Chavez, to play chess.

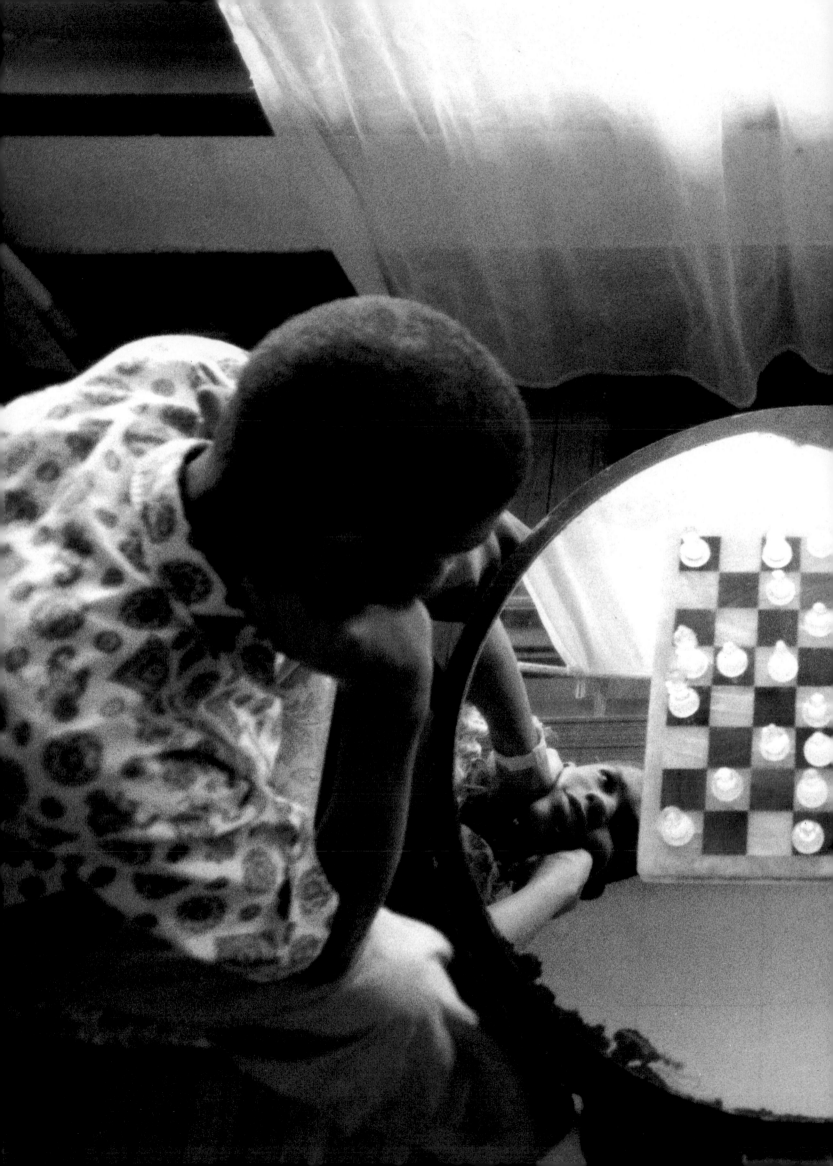

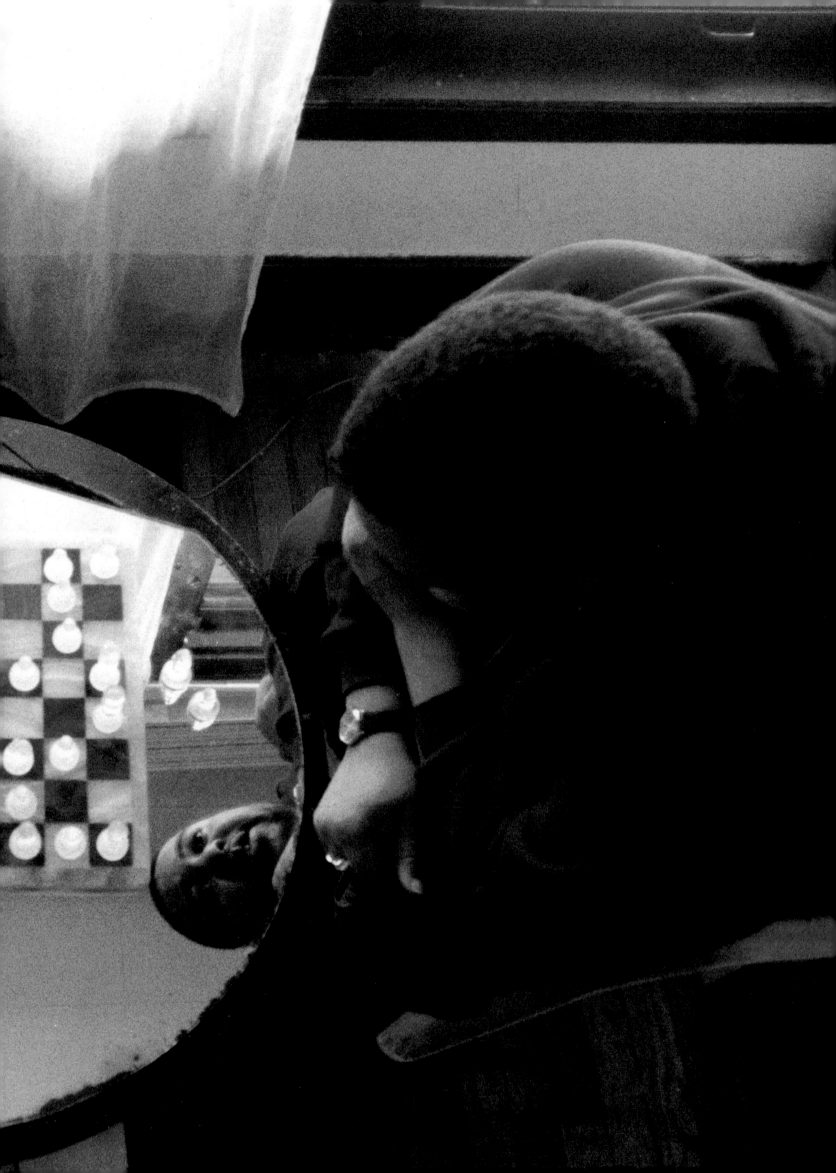

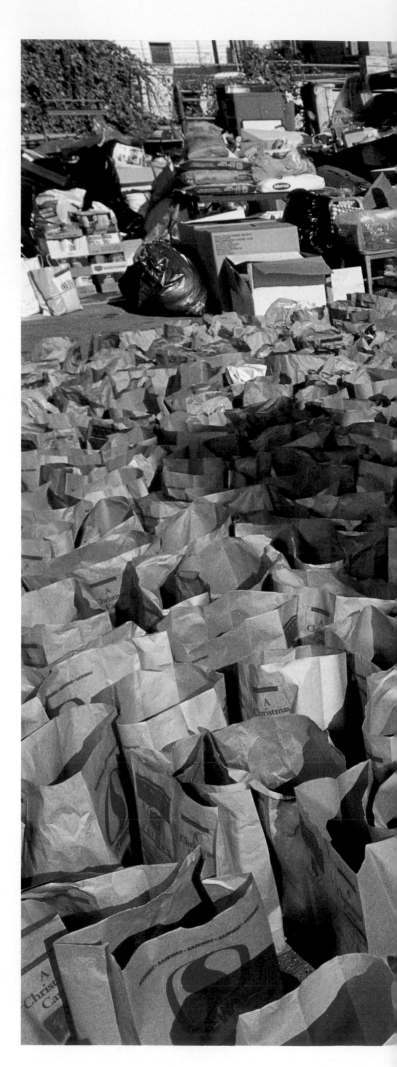

\mathcal{M}ary Ann Wright, known to thousands of Oakland, California, residents as Mother Wright, prepares and distributes hundreds of holiday food bags for needy people. Mother Wright says that the Lord's voice woke her up one day and told her to go feed the hungry. Using her $236 Social Security check, she bought, cooked and distributed food to indigent people in a nearby park.

Since then, Mother Wright has served hot meals each Saturday, rain or shine, to Oakland's homeless population. She has managed to bypass the bureaucracy that bogs down many social-service agencies. "The Lord has always shown me a way," says Mother Wright. "I tell my volunteers to fix the plates just like they would for themselves. The homeless are no less than you and me."

Photograph of Mother Mary Ann Wright by Doug Menuez

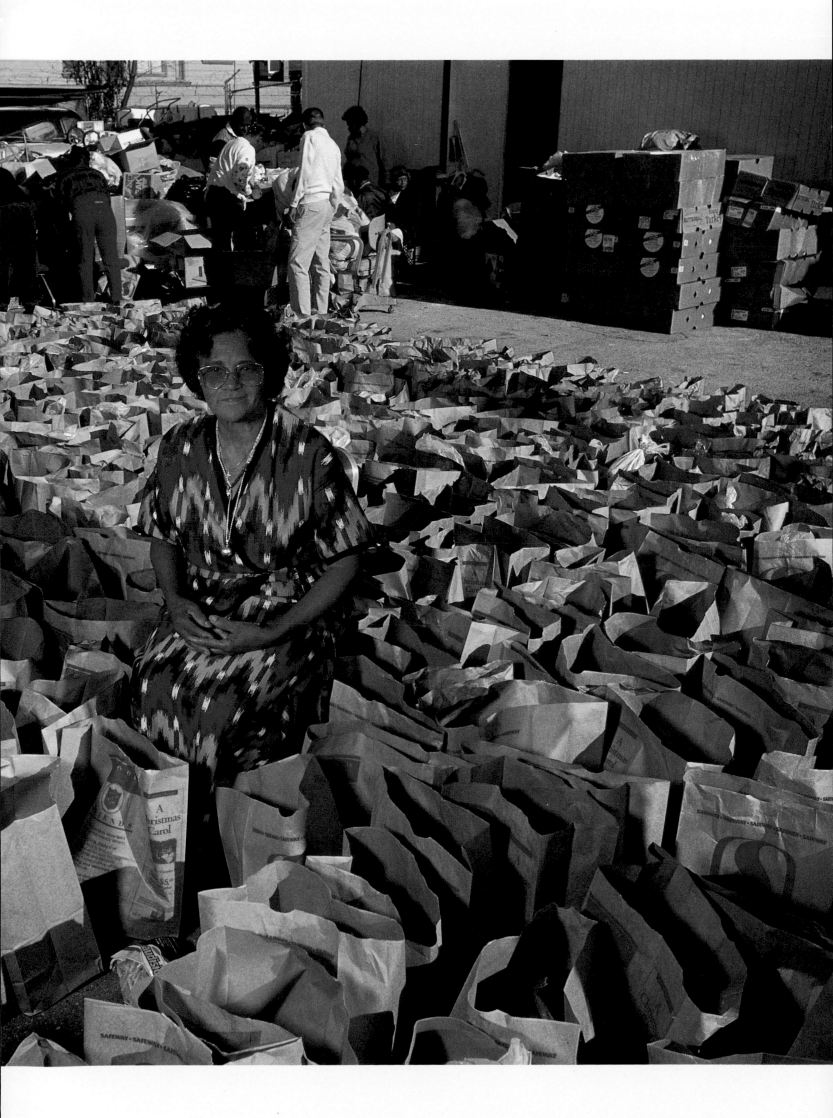

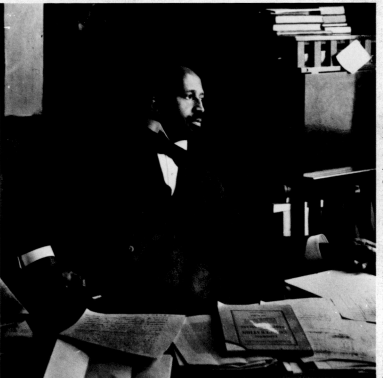

The Schomburg Center for Research in Black Culture, New York Public Library

In more than 20 books and 100 scholarly articles, W. E. B. Du Bois wrote pioneering historical and sociological explorations into African American life. His primary argument, expressed lyrically and passionately in The Souls of Black Folk (1903), was that an educated Black elite should lead African Americans to liberation. This concept, controversial at the time, was diametrically opposed to Booker T. Washington's emphasis on industrial education for Negroes. In 1905, Du Bois founded the Niagara Movement—a forerunner of the NAACP—to fight racial discrimination. Before his death at age 95, Du Bois joined the Communist Party, renounced his U.S. citizenship and moved to Ghana.

A QUEST FOR KNOWLEDGE

Acutely aware that "knowledge is power," southern plantation owners systematically barred enslaved Blacks from learning to read or write. This does not mean that all 18th-century African Americans were illiterate, however. In 1773—a time when most citizens could not read, let alone write books—self-taught Boston slave Phillis Wheatley published *Poems on Various Subjects, Religious and Moral,* a learned collection that reflected both the influence of English poet Alexander Pope and Wheatley's knowledge of Latin. The collection was the first published by a Black person in America and was widely hailed on both sides of the Atlantic.

But the major upsurge in African American education would not come until the Reconstruction Era, when the Freedmen's Bureau and several northern philanthropic and religious organizations undertook the task of educating more than four million newly emancipated slaves. Many of the nation's historically Black colleges were founded in this period, including Atlanta, Clark, Fisk, Hampton, Howard, Lincoln, Morehouse, Morgan and Spelman. Dedicated to the "uplift" of the race, these institutions, supported primarily by Black church and community groups, educated more than 70 percent of the nation's early African American teachers.

Activist and journalist Ida B. Wells was an ardent supporter of civil rights and the early women's movement. In 1889, she became part owner and, later, editor of Free Speech and Headlight, a Memphis newspaper. Outraged at the lynching of three friends, Wells used her prodigious writing skills to launch a lifelong campaign against injustice.

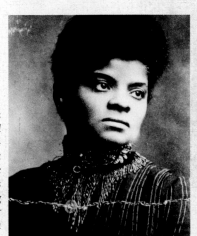

Oscar B. Willis/The Schomburg Center for Research in Black Culture, New York Public Library

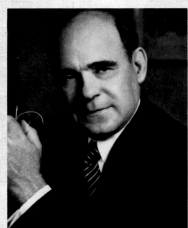

The Schomburg Center for Research in Black Culture, New York Public Library

Serving from 1926 to 1960, Mordecai Wyatt Johnson was the first African American president of Howard University. Under his leadership every school at the institution received accreditation, and some of the nation's most eminent scholars joined the faculty.

47

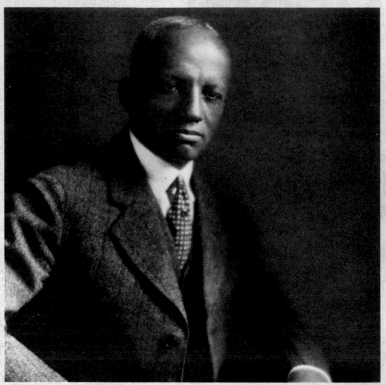

The Schomburg Center for Research in Black Culture, New York Public Library

The "father of African American history," Carter Godwin Woodson was born the son of former slaves in 1875. Although he did not attend school until he was 20 years old, Woodson earned his high-school diploma in less than two years and went on to receive a Ph.D. from Harvard University in 1912. Woodson wrote many important works on African American history including The Negro in Our History. In 1916, he became the founding editor of The Journal of Negro History.

And the teachers taught. In 1870, 80 percent of all African American adults were illiterate. Only thirty years later, more than half could read and write.

Another landmark in African American education occurred in 1881, when Booker T. Washington opened the Tuskegee Institute to prepare Blacks for vocational and industrial jobs. In 1904, activist/educator Mary McLeod Bethune, the seventeenth child of former slaves, founded Bethune-Cookman College, which continues to thrive today.

The quality of African American education improved and expanded in the 1950s and 60s, when Thurgood Marshall proved to the nation that separate couldn't be equal and when James Meredith, Charlayne Hunter-Gault and other pioneering students integrated the great Southern universities.

The legacy of the Freedmen's Bureau now goes forth in the work of the United Negro College Fund and other philanthropic and religious organizations that provide financial support for dozens of historically

Some of the nation's most distinguished African American scholars have taught at Howard University. In a photograph from the 1940s are (left to right) James M. Nabrit, Jr., president of Howard from 1960–69; Dr. Charles Drew, who conducted pioneering research on blood plasma; acclaimed poet Sterling Brown; sociologist E. Franklin Frazier; historian Rayford Logan and philosopher Alain Locke, the first African American Rhodes scholar.

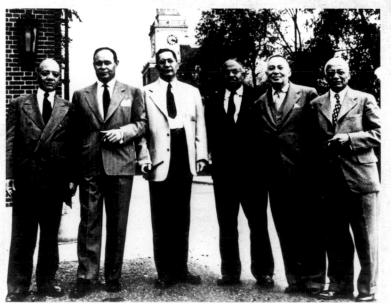

Wilbert Blanch/Moorland-Spingarn Research Center, Howard University

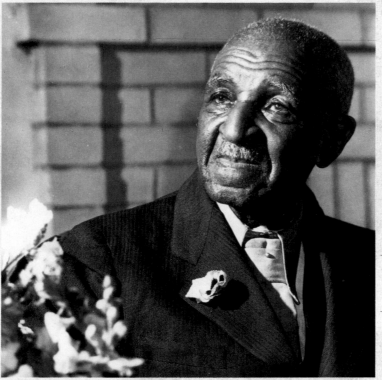

Born a slave, George Washington Carver became a distinguished scientist who won international fame for his research into the uses of peanuts. As a member of the faculty of the Tuskegee Institute, Carver developed more than 300 products from peanuts, including a milk substitute, face powder, soap and printer's ink. Named a fellow of the Royal Society of Arts of London in 1916, Carver also taught agricultural practices to Black farmers.

Black colleges and universities. Because of these institutions, the great-grandchildren of former slaves are now law professors at Howard, medical researchers at Yale and philosophers at Princeton.

The quest for knowledge—and its dissemination—took place not only in the ivory towers of academe, but also in gritty pressrooms of the Black newspapers. In the 19th century, John Russwurm's *Freedom's Journal* (1827) and Frederick Douglass's *The North Star* (1847) were pioneering publications that championed the cause of emancipation. And at the turn of the century, several important African American dailies and weeklies rose up to serve the wave of Black migrants from the South. There was the *Chicago Daily Defender*, founded in 1905 by the Sengstacke family, and C. B. Powell's *Amsterdam News*. *The Crisis*, an influential journal of thought, was launched by W. E. B. Du Bois in 1910, but it wasn't until the 1940s that John H. Johnson broke into the magazine world with *Negro Digest* (and later *Ebony* and *Jet*), leading the way for *Black Enterprise*'s Earl G. Graves and *Essence* publisher Ed Lewis.

But whether in the pressroom or the classroom, African Americans have learned one thing: Knowledge and achievement are inextricably bound. In the present-day environment of *de facto* segregation and inequitably and desperately underfunded schools, it is important to remember that the future of the African American community will depend on the quality of its education.

President of Morehouse College from 1940 to 1967, Benjamin E. Mays was called "the greatest schoolmaster of his generation." He is pictured here with pioneering educator, activist and presidential advisor Mary McLeod Bethune.

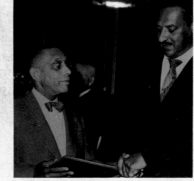

Living up to his pledge to "condemn injustice, race prejudice and the cowardice of compromise," Carl Murphy (shown here with Thurgood Marshall) was publisher and editor of the Afro-American newspapers from 1918 until his death in 1967. Founded in 1892 by his father, John H. Murphy, Sr., who was born a slave, the Afro-American newspaper chain is among the most successful Black-owned businesses in the country.

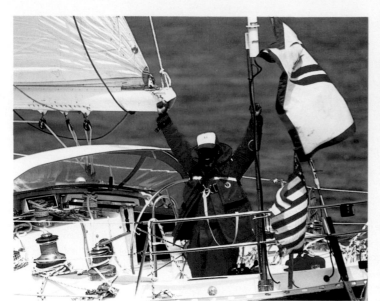

William Pinkney returns to Boston Harbor after a solo two-year sailing voyage around the world. Photograph by Tobias Everke/Gamma Liaison

On June 9, 1992, hundreds of cheering schoolchildren greeted William Pinkney as he docked his 47-foot sailboat *Commitment* in Boston Harbor. Pinkney thus ended a 32,000-mile odyssey as the first African American to sail alone around the world. "I did this to disprove the message I was given as a young man," said Pinkney, a former marketing executive from Chicago who was raised by a single parent on welfare. "As a young Black male I was told that I'd end up in jail, on drugs or dead. The thing is, I didn't believe that."

Pinkney embarked on his historic journey from Boston on August 5, 1990, heading south past the coast of South America, across the Atlantic Ocean to Cape Town, South Africa, through the south seas to Tasmania, around Cape Horn and back up the coast of South America.

Although Pinkney made his voyage solo, he was not alone. Before he set sail, he received a grant from the MacArthur Foundation to produce a newsletter, a videotape, a curriculum guide and a computer hookup that linked him with dozens of schoolrooms while he was at sea. Thousands of students in Boston and Chicago learned practical lessons in math, science and geography from Pinkney, who also shared his views on dreams, commitment and perseverance.

Inspired by his adventure, students mailed him letters, made boat models, studied navigation and wrote reports on the countries he visited. Upon his triumphant return, Pinkney reminded students of the value of hard work and determination. "No matter who you are, where you are or what people say, you and your dreams are important," he said. "If you get a sound basic education, if you are willing to work and never, never quit, you can make your dreams come true."

William Pinkney addresses an assembly at Dewey School in Evanston, Illinois. Photograph by Kevin Horan

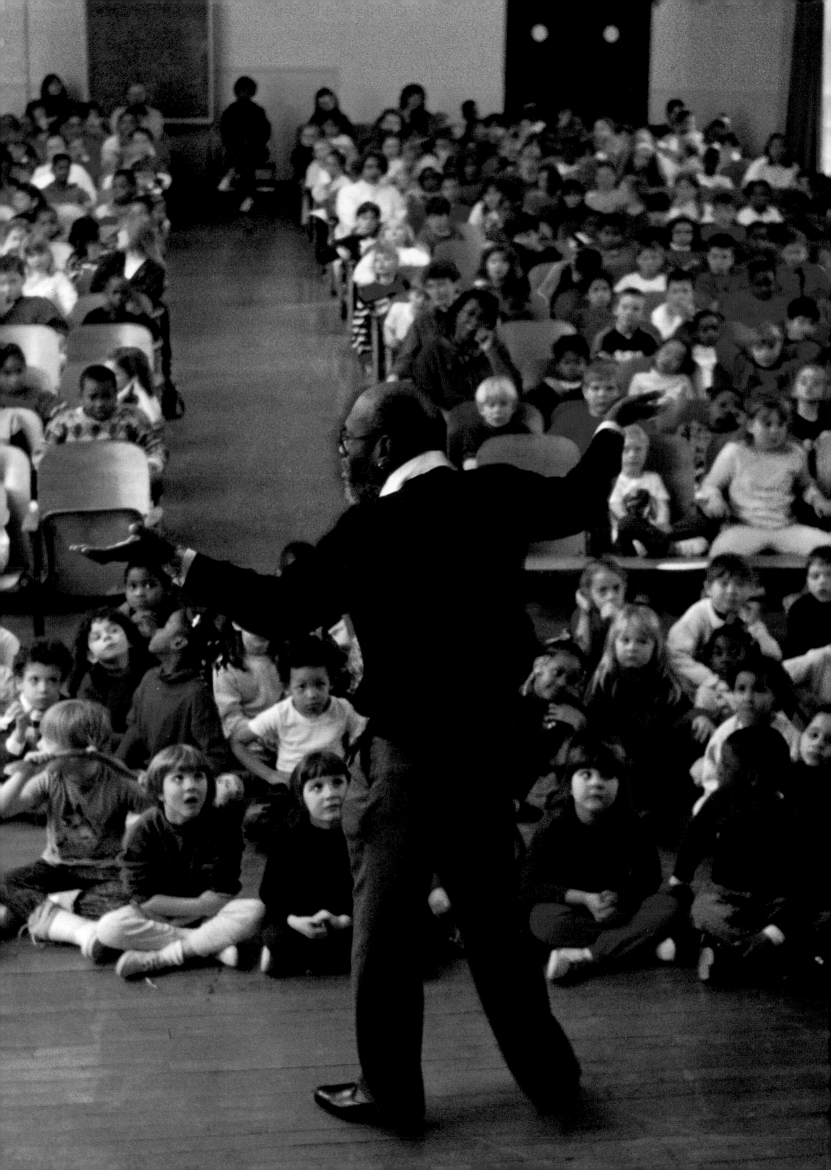

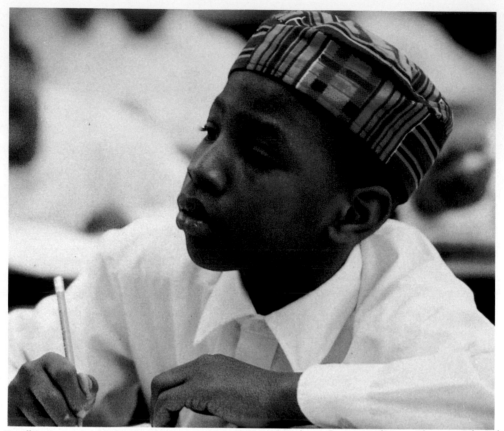

Terrell Lowery, a student in the fourth grade at Malcolm X Academy in Detroit, Michigan. Photo essay by Bob Black

\mathcal{M}alcolm X advocated cultural pride and racial self-sufficiency, so he would undoubtedly approve of the Afrocentric school in Detroit that bears his name.

"In my old school they didn't teach us hardly anything about African Americans, except in February during Black History Month," said a fifth grader who is among the 470 students who have enrolled in Malcolm X Academy since it opened in 1991. "Here, they do it everyday. And that's important to me."

Parents and educators agree that Black children who attend Afrocentric schools exhibit a genuine enthusiasm for learning that translates into high academic achievement. And because they are routinely exposed to the richness of African American culture, the children develop a strong sense of self-esteem that helps counter negative societal messages about Black people.

Instead of Halloween, students at Malcolm X Academy celebrate Heritage Day, dressing as Black historical figures and giving speeches. In addition to the federal Martin Luther King, Jr., holiday, the school also honors the birthdays of Harriet Tubman, Frederick Douglass, Sojourner Truth, Paul Robeson, Marcus Garvey and, of course, Malcolm X.

At Malcolm X Academy, the Pledge of Allegiance (which one parent noted "wasn't written for us") has been replaced by an oath that emphasizes the pride and determination of Black people. It ends with the Swahili word for power: "We at Malcolm X Academy will strive for excellence in our quest to be the best. We will rise above every challenge with our heads held high. We'll always keep the faith when others say die. March on till victory is ours: Amandla!"

At 9:30 a.m. each weekday, students arrive for school at Detroit's Malcolm X Academy.

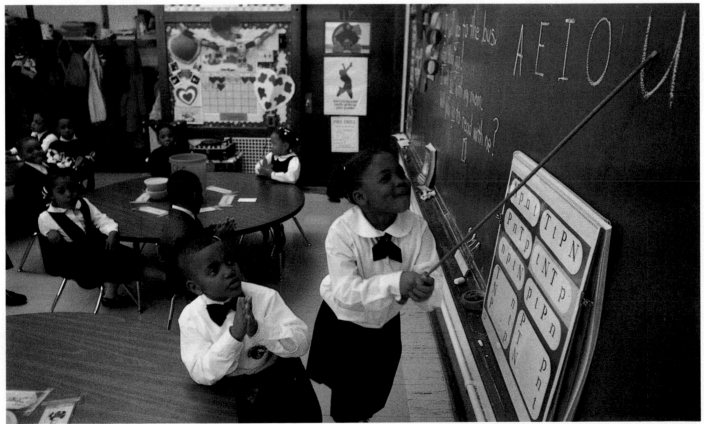

First grade students learn about their vowels as well as their heritage at Malcolm X Academy.

Following page: a Malcolm X Academy student takes his lessons seriously.

\mathcal{D}r. Franklyn G. Jennifer was the first alumnus to head Howard University since it was founded in 1867. Thenation's most comprehensive historically Black university, Howard has 12,000 students, 2,000 faculty members, a hospital, hotel publishing house and radio and television stations.

A plant virologist with a distinguished research career, Jenifer has held a wide array of academic and administrative posts. Widely published, he has written articles on topics ranging from plant biology to the impact of the Rodney King beating in Los Angeles.

Howard University's chairman of the Board of Trustees, Wayman F. Smith III, is also vice president of corporate affairs for the Anheuser-Busch Companies in St. Louis. A graduate of Howard University School of Law, Smith has also served as a St. Louis alderman and Municipal Court Judge.

Photograph of Dr. Franklyn G. Jennifer, former president, and Wayman F. Smith III, chairman of the board of Howard University, by Douglas Vann

\mathcal{D}r. James Comer, psychiatrist and director of the Yale University Child Study Center, surrounded by third graders at the Katherine Brennan School in New Haven, Connecticut. Based on his own upbringing in a strong Black family, Comer has developed a highly acclaimed "intervention model" that has helped educators across the country create a learning environment founded on commitment and accountability.

Photograph of Dr. James Comer, director of the Yale University Child Study Center, by John S. Abbott

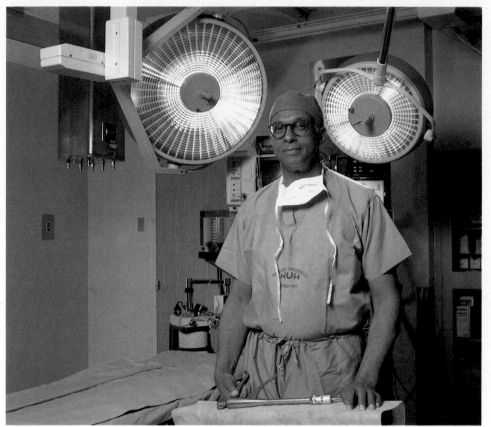

Photograph of Dr. LaSalle D. Leffall, Jr., chairman of the Department of Surgery, at Howard University by Jeffrey Henson Scales

*P*rofessor and chairman of the Department of Surgery at Howard University, Dr. LaSalle D. Leffall, Jr., is a leading surgeon, oncologist, medical educator and humanitarian.

Educated in the public schools of Quincy, Florida, Dr. Leffall graduated first in his class from both Florida A & M University and Howard University Hospital College of Medicine. Leffall has devoted his professional life to the study and treatment of cancer, especially as it relates to African Americans. As former president of the National Cancer Society, he initiated a program to address the rising incidence of cancer among Blacks.

Now in his 32nd year on the Howard faculty and his 23rd year as chairman of the surgery department, Dr. Leffall has helped to educate about 3,500 medical students and train more than 150 general-surgery residents.

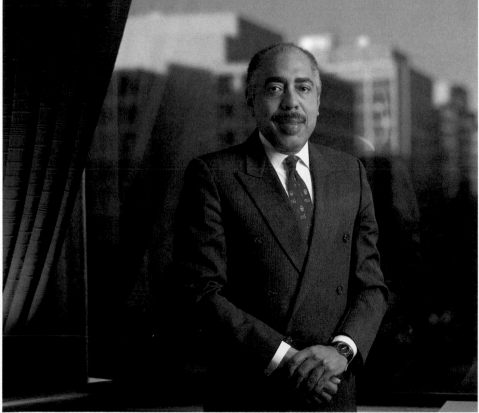

Photograph of Dr. Walter E. Massey by C. W. Griffin

*D*r. Walter E. Massey, one of America's most prominent scientists, is the senior vice president for academic affairs and provost of the University of California. A theoretical physicist, Massey is former director of both the National Science Foundation and the prestigious Argonne National Laboratory. Throughout his career, Massey has been a strong policy leader who has spoken out about the need for more minorities in scientific research. "Science and technology will provide the driving forces that create new jobs, improve our quality of living, and provide new opportunities for economic growth," Massey says. "It's extremely important that African Americans take part in this enterprise."

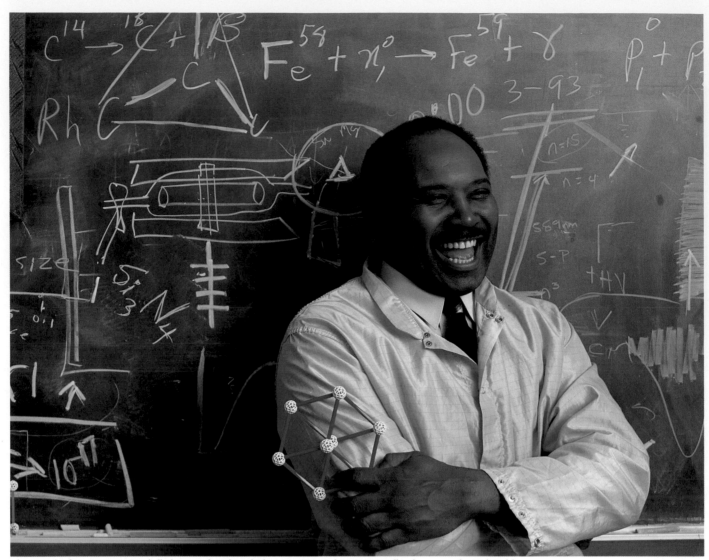

Photograph of Dr. James W. Mitchell, director of Analytical Chemistry Research at AT&T Bell Laboratories, by Nick Kelsh

\mathcal{H}ead of the Analytical Chemistry Research Department at AT&T Bell Laboratories in New Jersey, Dr. James W. Mitchell is among the nation's foremost scientists.

Raised in tough economic conditions during the Jim Crow era in North Carolina, Mitchell says that he decided at an early age to get a Ph.D. to improve his chances of acquiring a good job in a respected field. That mission was accomplished in 1970 when Mitchell received a doctorate in analytical chemistry from Iowa State University. Coauthor of the book *Contamination Control in Trace Element Analysis,* Mitchell has worked at AT&T Bell Laboratories for nearly a quarter of a century. Under his leadership, the Analytical Chemistry Research Department developed the first viable laser intracavity absorption spectrometer and conducted pioneering research on optical waveguide technology. To young people interested in pursuing careers in science, Dr. Mitchell offers the following advice: "A career in science can be enjoyable, rewarding and reasonably lucrative. It is, however, a lifetime of commitment to learning and being productive."

Photograph of Dr. Shirley Jackson, professor of physics at Rutgers University, by Nicole Bengiveno

A physicist who has conducted pioneering research on subjects such as elementary particles, charged density waves in layered compounds and polaric aspects of electrons on the surface of liquid helium films, Dr. Shirley Jackson was the first Black woman to receive a doctorate in physics from the Massachusetts Institute of Technology, in 1973. Currently on the faculty at Rutgers University, Dr. Jackson has also held positions at the Fermi National Accelerator Laboratory, the European Organization for Nuclear Research and at AT&T Bell Laboratories. In 1986, she was elected a fellow of the American Physical Society for her research accomplishments.

$$\frac{e^{-xt}\,dt}{t} \qquad (x > 0)$$

...ntal)

...ental Integral.

$$u = \frac{1}{t}, \quad dv = e^{-x}$$

$$du = -\frac{dt}{t^2}, \quad v =$$

$$= \int_x^\infty \frac{e^{-xt}\,dt}{x\,t^2}$$

$$\frac{e^{-xt}}{xt}\Big|$$

$$\frac{e^{-xt}}{x} = \frac{1}{x}\int_1^a \frac{e^{-xt}\,dt}{t}$$

One of the most distinguished professors of mathematics and physics in the country, J. Earnest Wilkins, Jr., began his teaching career as an instructor at the Tuskegee Institute, and later served as a physicist at the University of Chicago, a fellow at the Argonne National Laboratory and distinguished professor of applied mathematical physics at Howard University. He is widely published and has lent his expertise to many of America's foremost nuclear companies. Photograph by W. A. Bridges

\mathcal{U}niversity of Chicago sociologist Dr. William Julius Wilson is the author of several pioneering works on urban problems, including *The Truly Disadvantaged: The Inner City, the Underclass and Public Policy* (1987). Wilson argues that the current crisis in the Black community stems from the transformation of America from a manufacturing to a service economy. "Black males began dropping out of the labor force in increasing numbers as early as 1965," Wilson notes. "The primary source of their woes is the disappearance in the past two decades of hundreds of thousands of jobs."

Photograph of Dr. William Julius Wilson of the University of Chicago in the Woodlawn area of the city by Bob Black

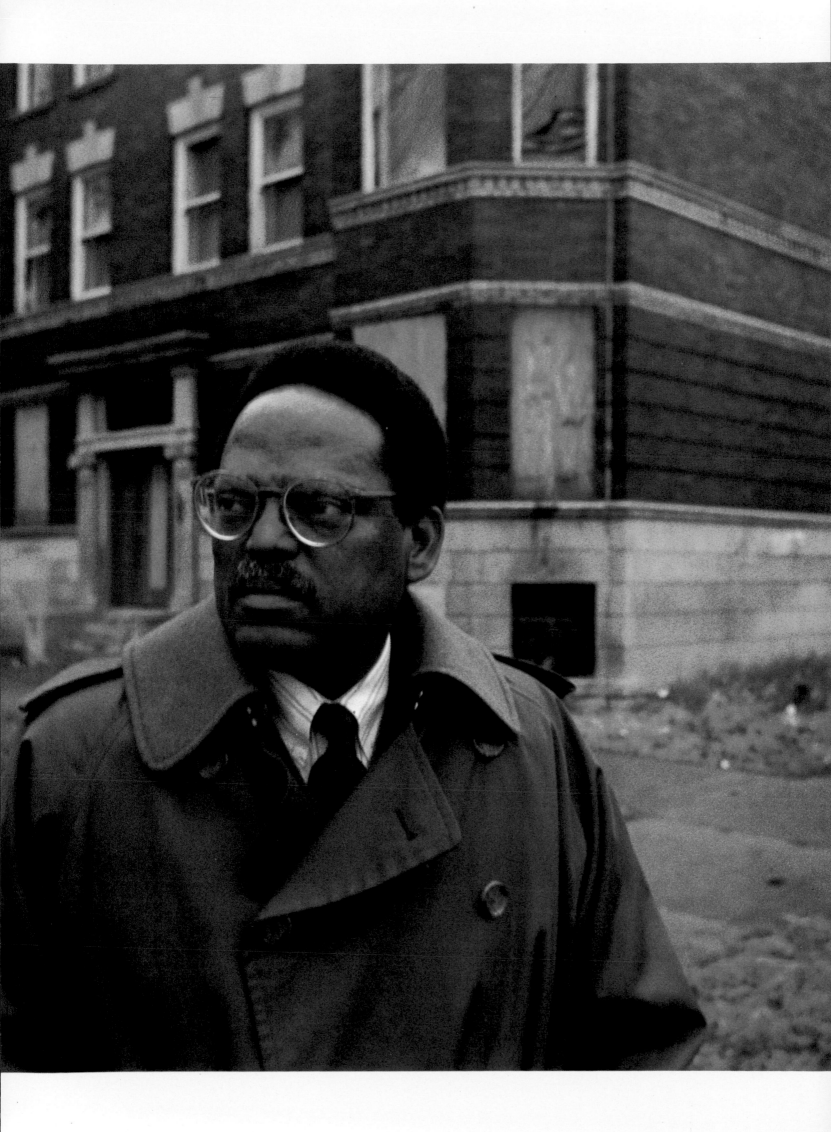

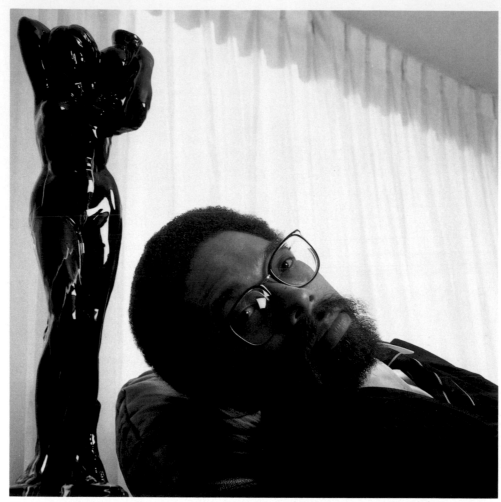

Photograph of Dr. Cornel West, professor of Religion and Afro-American Studies at Harvard University, by Anthony Barboza

*H*arvard University philosopher, theologian and scholar Dr. Cornel West is among the nation's most prominent intellectuals. As a young boy, West was inspired by a biography of Teddy Roosevelt, who like West was asthmatic. He read how Roosevelt had overcome his asthma, gone to Harvard and become a great leader. West followed Roosevelt's example, graduating from Harvard in only three years. A leading spokesman on African American-Jewish relations, West is the author of several books, including *Breaking Bread: Insurgent Black Intellectual Life and Race Matters.*

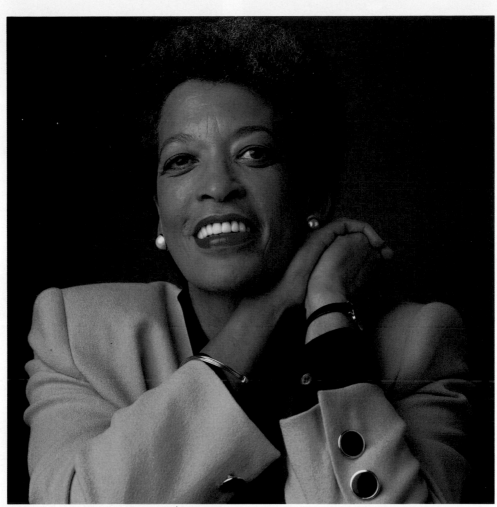

Photograph of Dr. Johnnetta B. Cole, president of Spelman College, by Gary Spector/Allford Trotman Associates

*O*n April 5, 1987, Johnnetta B. Cole became the first African American woman to be named president of Spelman College, the nation's oldest institute of higher learning for Black women. Affectionately called "Sister President" by students and alumnae alike, Dr. Cole has been a particularly effective and charismatic spokesperson for her institution. Originally founded to educate former slaves in the damp basement of an Atlanta church, Spelman now offers a broad spectrum of undergraduate degrees and counts such notables as Marian Wright Edelman of the Children's Defense Fund and Pulitzer Prize-winner Alice Walker among its former students.

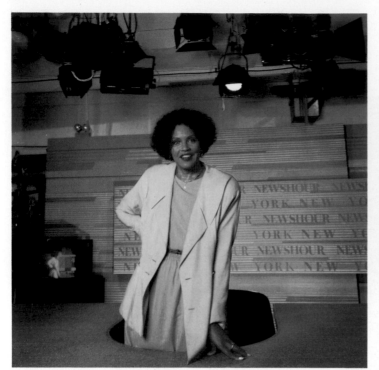

Photograph of PBS national correspondent Charlayne Hunter-Gault by Anthony Barboza

*I*nforming millions of viewers daily, Charlayne Hunter-Gault and Bryant Gumbel are among the nation's most prominent broadcast journalists.

Recipient of two Emmys, Hunter-Gault is national correspondent for *The MacNeil/Lehrer Newshour.* Raised in Georgia, she first attracted national attention when she braved hostile mobs to desegregate the University of Georgia in 1961. After completing her journalism studies, Hunter-Gault was hired as a secretary at *The New Yorker* magazine.

She was rapidly promoted to staff writer and later joined the metropolitan staff of *The New York Times.* Author of *In My Place*, a well-respected memoir about her upbringing in the segregated South, Hunter-Gault says: "Because of where we've come from, I think there is something in the blood and psyche of Black people that propels us to pursue the purest forms of equality, freedom and justice. In many respects, we have accepted—and really embrace—the highest moral standards that exist in America."

*W*hen two-time Emmy-winner Bryant Gumbel joined NBC's *Today Show* in 1982, he became the first African American to anchor the nation's oldest morning news program. Widely respected for his incisive, well-informed interviews, Gumbel earned a degree in Russian history from Bates College in Lewiston, Maine, where he was one of only three Blacks in a student body of nearly 1,000. In the early 1970s, Gumbel took a job working for a small monthly magazine, *Black Sport.* When he moved to broadcasting, he was quickly promoted up the ranks through sports and news to his groundbreaking appointment as host of *Today.*

Today Show host Bryant Gumbel talks about his trip to Africa during Black History Month at his daughter Jillian's school in Manhattan. Photograph by Nicole Bengiveno

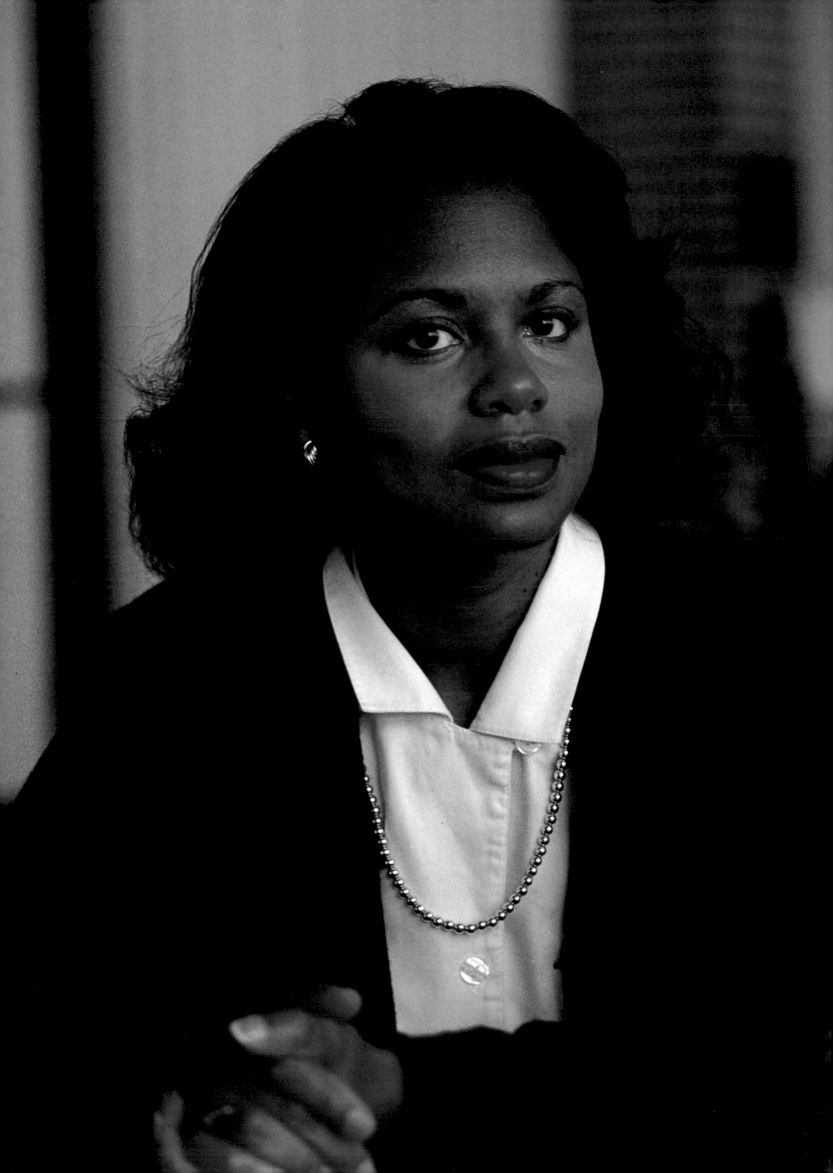

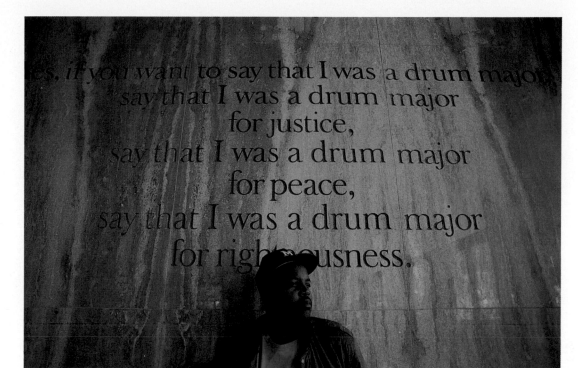

es, if you want to say that I was a drum major
say that I was a drum major
for justice,
say that I was a drum major
for peace,
say that I was a drum major
for righteousness.

A Morehouse College student stands next to a monument bearing a quote from the school's most distinguished graduate, Dr. Martin Luther King, Jr. Founded in 1867 and part of the Atlanta University system, Morehouse has educated Julian Bond, Maynard Jackson and many of the nation's most influential Black male politicians, clergymembers, attorneys, physicians, social activists, scientists, arts and business leaders. Photograph by W. A. Bridges

*I*n the fall of 1991, all of America was riveted to the television screen when University of Oklahoma law professor Anita Hill came forth with shocking charges of sexual harassment against U.S. Supreme Court nominee Clarence Thomas. Her televised appearance before the all-white, all-male Senate Judiciary Committee sparked a fiery debate about the treatment of women in all segments of American society.

In the aftermath of the Hill-Thomas controversy, an historic number of women ran for elective office, many of them winning against veteran male politicians. After the 1992 election, the percentage of women in the U.S. House of Representatives jumped by 68 percent and the number of women in the Senate rose from two to six.

Many political experts believe that Anita Hill and the outrage she inspired gave rise to a progressive movement that played an important role in the defeat of Republican President George Bush. Hill, who became a symbol of courage, said of her ordeal: "I came forward and did what I felt I had an obligation to do, and that was to tell the truth."

Photograph of University of Oklahoma law professor Anita Hill by David Burnett/Contact Press Images

*Mike Davis studies hard for his classes at Gage Park High
School. Mike, a senior, also works from 3:00 p.m. to
11:00 p.m., three days a week at a downtown Chicago
McDonald's. Photograph by Kevin Horan*

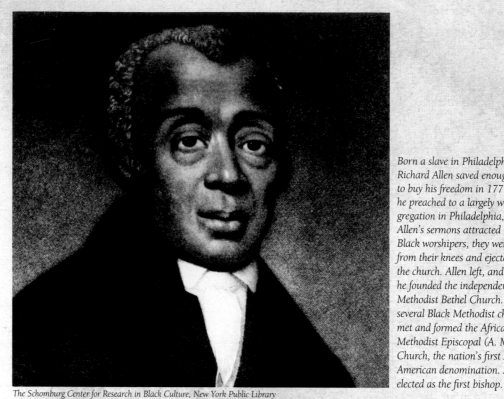

The Schomburg Center for Research in Black Culture, New York Public Library

Born a slave in Philadelphia, Richard Allen saved enough money to buy his freedom in 1777. At first he preached to a largely white congregation in Philadelphia, but when Allen's sermons attracted too many Black worshipers, they were pulled from their knees and ejected from the church. Allen left, and in 1794 he founded the independent Methodist Bethel Church. In 1816 several Black Methodist churches met and formed the African Methodist Episcopal (A. M. E.) Church, the nation's first African American denomination. Allen was elected as the first bishop.

A SPIRITUAL STRENGTH

African American spirituality has always been bound to social activism. Freedom of worship was among the first human-rights battles fought by Africans brought to America.

Upon their arrival, practitioners of indigenous African religions and African Muslims alike were forbidden to practice so-called heathen rites. Slave owners used Christianity to control and pacify the slaves, and African religions were forced underground, making them political as well as spiritual.

Even when slaves were forced to adopt the religion of their masters, they were not allowed to fully partake in it. The rite of baptism was permitted on a limited basis, but in almost all cases, Black preaching was forbidden. Some slaves and freed Blacks were allowed to worship in white congregations, but always with restrictions.

In African American communities outside the South, Black citizens banded into small religious societies that eventually established meeting houses, churches and distinctive Black Christian sects. The National Baptist Convention was founded as early as 1758 in Mecklenberg,

Adam Clayton Powell, Jr., spoke from two mighty pulpits: the Abyssinian Baptist Church in Harlem and the United States House of Representatives. In the House, Powell served as chair of the influential Education and Labor committee. From the pulpit he inherited from his father, he preached the gospel of self-determination. In 1967, Powell was expelled from Congress by his colleagues, accused of misuse of funds. Although he was reinstated two years later, he was defeated in 1970 in his bid for re-election.

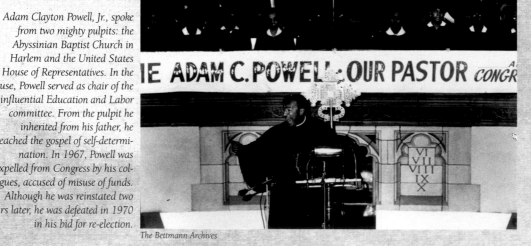

The Bettmann Archives

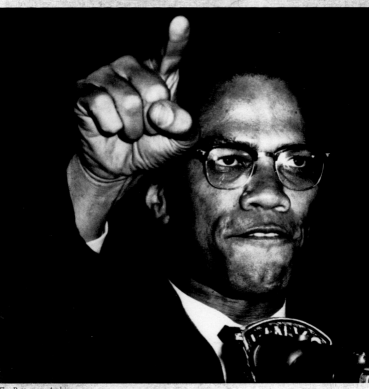

The Bettmann Archives

Born in Omaha, Nebraska, in 1925, Malcolm X became a member of the Nation of Islam while serving a six-year sentence for burglary in Massachusetts in the mid-1940s. Upon his release in 1952, he became one of the group's most resourceful organizers and a charismatic figure in the Black community. Assassinated in 1965 in the wake of a struggle over leadership within the Nation of Islam, Malcolm X is now remembered as a hero of the Black revolution.

Virginia. In 1766, five African Americans in New York formed the first Methodist congregation. And around 1779, a slave named George Liele established one of the first African Baptist congregations as the Silver Bluff Church near Augusta, Georgia. In 1796, the African Methodist Episcopal Zion Church was founded in New York.

Absalom Jones and Richard Allen formed the Free African Society in Philadelphia after their followers were forcibly removed from a Methodist church for sitting in the whites-only section. Initially, the society was nonsectarian and provided mutual aid to widows, orphans and the ill. Later, in 1816, the society was transformed as Allen formed five Black churches into the African Methodist Episcopal (A. M. E.) denomination.

Although the Methodist Episcopal Church split over the issue of slavery in 1844, many African American churches became an integral part of the abolitionist movement. Some, like Allen's Mother Bethel A. M. E. Church, became havens for escaped slaves. Other churches, like the A. M .E. Zion Church in New York, provided forums for abolitionist orators like Frederick Douglass, Catherine Harris, Harriet Tubman, the Reverend Jermain Louguen and Sojourner Truth. Still others actively supported the Underground Railroad with money, personnel and sanctuary.

Abolitionist preachers looked to the Old Testament book of Exodus for inspirational tales about the Hebrew slave rebellion in Egypt—and the divine intervention that allowed its success. It is no wonder that teaching a slave to read was punishable by the whip or death, and no surprise either that many of the leaders of the 19th-century slave rebellions and conspiracies had strong religious backgrounds. The most famous insurgent was a preacher named Nat Turner.

As the most effective center of community activism, the church became more directly involved with politics during Reconstruction. Of the 20 Black congressmen and two Black senators elected to Congress during the period, many were ministers, such as the Reverend Hiram Revels of Mississippi, the first African American to serve in the United States Senate.

As the Great Depression began, Black churches evolved as havens of philanthropy, encouraging mutual aid, collecting funds and distributing

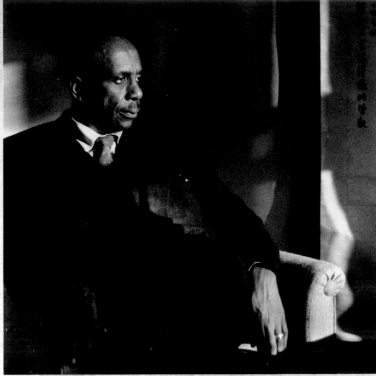

Courtesy of Mrs. S. B. Thurman

Born to a poor family in Florida, Dr. Howard Thurman became a nationally known educator, minister and author of 22 books who inspired a generation of civil rights activists. During his distinguished career, Dr. Thurman taught at leading Black institutions such as Howard University and Morehouse College. In 1944, Thurman founded the San Francisco Church for the Fellowship of All Peoples, the nation's first interracial interdenominational parish.

food and clothing to those in need. The hardships of the period also gave rise to nontraditional faiths such as Father Divine's Peace Mission, Sweet Daddy Grace's United House of Prayer and Rabbi Cherry's Black Hebrews. It was also during this period that Wallace D. Fard and Elijah Muhammad established the Nation of Islam, which found its strength in Black nationalism and a strong link to African heritage.

Great modern Black religious leaders include Dr. Howard Thurman, the distinguished theologian and dean of the chapel at Howard University who cofounded the Church for the Fellowship of All Peoples in San Francisco, the first interracial, interdenominational congregation in the United States. The Reverend Dr. Martin Luther King, Jr., worked through the Baptist church and created the Southern Christian Leadership Conference (SCLC), which continues today as a network of religious and civil rights organizations.

The tradition of Black religious/political leaders has continued throughout the 20th century. Adam Clayton Powell, Jr., who served 11 terms in the United States Congress, is one of the best-known examples. Others include the Reverend Andrew Young, the Reverend Jesse Jackson; former congressman and president of the United Negro

The doctrines of Islam require Muslim women to wear modest clothing that covers the head and most of the body. This photograph from the 1960s shows Black Muslim women, dressed in white, seated separately from men during worship.

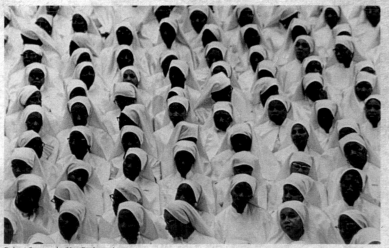

Robert Sengstacke/Ken Barboza Associates

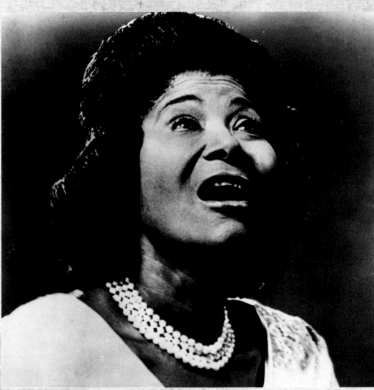

America's premier gospel singer learned how to make a joyful noise listening to Bessie Smith records. Mahalia Jackson's "Move On Up a Little Higher" was the first gospel record to sell over a million copies, opening up an industry that would later spotlight Shirley Caesar and Aretha Franklin.

The Schomburg Center for Research in Black Culture, New York Public Library

College Fund, the Reverend William Gray; and the Reverend Walter Fauntroy of Washington, D.C.

Although women have still not achieved uniform equality within the traditional Black church, figures such as Dr. Mary McLeod Bethune of the Baptist church and Arnia C. Mallory, a prominent member of the Church of God in Christ, were great educational leaders and political advisors. The women's conventions of the seven historic Black denominations continue to form powerful networks for religious, social, political and economic action.

Today, the African American church still exists to nurture the spirit. But as the 20th century comes to a close, it has evolved in response to new challenges. The Pentecostal churches, the Nation of Islam and more orthodox Islamic sects have become increasingly attractive to many, and the importance of prison ministries has grown. In the Roman Catholic church, Bishop Moses B. Anderson has risen to become auxiliary bishop of Detroit.

The Reverend Cecil Murray of Los Angeles's First African Methodist Episcopal Church warns that the Black church must continue to fulfill social as well as spiritual needs. Increasingly, African American congregations provide day-care centers for children and senior citizens. Churches build housing, establish credit unions and operate blood banks. They are called on to quell gang violence and to provide health information. They provide counsel to drug and alcohol abusers, shelter the homeless and give support to people infected with HIV.

A solid rock in the Black community, the church strengthens the human spirit while reinforcing the community's political and economic infrastructure. In African American churches and temples, salvation and service are a part of the same package. "You can't speak to someone about God if they're hungry," says the Reverend Charles Carter of St. Augustine's Church in Oakland, California. "If you're going to save their soul, you have to save their bodies too."

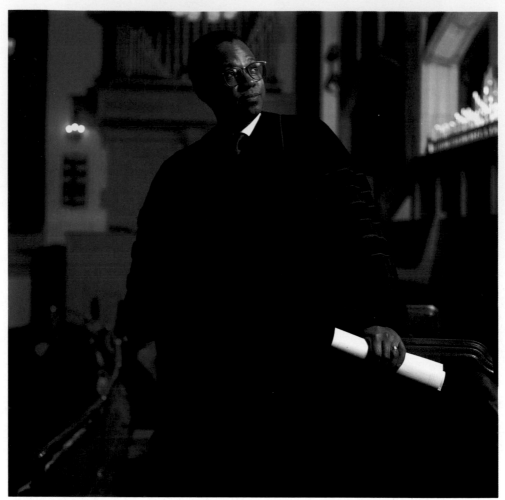

Photograph of the Reverend Calvin O. Butts III, pastor of Harlem's Abyssinian Baptist Church, by Jeffrey Henson Scales

*W*hen the Reverend Calvin O. Butts III was appointed head pastor of Harlem's Abyssinian Baptist Church in 1989, he knew he had a big pulpit to fill. Abyssinian's parishioners constitute one of the largest Protestant congregations in the world. His predecessors included Adam Clayton Powell, Sr., who oversaw the building of the present church on West 138th Street, and Adam Clayton Powell, Jr., who turned the church into an important political forum in the 1950s and 1960s while serving 11 terms in the U.S. Congress.

The son of a chef and a welfare department-administrator, Reverend Butts graduated from Morehouse College, Union Theological Seminary and Drew University. He first joined Abyssinian as Pastor Samuel Proctor's assistant. In many ways, Butts's style echoes Adam Clayton Powell, Jr.'s. He is outspoken and politically active, spearheading a campaign to paint over billboards advertising liquor and cigarettes in his community. "I'll always be political," says Butts, "but I can't do what I want as pastor of Abyssinian and run for office."

Through Abyssinian, the Reverend Butts oversees the church's many community programs, including a health watch for people with AIDS and a youth council for teenagers. The church also builds and renovates housing for middle-income families, senior citizens and the homeless in Central Harlem.

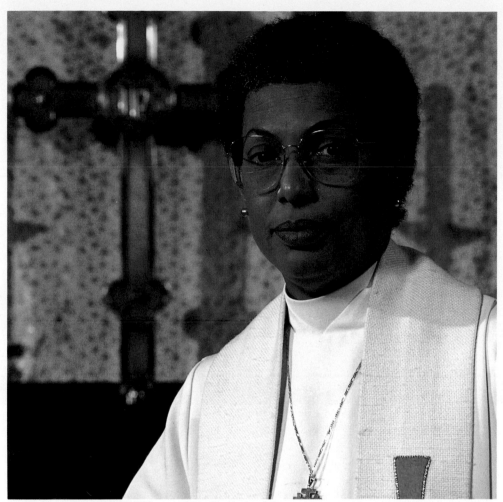

Photograph of Bishop Barbara Clementine Harris by John Nordell/JB Pictures

*B*arbara Clementine Harris made history when she was consecrated as bishop of Massachusetts on February 11, 1989. Harris the first woman to be elected bishop since the establishment of the Episcopal Church in the United States in 1789. Her election was opposed by some Episcopalians who still consider both the Episcopate and the ordained ministry to be the exclusive domain of men.

A native of Philadelphia, Harris was ordained a priest of the Episcopal diocese of Pennsylvania in 1980 only four years after the Episcopalian general convention approved the admission to the ministry. Previously, Bishop Harris had pursued a career in public relations and had been involved with the civil right movement.

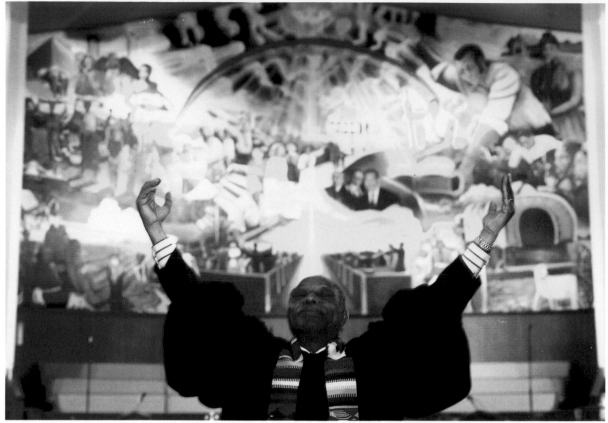

The Reverend Cecil L. Murray, pastor of Los Angeles' 8,500-member First African Methodist Episcopal Church, says his mission is to "take the church beyond its walls." Photograph by Anthony Barboza

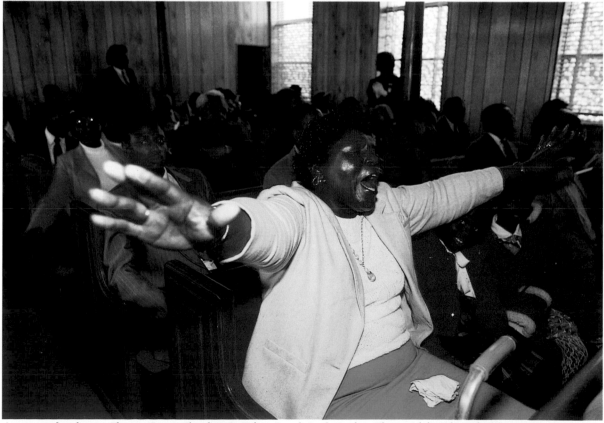

A moment of epiphany at Ebenezer Baptist Church in St. Helena Sound, South Carolina. Photograph by Dilip Mehta/Contact

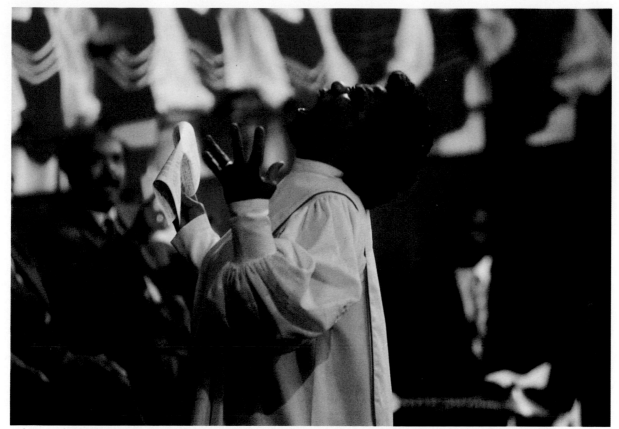

A choir member lets loose at the Reverend Clay Evans' Fellowship Missionary Baptist Church in Chicago. Photograph by Bob Black

The Reverend Doug Miller, "the minister of music," holds forth at Bethel A. M. E. Church in Baltimore, Maryland. Photograph by Sarah Leen/Matrix

San Quentin Prison chaplain Earl Smith. Photo essay by Ed Kashi

When chaplain Earl Smith ministers to the inmates of San Quentin or lectures students about the perils and consequences of the criminal life, he speaks from experience. Smith knows how close he came to serving time while growing up in Stockton, California.

Although he came from an intact Christian family that valued education, Smith was a drug abuser at 11 and a dealer by age 13. Also a math whiz, Smith got good grades and became student body vice president—all while selling drugs and committing burglaries. When he was 19, Smith was shot six times when a drug deal went awry. In the hospital he heard a voice saying, "You are not going to die, I have something for you to do."

After making a truly miraculous recovery, Smith decided to join a church—where he heard that voice again, first telling him to preach, then directing him to minister to the inmates of San Quentin, a calling he undertook in 1983. "A lot of the guys know me from the streets," he says. Even the man who pumped him full of bullets was in San Quentin when Smith began his ministry.

Smith lives on the grounds of San Quentin with his wife, Angel, and their four children. "I'm on call 24 hours a day," he says. Smith sees his mission as twofold. "I see myself always being chaplain in a prison…because I need to know what's going on. But I also want to work with today's youth so they don't end up being my parishioners tomorrow."

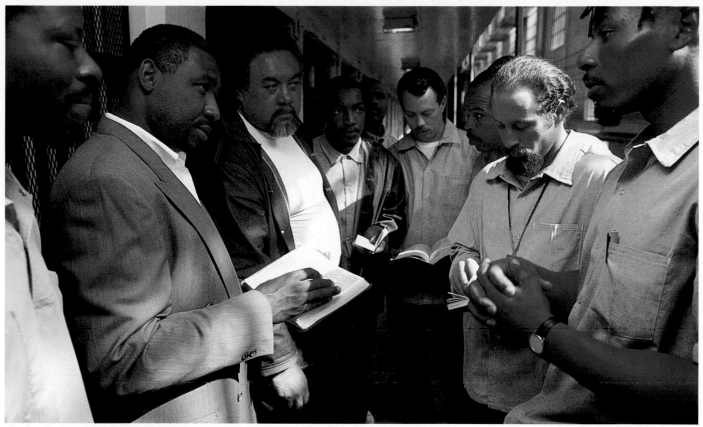

Chaplain Earl Smith holds an impromptu prayer session with inmates in North Block.

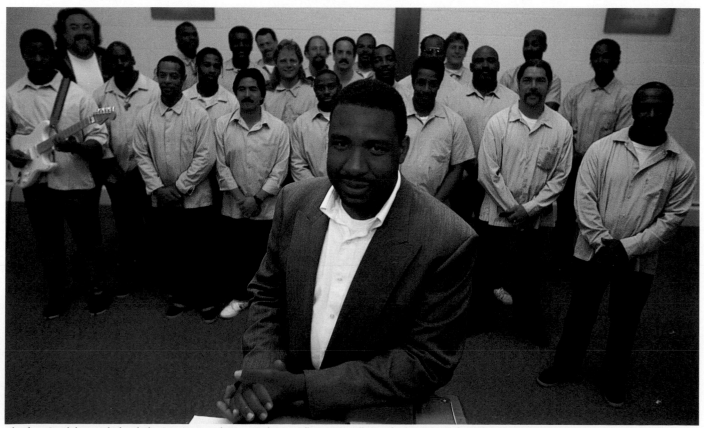

Chaplain Smith has worked with the San Quentin choir to produce an album, He's All I Need. The prisoners have their own label, called Count Time Productions.

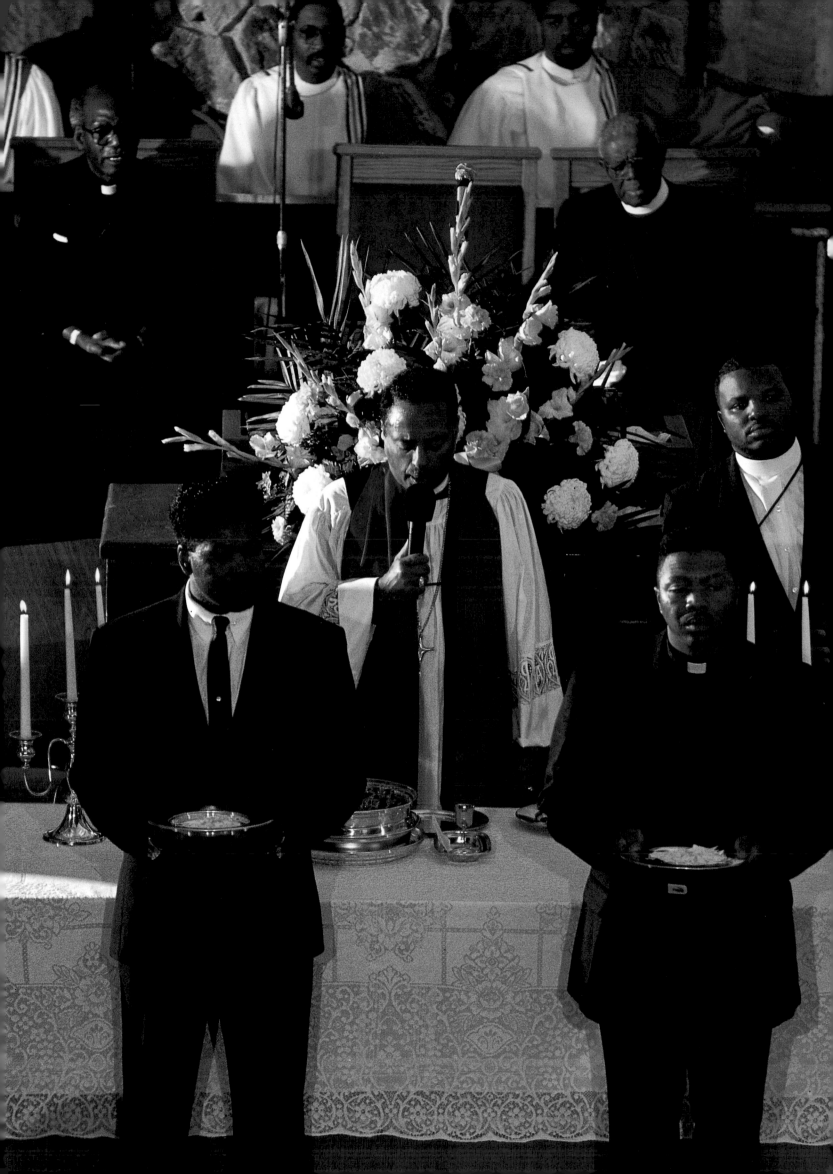

Photograph of the Reverend Cecil Williams of San Francisco's Glide Memorial United Methodist Church by Chris Stewart

\mathcal{B}ishop Wilbur Wyatt Hamilton has been minister of the 800-member Greater Victory Temple Church of God in Christ for more than a decade. Located on Northern California's Monterey Peninsula, the church provides numerous outreach services for the community, including a drug counseling program for inmates released from nearby Soledad Prison, a support group for teens and a parenting program designed to strengthen African American families.

"When we church, we church," says Hamilton about Greater Victory Temple's long history of activism. Hamilton, who also serves as general secretary of the 4.5 million-member Church of God in Christ, has had a distinguished career in community and public service, including ten years as the executive director of the San Francisco Redevelopment Agency, where he had responsibility for managing and directing a $1.5 billion urban revitalization program.

Photograph of Bishop Wilbur Hamilton, general secretary of the Church of God in Christ, by Michael Allen Jones

\mathcal{A}s minister of liberation at San Francisco's Glide Memorial United Methodist Church for three decades, the Reverend Cecil Williams is a national leader in the fight against crack-cocaine abuse and a strong advocate for the empowerment of the African American family.

Like a rescue ship in the stormy waters of a difficult neighborhood, Glide is the most comprehensive nonprofit provider of human services in San Francisco. The church serves 3,300 free meals a day and offers a children's program, a computer training center and a crisis center for the poor, the homeless and single-parent families.

Glide implemented a landmark recovery program for people suffering the ravages of crack cocaine and other addictions and an HIV project to provide education, support and counseling for people infected with HIV.

Williams has a long history of activism. He marched with Dr. King, stood fast with the Black Panthers and raised funds for antiapartheid efforts. Author of *No Hiding Place: Empowerment and Recovery for Our Troubled Communities*, Williams is a powerful advocate for the disenfranchised of all colors and creeds.

Photograph of Kwanzaa creator Dr. Maulana Karenga by Lester Sloan

*F*rom a Swahili phrase for "first fruits" *(matunda ya kwanzaa)*, the Kwanzaa feast is linked to traditional African harvest festivals. Celebrated by more than 20 million people around the globe, the ceremony was created in 1966 by Dr. Maulana Karenga, professor and chair of the Black Studies Department at California State University at Long Beach.

"Kwanzaa reaffirms our African culture and the bonds between us as a people," Karenga says. "It holds meaning for African Americans because it gives us a chance to meditate on the mission of our lives and to recommit ourselves to our people, our struggle and to ever-higher levels of human life."

Kwanzaa, which is celebrated from December 26 to January 1, is based on seven principles: Umoja (unity), Kujichagulia (self-determination), Ujima (collective work and responsibility), Ujamaa (collective economics), Nia (purpose), Kuumba (creativity) and Imani (faith). During each of the seven nights of Kwanzaa, celebrants light candles to symbolize their commitment to strengthening Black culture through improving their family, community and social relationships.

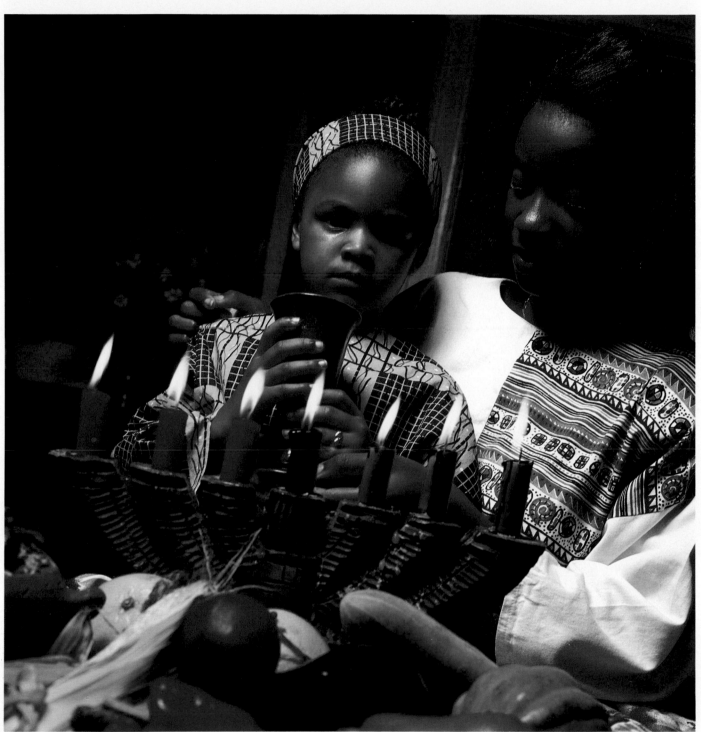

A young girl holds an Umoja (unity) cup used to pay tribute to African ancestors. Photograph by Albert Trotman/Allford Trotman Associates

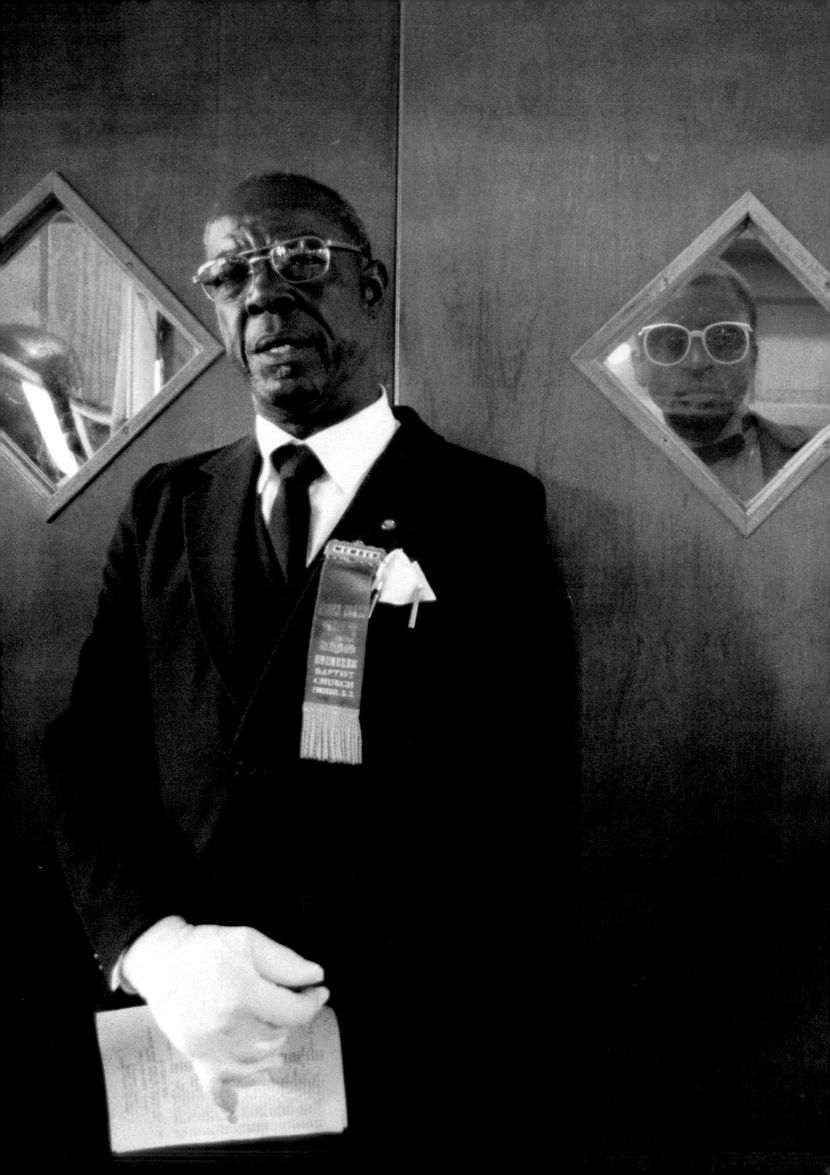

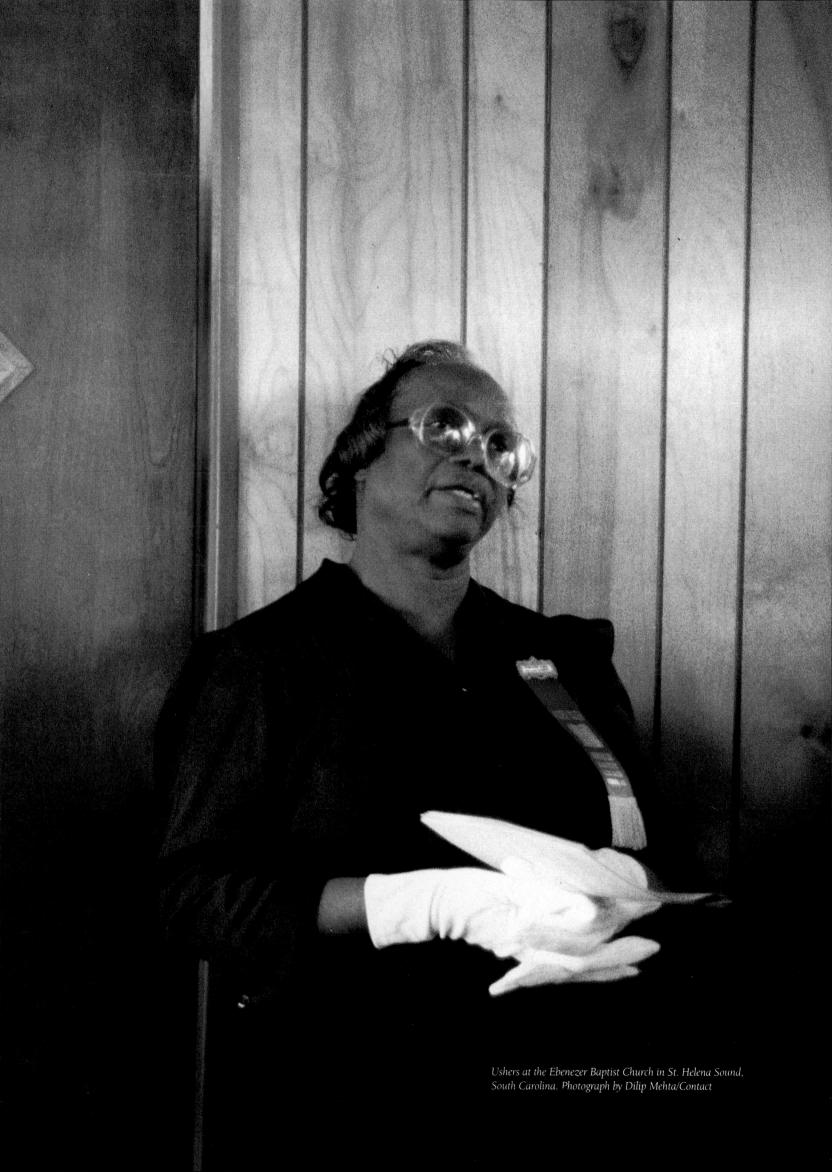

Ushers at the Ebenezer Baptist Church in St. Helena Sound, South Carolina. Photograph by Dilip Mehta/Contact

Taurian Osborne prays at the New Fellowship Missionary
Baptist Church in Miami, Florida.
Photograph by Jeffery Allan Salter

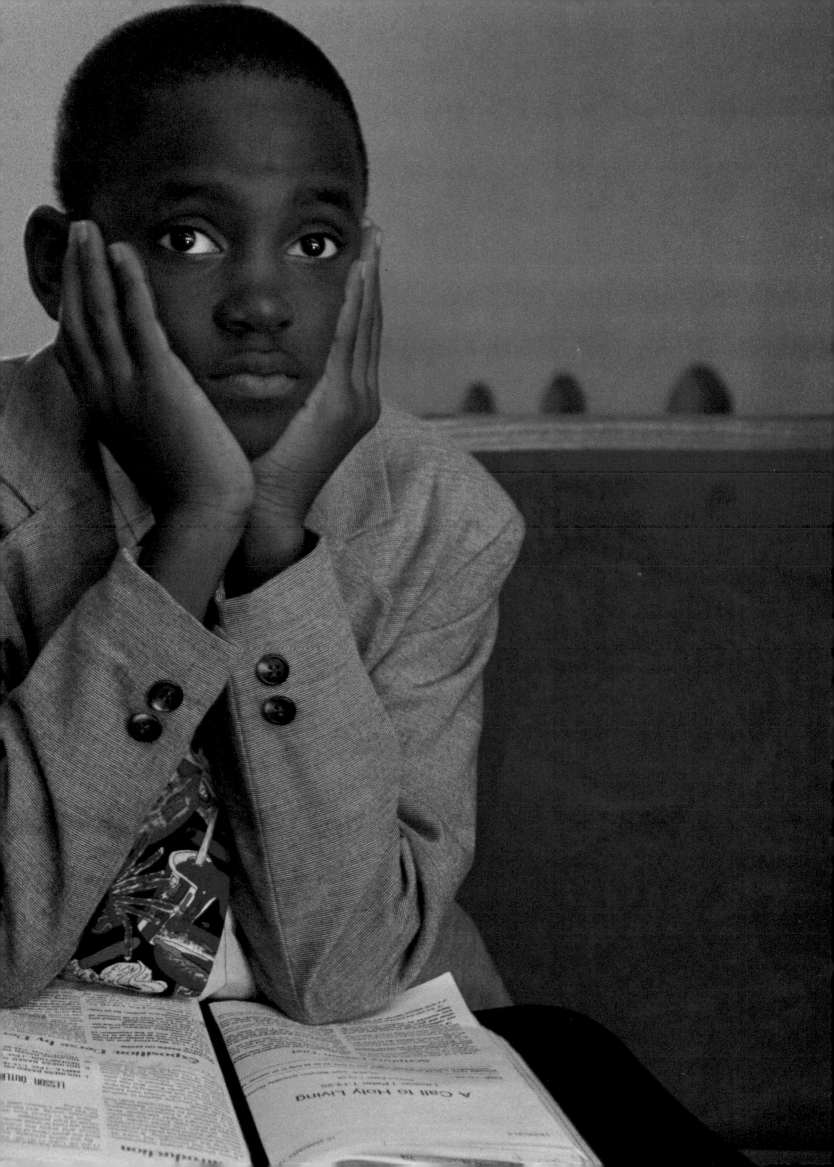

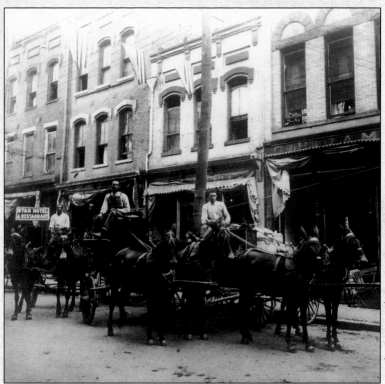

Courtesy of Charles H. James II

In 1883, Charles H. James was peddling trinkets door to door in West Virginia. By 1916, he had built his business into a prosperous fresh fruit and vegetable distribution company. Today C. H. James & Co., the oldest African American business in America, is an $18 million food wholesaler headed by James's great-grandson, Wharton-educated Charles H. James III.

ECONOMIC ACHIEVEMENT

The wealth of the African American community lies in its history of passionate persistence in the face of racist laws and businesses, "redlining" financial institutions and organized labor that often discriminated on the basis of race. And it has often been persistence, despite fearsome obstacles and unlikely odds, that has lifted many African Americans to inspiring levels of economic achievement.

In the 1780s, a Black sea captain named Paul Cuffe audaciously won equal rights for Africans in Massachusetts by successfully challenging an unfair system of taxation. Later, Cuffe entered business and became the wealthiest African American in the nation, owning his own maritime fleet and shipyard.

In 1883 in West Virginia, Charles H. James peddled trinkets, then scarce fruits and vegetables. Today, his great-grandson, Wharton-educated Charles H. James III, heads what has become an $18 million food-distribution business, C. H. James & Co.

At the turn of the century, Madame C. J. Walker—born Sarah McWilliams in a small cabin in Delta, Louisiana—started a Black beauty-care company with the $1.50 in her pocket, and became the first female African American millionaire.

In 1900, Booker Taliaferro Washington (seated, second from left)—ex-slave, educator and founder of the Tuskegee Institute— established the National Negro Business League to promote African American capitalism. A pre-eminent leader of the Black community at the turn of the century, Washington believed that Blacks could preserve their rights and improve their position in society primarily through industriousness, economic success and practical education.

The Library of Congress

91

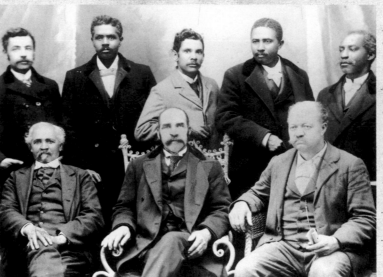

The Library of Congress

In 1902, Warren G. Coleman, an African American entrepreneur, opened the Coleman Manufacturing Company, a cotton-knitting mill in Concord, North Carolina. It was the first Black-owned cotton mill in the South, and one of the few that employed African Americans. Coleman had made his fortune dealing in iron, junk, rags and real estate. He raised $23,000 to finance the mill by selling stock to African Americans of modest means and bringing in white investors, who joined his board of directors. After Coleman died in 1904, the mill failed. It would be another 60 years before African Americans again won employment in Southern cotton mills.

Milton Grant quit his job as chief railway cook for Chicago's Rock Island Line in 1923 and headed west to Pasadena, California. Discovering that there was no garbage service outside the city limits of Pasadena, he started his own sanitation business, then expanded into hog ranching and real estate. When a Pasadena bank turned him down for a loan in 1947, Grant took it as a challenge. Together with Elbert Hudson, he founded Broadway Federal Savings, the first federal thrift association organized by African Americans on the West Coast.

In the 1930s and 1940s, the Brotherhood of Sleeping Car Porters, led by A. Philip Randolph, and the International Longshoremen's & Warehousemen's Union spearheaded fair labor and employment practices for African Americans. These labor organizations were in sharp contrast with other skilled trades, which were notoriously discriminatory. At this time, Blacks also made important inroads as professionals. Architect Paul Williams earned renown for his movie-star mansions as well as his plans for schools, airports and public housing. Thousands of other well-educated African Americans, restricted in their career paths, found advancement and opportunity in the U.S. Postal Service.

Economic opportunities for African Americans expanded greatly following the civil rights breakthroughs of the 1960s. New Black professional, business and labor organizations sprang up, including the National Black MBA Association, the National Association of Investment Companies and the Coalition of Black Trade Unionists. Barriers to Blacks in organized labor fell as African American membership was extended in collective bargaining units such as the United Auto Workers and the Teamsters.

Madame C. J. Walker, a Black beauty-care entrepreneur, was the first self-made female millionaire. Born Sarah McWilliams in a Louisiana sharecropper's shack in 1867, she started her company with $1.50 in 1904. By 1919, 25,000 African American women were selling her products nationwide.

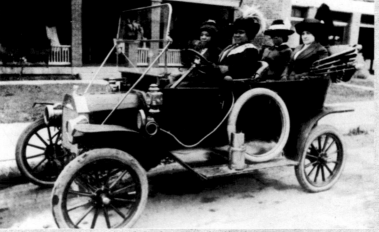

The Schomburg Center for Research in Black Culture, New York Public Library

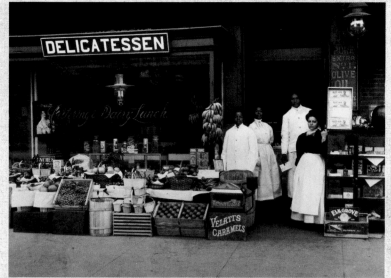

Scurlock Studio, Washington, D.C.

For generations, many African Americans have prospered by providing basic goods and services to the Black community. This store, the Underdown Family Delicatessen, was at 14th and 'S' Streets, N.W., in Washington, D.C., circa 1904.

Since the 1980s, African Americans have continued to reach higher and farther than ever in both American and global business circles. The late Reginald Lewis, educated at Harvard and trained in the financial maneuverings of Wall Street, attained the highest ranks of international finance when he purchased the European holdings of Beatrice Foods in 1987 for $985 million.

Through the decades, two lessons seem clear. Economic success comes to African Americans only when they make the most of every opportunity offered and only when they create their own opportunities where none exist. African Americans achieved startling success only when they refused to succumb. Secondly, while individual initiative in this area has always been significant, it is important to remember that breaking new ground has often required the collective strength of the community.

Today, institutional barriers to capital remain, public understanding of the roots of economic inequality is still limited and collective determination to enforce antidiscrimination policies continue to be unfulfilled. Still, to paraphrase the Black poet Robert Hayden, much progress has been made on the economic journey from "can't to can."

Born in Jamaica, Marcus Garvey came to New York City in 1916. Founder of the Universal Negro Improvement Association, the weekly newspaper Negro World and the Black Star steamship line, Garvey preached economic and political self-determination. He also proclaimed that Blacks should relocate to Africa because they would never achieve freedom or equality in the United States. In the early 1920s Garvey had an estimated 1-to-2 million followers involved in his "Back-to-Africa" movement.

The Schomburg Center for Research in Black Culture, New York Public Library

The Schomburg Center for Research in Black Culture, New York Public Library

Paul R. Williams was one of the nation's most accomplished architects during the first half of this century. Although he was told in his youth that an African American could never become a successful architect, Williams vigorously pursued his career, graduating from the University of California and the Beaux Arts School of Design. He designed naval bases, schools and other public buildings, and earned international acclaim for the lavish mansions he designed for movie stars. Williams was president of the Los Angeles Art Commission and was awarded the NAACP's Spingarn Medal in 1953 for his exceptional achievements.

93

*B*efore he died in 1993 at the age of 50, Reginald Lewis presided over the largest African American-owned business in the nation, billion-dollar TLC Beatrice International Holdings, Inc., headquartered in Manhattan.

Even as a youth, Lewis aimed high. Raised with five half-brothers and half-sisters in a tough part of Baltimore, he was captain of the football, basketball and baseball squads at Dunbar High School. He went on to play football at Virginia State University. But when a shoulder injury ended his sports career, Lewis switched his focus from sports to studies and graduated from Harvard Law School in 1968.

After practicing law in New York for 15 years, Lewis started TLC Group, a financial holding company. Lewis's first deal was the purchase of McCall Pattern Company in 1984 in a $24.5 million leveraged buy-out. In 1986, he sold the company for $95 million—earning a dazzling return. One month later, Lewis bought Beatrice's giant international food business for $985 million.

In 1988, he established the Reginald F. Lewis Foundation, which has donated millions to cultural, educational and civil rights organizations. One of his largest donations was a $1 million gift to Howard University. But Lewis made headlines in 1992, when he gave a $3 million donation to Harvard Law School, the largest contribution by an individual in the school's 175-year history. Harvard's new international law center, named for Lewis, is the first Harvard building to be named for an African American.

Photograph of Reginald Lewis by Jeffrey Henson Scales

John Reeves handles a lasso at his 100-year-old family ranch.
Photo essay by Larry Price

The Black cowboy has long been a fixture of the American West. In the 1870s, there was the range-riding sharpshooter Nat Love, also known as "Deadwood Dick," and later there was Bill Pickett, who invented the sport of steer wrestling.

The tradition lives on today in Live Oak, Texas, where father and son T. J. Williams and John Reeves still rope cattle and raise cutting horses on the ranch formed by T. J.'s grandfather, Troy Taylor, in the 1880s.

Taylor, a cattlehand, saved his wages to buy his own spread. Starting with 20 acres, the ranch eventually grew to 400.

In the 1960s, Williams established his own reputation as a famous cowboy when he became the first African American cowboy to compete in major cutting-horse championships in Texas and the Southwest. Williams was widely known as the "Tennis Shoe Cowboy" because he never wore boots, preferring instead tennis shoes with spurs attached.

Son John Reeves also has a special love of horses. In addition to his regular ranch duties, Reeves boards horses, trains cutting horses and gives riding lessons. He's currently training his own son, "Little John," to be a sixth-generation cowboy.

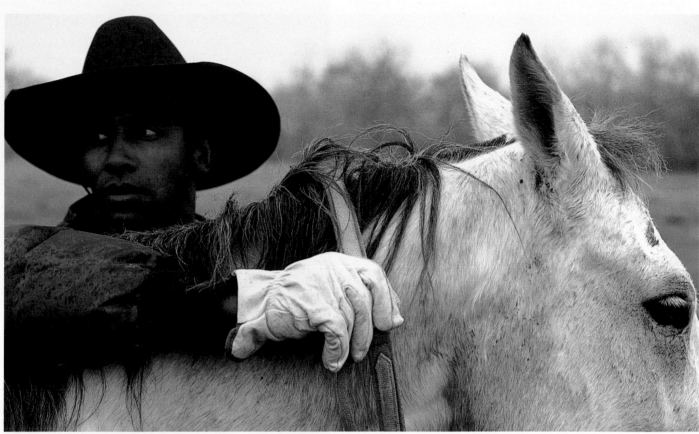

Fifth-generation cowboy John Reeves, 35, handles ranchwork on his family's 40-acre Texas spread. He also trains cutting horses and teaches riding.

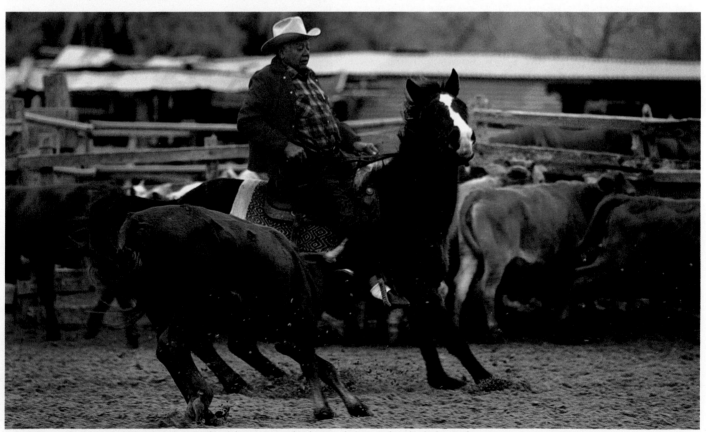

T. J. Williams, the 70-year-old "Tennis Shoe Cowboy," demonstrates that he can also cut cattle in his bedroom slippers.

Oprah Winfrey, talk-show host, actress and entrepreneur, has captivated millions since her first local talk show, "A.M. Chicago," aired against established host Phil Donahue in 1984. Just a year later, Winfrey became the first African American woman to host a nationally syndicated program, renamed "The Oprah Winfrey Show."

Today, "Oprah" is the top-rated talk show in television history, and Winfrey is one of the highest-paid entertainers in America. She is also the first African American woman (and only the third female after Mary Pickford and Lucille Ball) to own her own major TV and movie production studio, Harpo (Oprah spelled backward) Productions.

At her expansive studio facilities, Oprah tapes her own show and is planning television specials and feature film productions of works such as Toni Morrison's novel *Beloved* and Zora Neale Hurston's *Their Eyes Were Watching God.*

Winfrey's meteoric success follows the poverty and pain of her early years. For much of her childhood, Winfrey was shuttled between her grandmother in Kosciusko, Mississippi, her mother, who worked as a maid in Milwaukee, and her father, a barber and grocer in Nashville. During this time, she also endured sexual abuse at the hands of relatives.

But Winfrey's talent and success in school opened many doors. A natural actress and outstanding public speaker, she attended the 1970 White House Conference on Youth in Washington and was voted Miss Black Tennessee. She started working as a radio news announcer while attending Tennessee State University in Nashville, then launched her television career.

Winfrey is committed to addressing social issues head-on, both on the air and off. In addition to testifying before Congress to spur passage of the National Child Protection Act, she and the women on her staff volunteer as Big Sisters to 24 teenage girls from a tough Chicago housing project.

Photograph of Oprah Winfrey by Kevin Horan

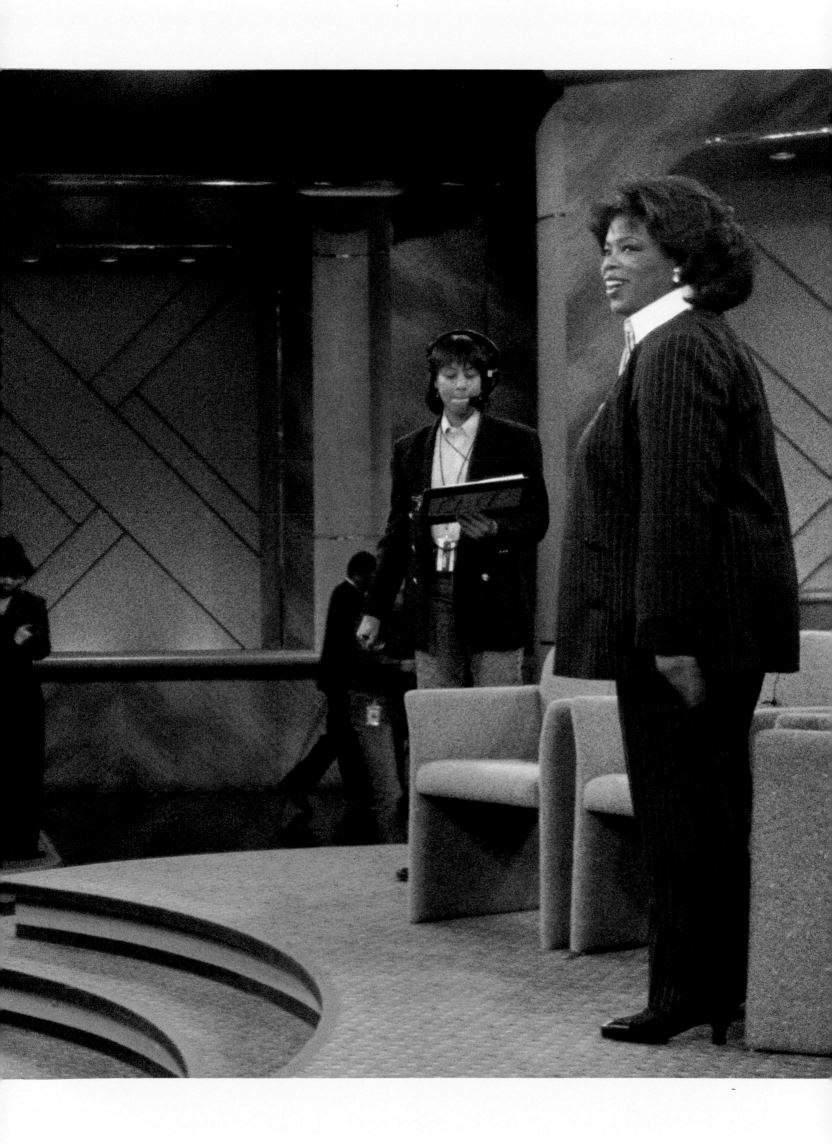

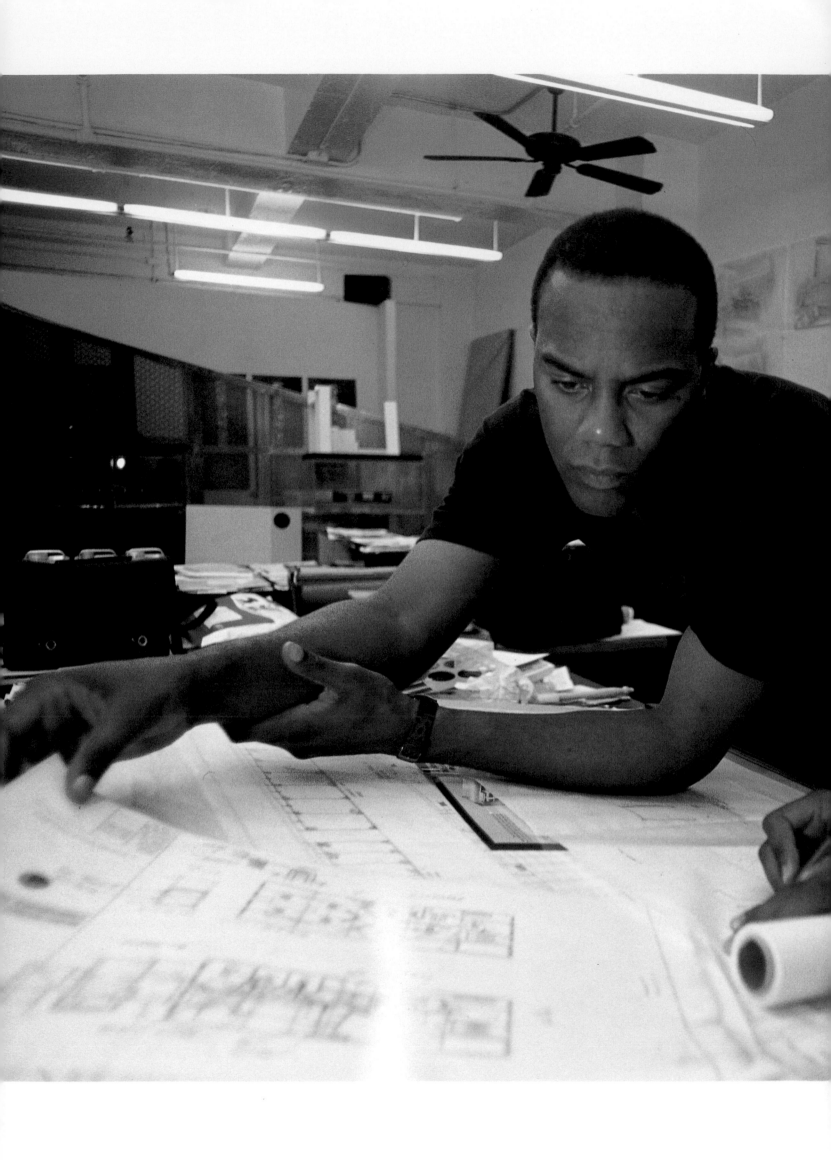

Architect Jack Travis relaxes in his Manhattan apartment surrounded by his collection of rhythm beaters and hand-carved chairs from West Africa. Photographs by Nicole Bengiveno

*O*ne of the most vocal and visible African American architects, Jack Travis has designed homes for film maker Spike Lee and actor Wesley Snipes, and was a consultant on Lee's film *Jungle Fever.* He is also the author of *African American Architects in Current Practice* and serves on the American Institute of Architects' new task force on diversity.

Just as there are strong Afrocentric influences in music and fashion, Travis expects to see a new Afrocentric style of architecture emerging as more Blacks enter the profession. "For the first time, African American architects are not just trying to catch up with a predominantly white profession," Travis says. "We are beginning to contribute new ideas on our own terms."

Travis was drawn to architecture as a child growing up in Las Vegas, Nevada. His parents were from the rural South and had little schooling, but they sent Travis to Catholic school so that he would get a good education. As a ten-year-old, Travis would daydream about redesigning his schoolbuilding, and a nun suggested that he read a book about how to become an architect. "I practically memorized that book," he says. "It said I had to be a leader, know math and be able to draw."

Already good at math and a natural leader as captain of nearly every football, baseball and basketball team he joined, Travis worked on his drawing and designing skills, earning a bachelor's degree in architecture from Arizona State University and a master's from the University of Illinois at Urbana-Champaign.

Today, Travis's Manhattan practice employs three architects and two interior designers. Travis also travels the country speaking to African American architecture students about his three rules for success: honesty, integrity and fortitude. "If you never give up," Travis tells them, "you will eventually succeed."

Travis reviews designs by Adegboyega Adefope, a Nigerian-born architect-in-residence.

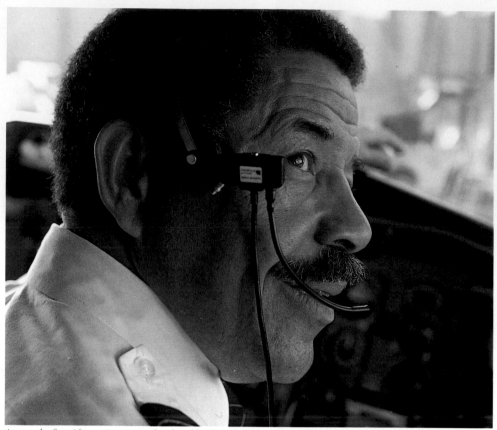

Among the first African American pilots hired by United Airlines, William Norwood has been a captain since 1983.
Photo essay by Kevin Horan

For African Americans, one of the most vivid color lines has run through the field of aviation. Until the beginning of World War II, Blacks were barred from flight training in the military. In 1939, the Tuskegee Flying School broke that barrier by training Black aviators for the Army Air Corps. Many of these legendary Tuskegee Airmen distinguished themselves in North Africa and Italy during World War II as members of the intrepid 99th Pursuit Squadron.

Long after the war ended, however, Blacks were still shut out of commercial and passenger aviation. One of the pioneer aviators to break through the commercial color line was William Norwood, who became the first Black pilot for United Airlines in May 1965.

A native of Centralia, Illinois, Norwood was inspired to fly by the principal of his segregated elementary school, a former Tuskegee Airman. Norwood earned his private pilot's license in ROTC training at Southern Illinois University, where he majored in chemistry and was the first African American quarterback on the football team. After college, Norwood served as a B-52 pilot in the Air Force.

Five months before the Civil Rights Act of 1964 took effect, Norwood applied for a commercial pilot position with United Airlines. He was among the first African American accepted for training by United and, in 1983 became the first to achieve the rank of captain. Today, Norwood is one of 210 African American pilots flying for United.

United Airlines pilot William Norwood conducts a preflight inspection of a new Boeing 767.

In the control tower at O'Hare International Airport outside Chicago, Norwood checks in with his son William, Jr., an airtraffic controller. Norwood's younger son, George, is an attorney in South Bend, Indiana. His wife, Molly, runs Blue Ribbon Press from an office in their home.

Jonas Kennedy and farmhand John McRae prepare to fertilize the green acres of grain.

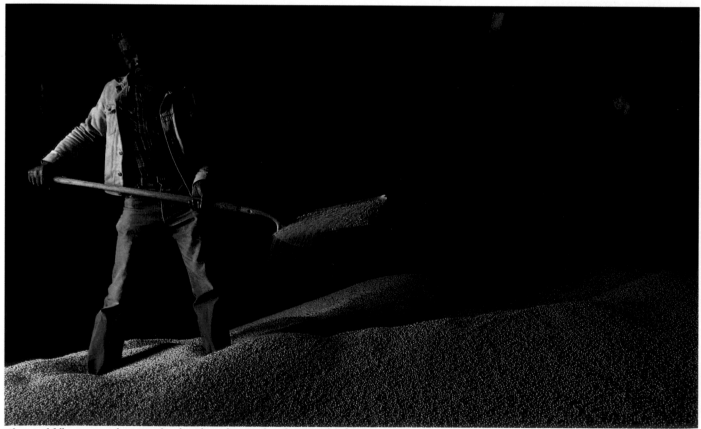

Above and following spread: McRae shovels soybeans harvested on the Kennedy's farm.

The Kennedy farm comprises 700 acres near Bennettsville, South Carolina. Photo essay by Jeffery Allan Salter

Two miles west of Bennettsville, South Carolina, Jonas and Odette Kennedy farm 700 acres of corn, soybeans, wheat and barley. Kennedy's family has owned the farm since his grandfather, Jonas Thomas, purchased the land in the late 19th century.

Like many African American farmers, the Kennedys may be the last generation of their family on the land. Their only child, a daughter, moved to Maryland, where she teaches school. Kennedy now runs the operation himself with two full-time farmhands.

"Farming is something I love to do, but the Black farmer is becoming extinct," Kennedy reflects. In 1920, there were nearly a million African American farmers, but by 1982, more than 93 percent had sold or lost their farms. There are only some 20,000 Black farmers left in the United States today.

"Farming is very tough," explains Kennedy. "Young farmers who try to start now can't get enough money together to get going. And many existing farms are too small to make a living. It's hard to survive with less than 400 or 500 acres." The average African American-owned farm is less than 100 acres, according to the Federation of Southern Cooperatives/Land Assistance Fund (FSC/LAF).

To help them stay on their land, the FSC/LAF offers Black farmers technical assistance, teaches farm management skills, offers small loans and organizes farm cooperative associations. But the assistance may not be enough for African American family farmers like Kennedy, who see their children leave the farm for urban jobs. The death of these long family traditions may mean the end of a hard-won Black heritage of independence and self-sufficiency on the land.

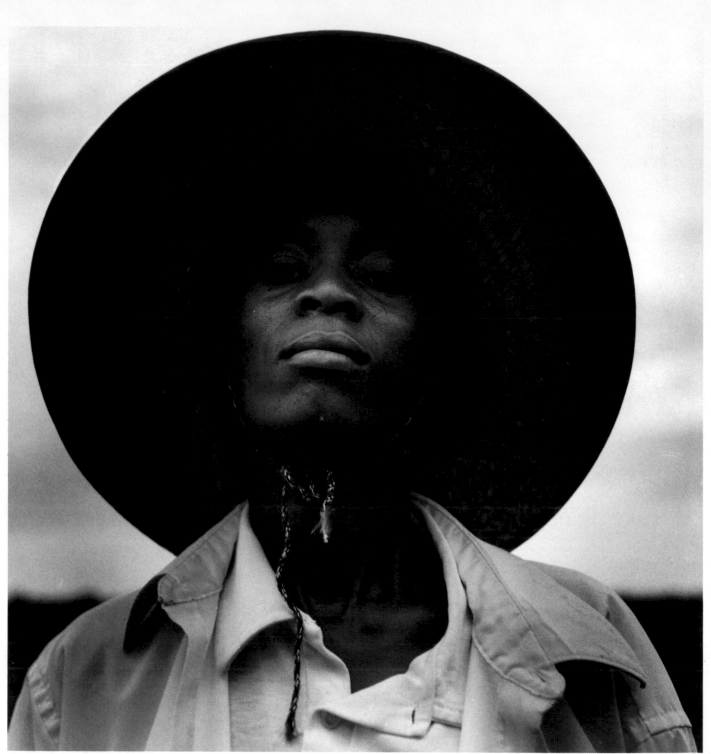

Photographs by Ken Light/JB Pictures

\mathcal{F}or nearly four centuries, African Americans have sown, planted and harvested the land. The number of Black agricultural workers began to decline in the 1940s, when millions migrated north for urban jobs. Today, however, many African American farmworkers, like seasonal worker Shirley Clark, above, still cultivate cotton in Southern fields.

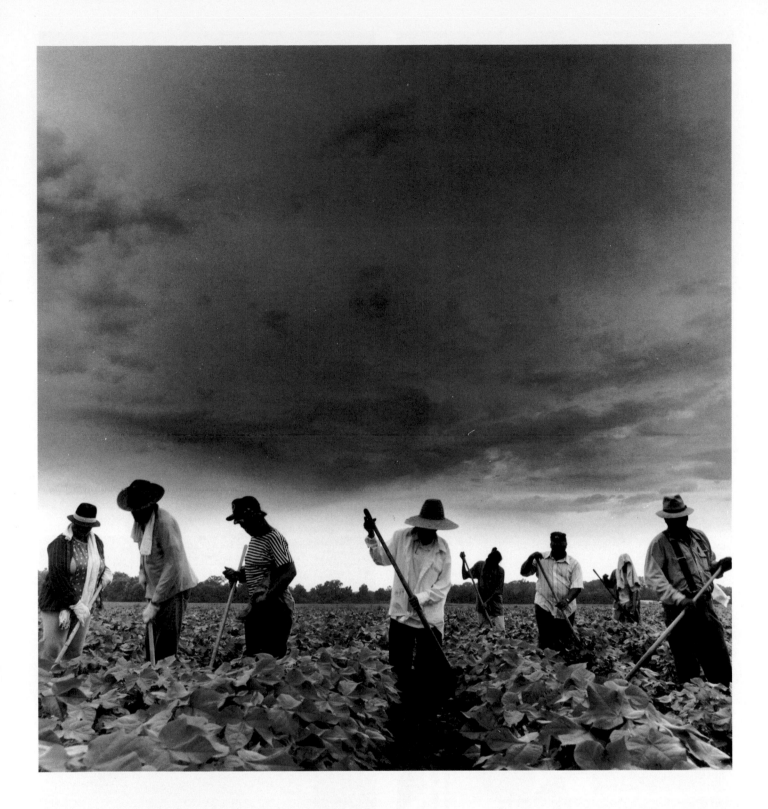

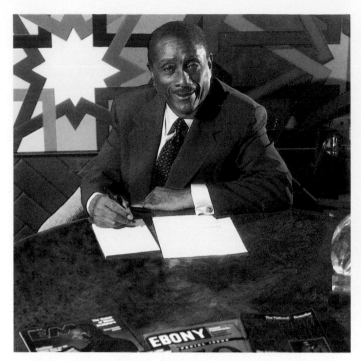

In 1942, John H. Johnson pledged his mother's furniture to secure a $500 loan and launched *Negro Digest,* the first commercially successful magazine celebrating African American aspirations and achievements. He followed that success with *Ebony* and *Jet.* By the 1980s, Johnson Publishing Company was a highly successful media, insurance and cosmetics conglomerate with nearly 2,000 employees and more than $250 million in revenues. *Photograph by Bob Black*

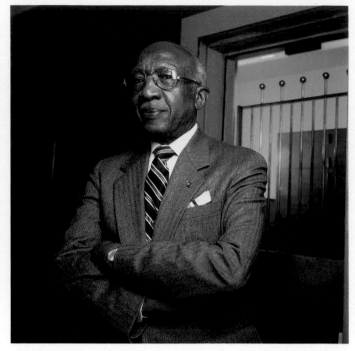

Richard T. Greene is president and director of Carver Federal Savings Bank, the largest African American financial institution in the nation. Greene was born and raised in Charleston, South Carolina, and educated at Hampton University, New York University and the Wharton School of Banking and Finance. He is active in the 100 Black Men and the Harlem Urban Development Corporation.
Photograph by Jeffrey Henson Scales

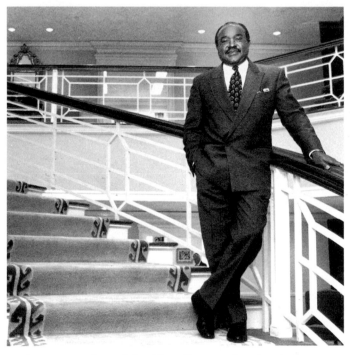

Carl Ware, president of the Africa Group and senior vice president of the Coca-Cola Company, is responsible for international operations in a rapidly expanding region that includes 44 African nations. Since joining the Company in 1974, Ware has held a number of increasingly responsible positions, leading to his current assignment. His broad background in the public and private sectors includes a term during the 1970's as president of the Atlanta City Council.
Photograph by W. A. Bridges, Jr./Atlanta Journal-Constitution

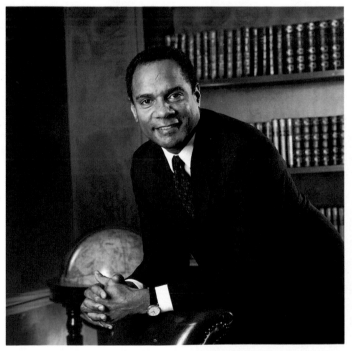

Kenneth I. Chenault, president of the charge-card group for American Express Travel-Related Services, Inc., rocketed to the company's highest levels. In 1987, at age 35, the Harvard-educated lawyer was named head of the company's Platinum and Gold Card division, after he had tripled the merchandise division's profits in three years.
Photograph by Anthony Barboza

W. Don Cornwell heads Granite Broadcasting Corporation, which owns and operates a group of NBC- and ABC-affiliated television stations. A native of Tacoma, Washington, Cornwell holds an M.B.A. from Harvard University and was formerly vice president of investment banking at Goldman, Sachs. Active in the community as well as commerce, Cornwell is a director of the New York City Schools Volunteers Program and The Alvin Ailey Dance Theater.
Photograph by Anthony Barboza

Hotel executive L. Gregory Brown, a graduate of the University of Maryland and a former Navy midshipman, is resident manager of the 1,224-room Atlanta Hilton and Towers.
Photograph by W. A. Bridges, Jr.

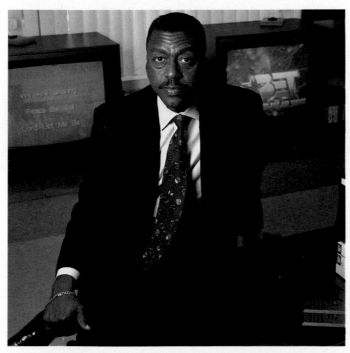

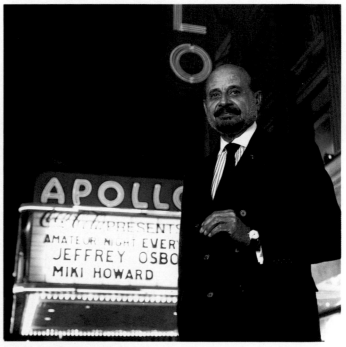

In 1979, Robert Johnson founded Black Entertainment Television (BET) with a personal loan for $15,000. By the end of 1991, his successful cable network had 29 million subscribers and became the first entertainment company founded by an African American to be publicly traded on the New York Stock Exchange. Johnson is also publisher of the magazines *YSB* and *Emerge*.
Photograph by Keith Jenkins

Once Malcolm X's lawyer, Percy Sutton has succeeded in both elective politics and business. A former trustee of the National Urban League, Sutton was elected to the New York state assembly in 1964, then succeeded Constance Baker Motley as Manhattan borough president. In 1978, he joined his son, Pierre, in a radio broadcasting venture that they eventually built into Inner City Broadcasting Corporation, a $28 million multimedia conglomerate that includes Harlem's famed Apollo Theater.
Photograph by Jeffrey Henson Scales

111

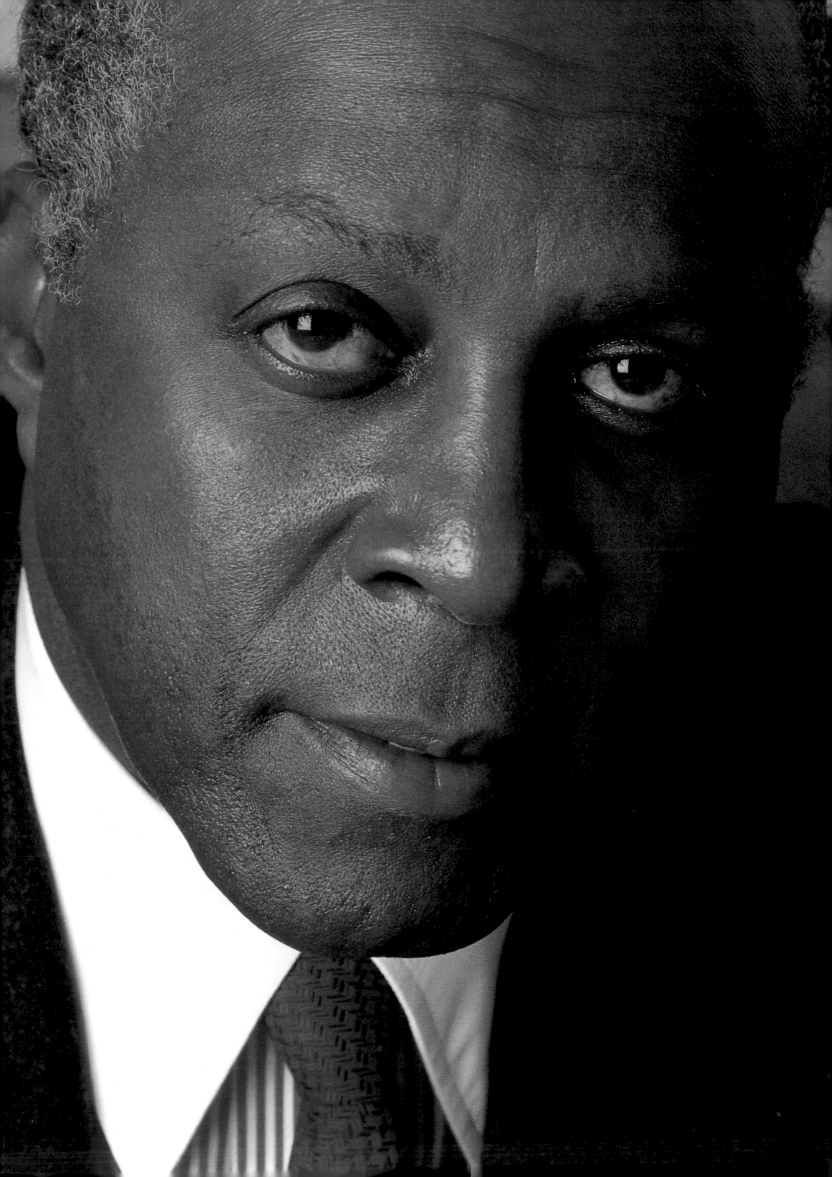

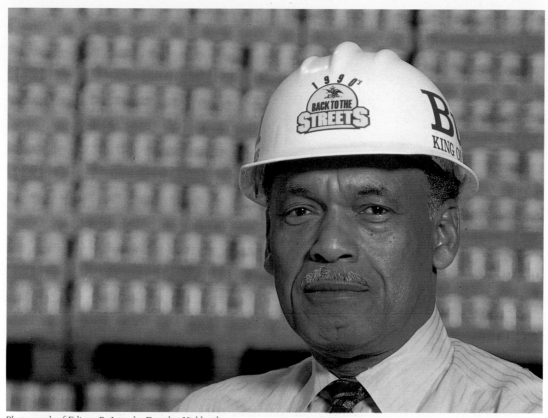

Photograph of Edison R. Lara by Douglas Kirkland

Photograph of attorney and presidential advisor Vernon E. Jordan, Jr., by C. W. Griffin

*H*is grandfather was a sharecropper; his father, a mail clerk. Now the ultimate insider, Vernon Jordan is an influential Washington attorney, corporate director and close advisor to President Bill Clinton.

Jordan signed on with the civil rights movement in 1960 as an attorney in Atlanta. Over the next 12 years, he served as the Georgia field secretary for the NAACP, director of the Southern Regional Council of the U.S. Office of Economic Opportunity, director of the Voter Education Project and executive director of the United Negro College Fund. In 1972, he was named executive director of the National Urban League, an influential position he held for a decade.

Jordan now practices law with the prestigious Washington firm of Akin, Gump, Strauss, Hauer and Feld. In 1992, he was tapped to chair Bill Clinton's presidential transition team and to serve as a key advisor to the president. Jordan also serves as a director of 11 of America's largest corporations, the Ford Foundation, the Joint Center for Political and Economic Studies and the Brookings Institute.

*E*dison R. Lara has combined business acumen with a dedication to the African American community. Lara is president and owner of Westside Distributors, one of the largest African American-owned businesses in the nation. With office and warehouse facilities located in South Central Los Angeles, Westside Distributors provides employment opportunities for local residents and makes a significant contribution to the local economy.

Lara has been honored as "the most outstanding Black businessman in the nation" by the 100 Black Men of America. Lara supports the United Negro College Fund, the Martin Luther King Awards and the Challengers Boys and Girls Club.

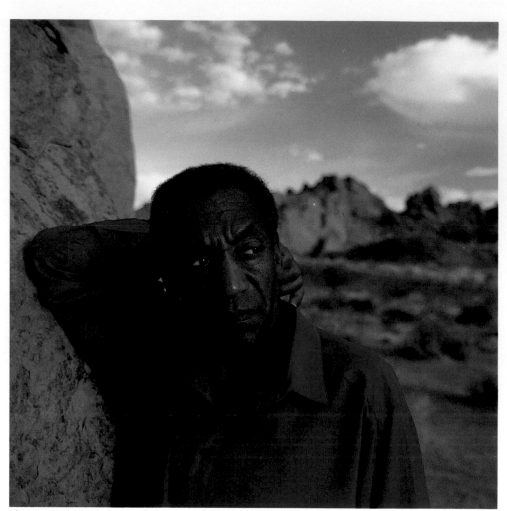

Photograph of television pioneer Bill Cosby by Eddie Adams/Sygma

For more than 20 years, through records, television, movies and concert performances, Bill Cosby has been one of America's most successful and beloved entertainers. With "The Cosby Show," he brought to American television its first authentic portrayal of the intact, wholesome, aspiring and successful African American family. In doing so, Cosby has completed his transition from a performer to a highly respected and nationally regarded businessman. He is also the author of several best-selling books, including *Fatherhood*.

Cosby has also made history in the field of philanthropy. He and his wife, Camille, contributed a record-breaking $20 million to Spelman College in 1988.

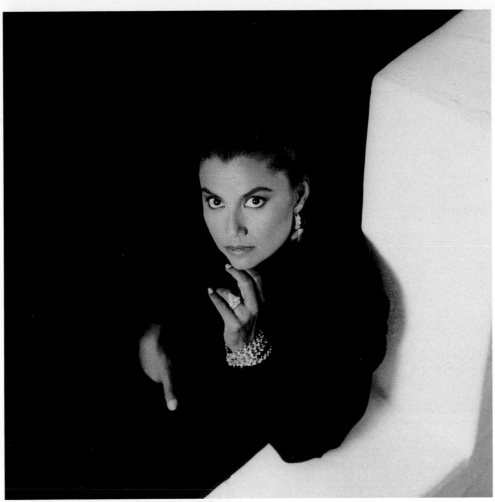

Photograph of Suzanne De Passe by Bonnie Schiffman/Onyx

*W*hile Suzanne De Passe has always worked behind the scenes, she has also made entertainment history. Under the tutelage of Motown's Berry Gordy, Jr., De Passe developed superstar acts such as the Jackson Five and the Supremes. She was nominated for an Academy Award for cowriting the script for *Lady Sings the Blues,* and won an Emmy for producing "Motown 25: Yesterday, Today, Forever."

After 20 years with Motown, she formed De Passe Entertainment, which produced the acclaimed television miniseries "Lonesome Dove," winner of seven Emmys.

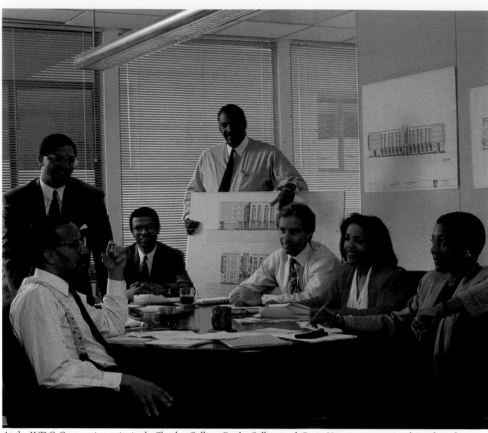

At the WDG Companies, principals Charles Collins, Paula Collins and Craig Kammerer present their plans for a new medical center in San Francisco. Listening are venture capitalists Edward Dugger III (second from left) and Liz Harris (far right) of UNC; Barry Lawson Williams (standing), president of Williams Pacific Ventures; and Peter Thompson (third from left), president of Opportunity Capital Corporation. Photograph by Tom Zimberoff

\mathcal{E}ntrepreneurial African American-owned firms like San Francisco's WDG Companies benefit from a growing network of Black and minority venture capitalists throughout the United States. WDG owns, manages and develops residential, commercial and mixed-use projects. The firm is active in major community and economic development projects in the San Francisco Bay Area.

Cross Colours is a fast-growing new company that markets African American culture to a mainstream audience. Created by Carl Jones, a Los Angeles fashion designer and entrepreneur, Cross Colours' vibrant line of hip-hop fashions had more than $15 million in sales in 1991, the company's first year. Cross Colours also sells a social message with its leather jackets, baseball caps, baggy pants and housewares: Reinvest in the community, fight for equality; stop the violence and work for peace.

\mathcal{R}ap impresario Russell Simmons heads Rush Communications, a conglomerate of seven record labels that includes Def Jam Recordings. It is a hugely successful enterprise that brings urban music and comedy to the mainstream, crossover audience. Cofounded by Simmons and former partner Rick Rubin in 1984 in a New York University dorm room, the label represents both well-known and emerging rap artists such as Run-DMC, LL Cool J, Public Enemy, Slick Rick and EPMD.

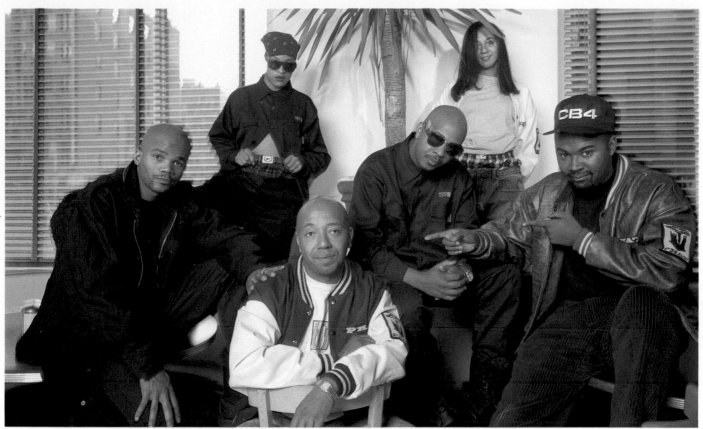

Rap mogul Russell Simmons and the staff of Def Jam Recordings. Photograph by Tony Barboza

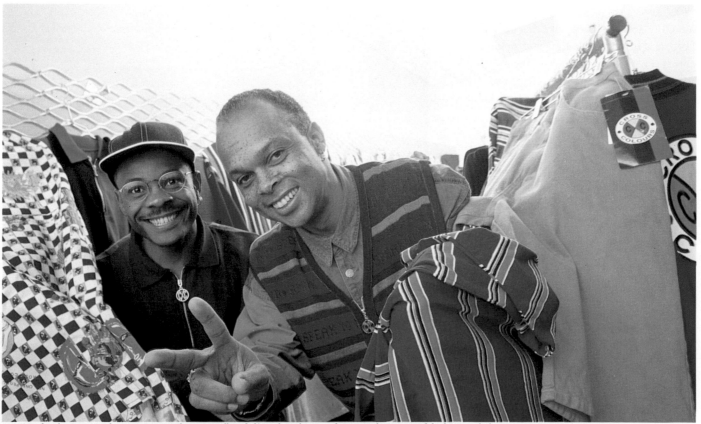

*Los Angeles designers and entrepreneurs Thomas Walker (left) and Carl Jones of Cross Colours, one of the hottest clothing companies in the country.
Photograph by Douglas Kirkland*

\mathcal{D}avid Lloyd is president and sole owner of San Diego's Bay City Marine, probably the largest African American-owned shipyard in the country. Certified as a master ship-repair firm and known for its high quality and cost efficiency, Bay City brings in revenues of $15 million to $20 million a year from Navy and corporate contracts.

Until he moved to San Diego in the 1950s, Lloyd had never seen the ocean or a ship. He grew up in a poor family in rural Monroeville, Alabama, then migrated west to California in his teens. Lloyd once considered throwing himself in front of a train because he felt his prospects were so dim. But through the 1950s and 1960s, he worked as a janitor, laborer and painter for several ship-repair firms in San Diego, and honed his drafting and welding skills at trade school. Because of the intense competition for shipyard jobs, Lloyd was determined, he says, "to do every job a little better than anybody else."

That commitment to excellence paid off. Soon his reputation for quality work spread, and boat owners began asking him to work on their vessels. In 1971, he formed Bay City Marine with three partners, whom he bought out over the next eight years. In 1979, the company became the only minority-owned firm to be awarded a master ship-repair contract with the Navy. Today, Bay City has nearly 100 employees and 600,000 square feet of facilities.

Over the years, Bay City has completed some $600 million in contracts. Lloyd has been praised for completing Navy contracts on time and under budget, and in 1984, he was selected as minority entrepreneur of the year by the U.S. Department of Transportation.

Photograph of industrialist David Lloyd by Douglas Kirkland

For generations, African Americans have harvested sweet, briny Gulf oysters in Louisiana. Photographs by Larry Price

O n the edge of the Mississippi Delta, Arthur Reddick's crew set sail in the wooden boat, *Mr. Tim*, to dredge oysters from the muddy Gulf shallows. Like their fathers before them, these oystermen have fished for the succulent crustaceans their entire life. Five or six months a year, they set out from Point a la Hache, Louisiana, for one to three days of oystering 25 to 50 miles off the coast. On a good day at sea, they can haul up 35 to 40 sacks and sell them for a fair price in the market. It is a tradition that the oystermen have followed for generations, and it is a life—and a living—that they heartily enjoy.

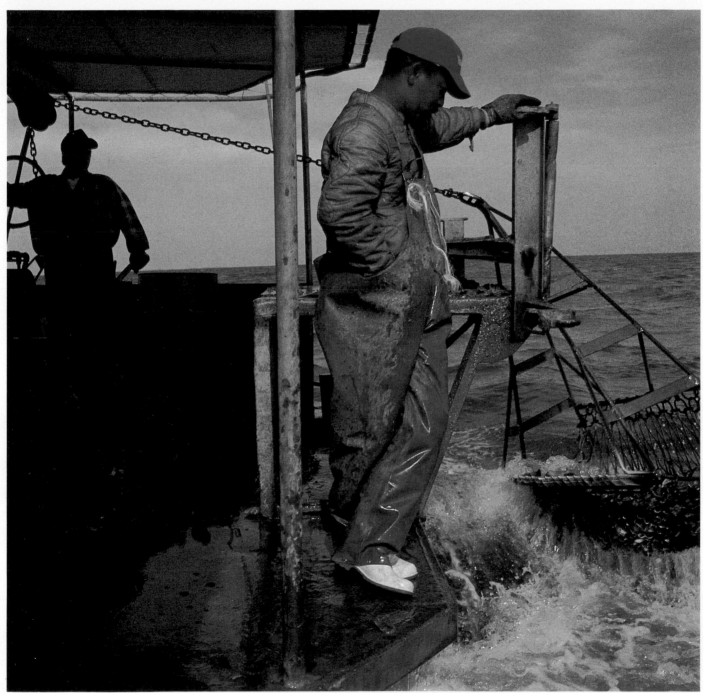

August Bartholemy (right) and Herman Isidore raise a dredge filled with Gulf oysters.

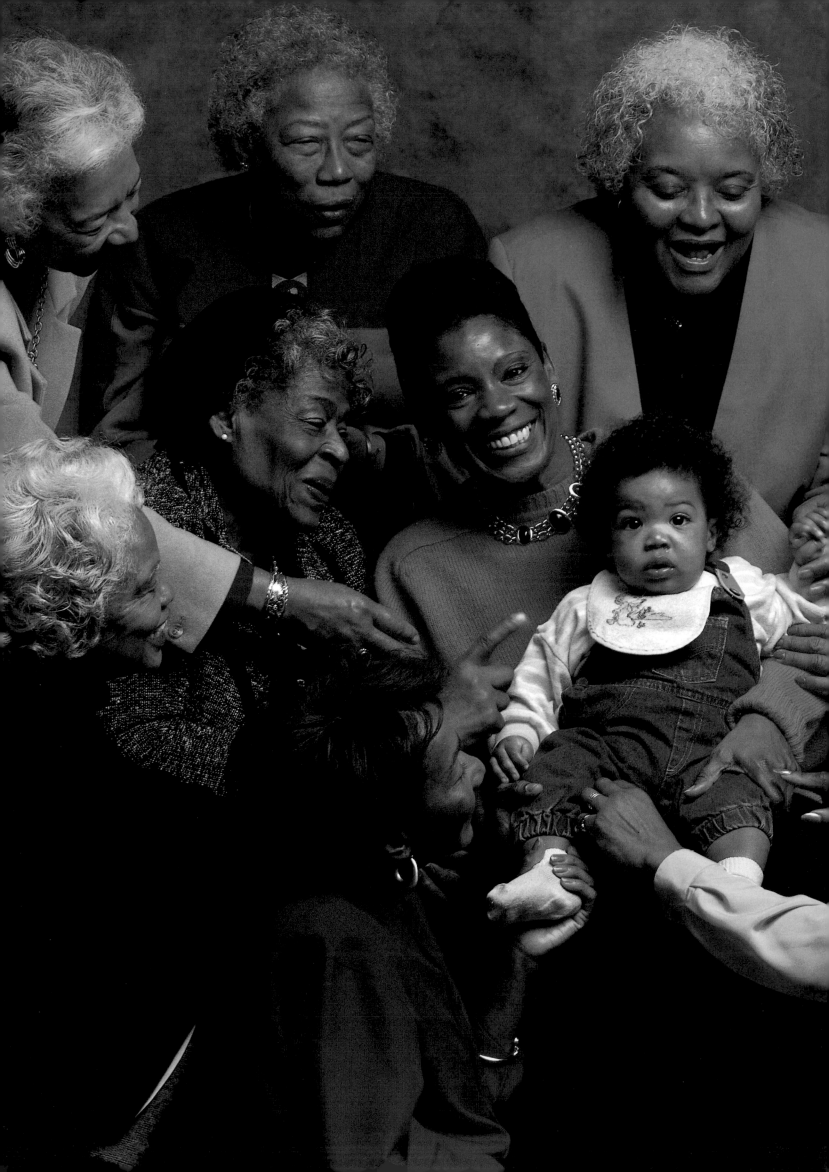

Call-A-Granni Minnie Moody with one of her charges. Photographs by Nick Kelsh

*F*lorence Johnson (left, holding the baby) is founder and president of Call-A-Granni, Philadelphia's ingeniously successful in-hotel and in-home child-care service. A graduate of Howard University, and a high-school guidance counselor by profession, Johnson hit on the idea for the unique service in 1983. With a new convention center opening in town, she realized there would be additional need for qualified child care.

Johnson started her business by signing up two hotels with ten "grannies," all carefully screened child-care workers. Since then, the business has grown steadily. Seventy grannies are now on call at every major hotel and many private homes in Philadelphia. Johnson's grannies also offer care for sick children.

"We've got African American grannies, white grannies, Jewish grannies—you name it," Johnson says. And not all her grannies are grandmotherly anymore; they range in age from 76 to as young as 27.

Despite the company's success, Johnson still counsels kids in Philadelphia high schools and hopes to be a principal someday. In the meantime, she says, Call-A-Granni offers a welcome balance to her life. "The kids I work with at school have every pathology imaginable," she says. "This business offers me the chance to work with kids who are happy and very loved."

Florence Johnson with some of her 70 Call-A-Grannies

123

During the period of enslavement, African American black-
smiths invented many tools to ease the burden of plantation
work. A few, like Philip Simons, a retired ironworker in
Charleston, South Carolina, still practice the craft.
Photograph by Karen Kasmauski/Woodfin Camp & Associates

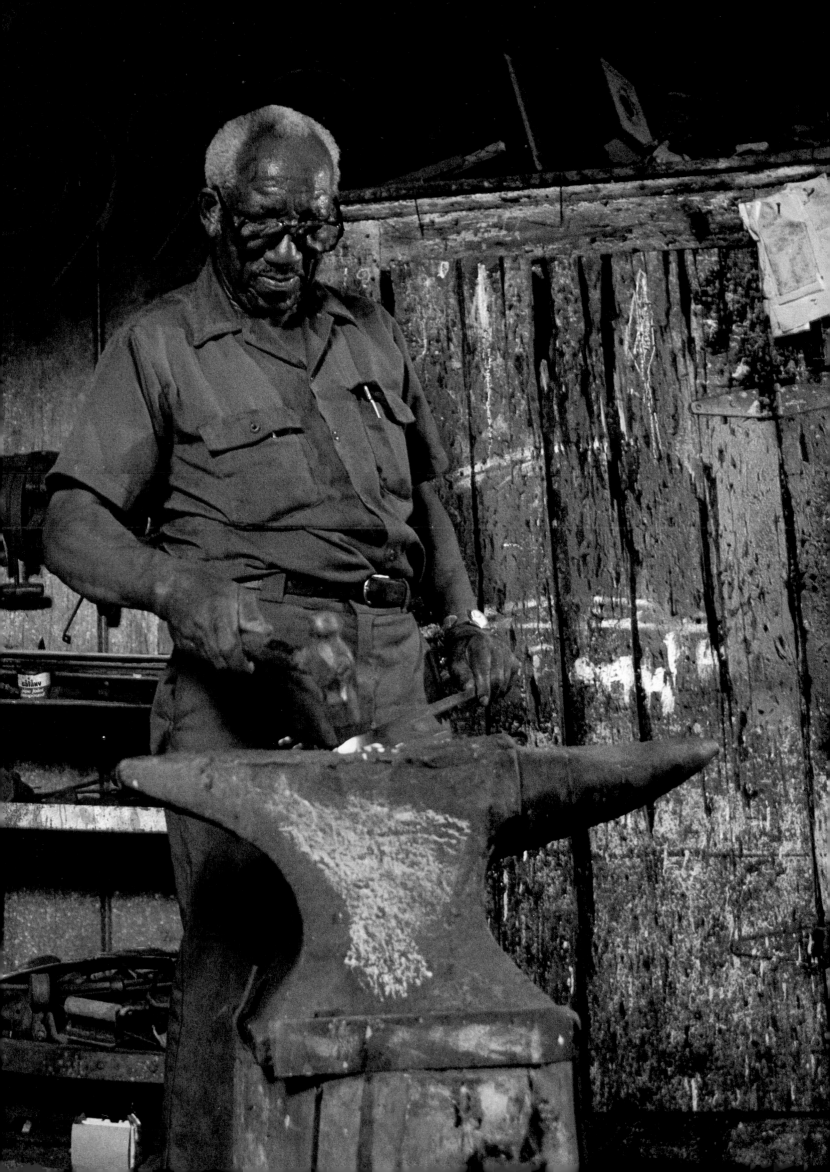

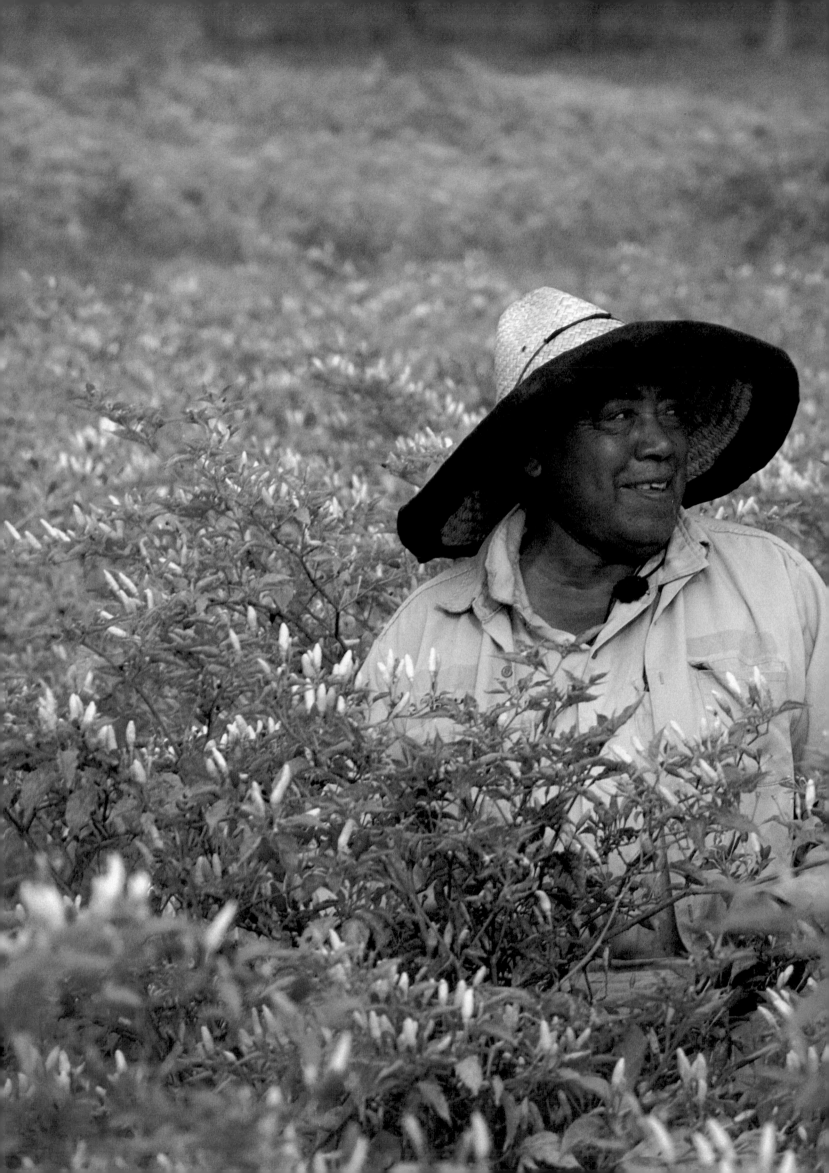

Picking peppers in Atchafalaya, Louisiana. Photograph by
Momatiuk-Eastcott/Woodfin Camp & Associates

D. C. Fowler and Alfred McMichaels feed cattle on the
Wallace Ranch in Loraine, Texas. The ranch was founded in
1885 by ex-slave Daniel Webster "80 John" Wallace, who
was considered to be one of the most progressive farmers and
ranchers in Mitchell County. Wallace owned more than 500
head of cattle and 8,000 acres of ranchland.
Photograph by Larry Price

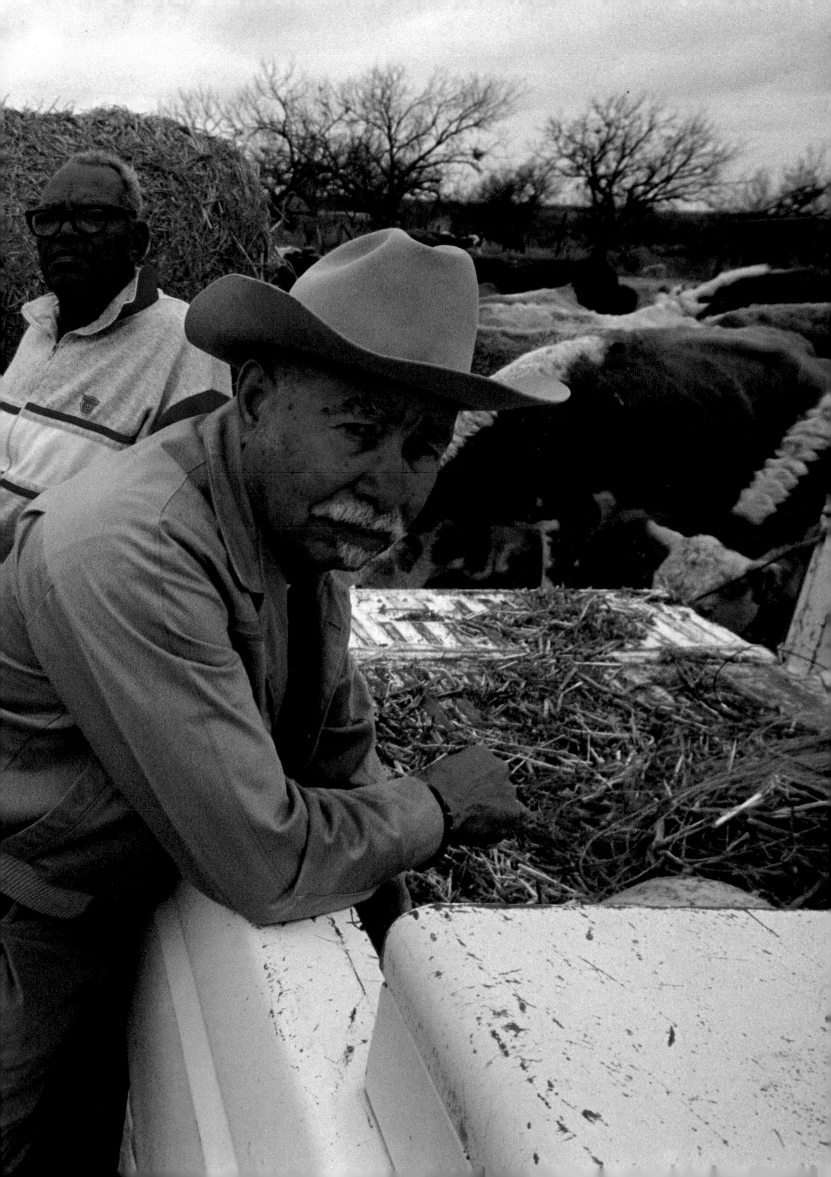

Nat "King" Cole and Ella Fitzgerald met where style and talent merge. The son of an Alabama preacher, Cole led his famed trio and became the first Black entertainer to host a national television show. "The First Lady of Song" got her start in an amateur show at the Apollo Theater in New York City and defined scat singing for an entire generation of jazz singers.

A CULTURAL RICHNESS

In many ways, the United States has carved the face of its culture in the image of its Black citizens. African Americans have named the tunes, called the steps, cursed the darkness of ignorance and shed the light of knowledge with words and pictures. The music, the dance, the words and memories stowed away on the slave ships emerged the moment Africans landed in the Americas and transformed forever the culture of the New World.

On the plantation, Africans performed on traditional drums, wood-winds and string instruments as they had for centuries. After the Civil War came the minstrel shows including illustrious performers like Bert Williams and George Walker. By the turn of the century, Scott Joplin was the "king of ragtime" in St. Louis, while in Memphis, composer and music publisher W. C. Handy earned the title "father of the blues." Ma Rainey and Bessie Smith brought the blues to life, and down in New Orleans, young Jelly Roll Morton made the move from ragtime to jazz, all the while claiming to have invented America's most influential indigenous art form.

As African Americans migrated north to Kansas City, Chicago and New York, so did their music. New York's Cotton Club was the home of orchestra leader Duke Ellington, the most prolific composer in jazz history.

A chanteuse whose fame spanned continents, Josephine Baker was also an uninhibited dancer and style setter. Baker spied for the French Resistance during World War II, appeared at the March on Washington and performed at benefits for SNCC, CORE and the NAACP.

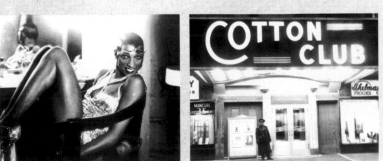

Entertainers like Cab Calloway, Duke Ellington and Lena Horne drew tony white crowds from downtown to Harlem's famed Cotton Club. With few exceptions, Blacks were allowed in only as entertainers, cooks and waiters.

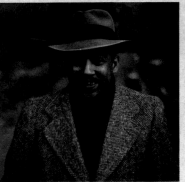

Langston Hughes could express quiet rage in a work like Montage of a Dream Deferred, create plays like Mulatto and musicals like Simply Heavenly. A graduate of Lincoln University, he was a wordsmith for the common folk.

Henri Cartier Bresson/Magnum

Chuck Stewart/Ken Barboza Associates

Jazz innovator, leader of the New Wave and one of the most revered figures of modern jazz, John Coltrane played with and inspired the likes of trumpeter Miles Davis, drummer Art Blakey and pianist McCoy Tyner.

Best known for his landscapes, African American and religious subjects, Henry Ossawa Tanner had to travel to France to gain recognition as an artist.

The Schomburg Center for Research in Black Culture, New York Public Library

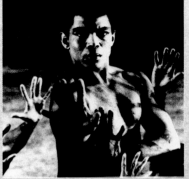

The Schomburg Center for Research in Black Culture, New York Public Library

Alvin Ailey revolutionized modern dance with his Black heritage pieces. His signature works such as The River, Revelations and Pas de Duke, have given the word "classic" a new meaning.

When jazz begat swing, Count Basie moved to the forefront of American popular music. Later, trumpeter Dizzie Gillespie, saxophonist Charlie "Bird" Parker, and pianist Thelonious Monk developed a jazz form called bop.

African Americans such as Ruth Brown, Fats Domino, Chuck Berry and Little Richard also played an important part in the creation of rock and roll, although at the time recognition was difficult to come by.

Among the first African Americans to merge creativity with enterprise on a large scale was Berry Gordy, Jr. The former autoworker opened the Motown Record Corporation in Detroit in 1959, mining local talent like Diana Ross, Martha Reeves and the Temptations. Stax Records of Memphis developed Al Green, Carla Thomas and the Barkays. Today's young music moguls, such as Prince, Andre Harrell of Uptown Records and Queen Latifah, follow in their footsteps.

Dance, too, was an amalgam of African and Caribbean influences. Centuries before break dancing, turn-of-the-century Blacks did the Cakewalk. In modern times, Bill "Bojangles" Robinson, Sammy Davis, Jr., and the Nicholas Brothers popularized the art form of tap. Puritanical critics dismissed choreographer Katherine Dunham's Afro-Caribbean-influenced work in the 1940s, Cabin in the Sky, as "primitive." Of course, compared to the flamboyant Josephine Baker's Parisian La Revue Negre in the mid-1920s, Dunham was comparatively prim. But both of these women were trailblazers who paved the way for choreographers from Talley Beatty to Alvin Ailey and Bill T. Jones.

With some notable exceptions like Henry Ossawa Tanner, Edmonia Lewis and Edward M. Bannister, African American leadership in the visual arts was not fully appreciated until the 20th century. Among the most esteemed painters of the century are Jacob Lawrence, known for his use of vibrant color and patterns, and Romare Bearden, popular both as a painter and collagist. Modern African American sculptors include Elizabeth Catlett, who created the larger-than-life bronze statue of Louis Armstrong in New Orleans' Armstrong Park and Selma Burke, whose sculpted image of President Franklin Roosevelt appears on every U.S. dime.

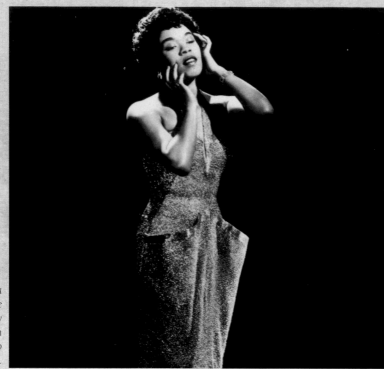

The Driggs Collection/Magnum

The Divine One—even Ella Fitzgerald called Sarah Vaughn "the greatest"—was discovered by Billy Eckstine at the Apollo Theater in New York. Her sultry contralto has proved timeless.

The great flowering of Black literature occurred during the Harlem Renaissance, and it was then that a wide range of truly distinctive Black literature emerged. Langston Hughes wrote such evocative works as *The Negro Speaks of Rivers* as well as plays (*Mulatto*), musicals (*Simply Heavenly*) and stories (the *Jesse B. Semple* series). Claude McKay, Countee Cullen and Zora Neale Hurston were also prolific during this era.

In the middle of the century, literary images of Black life emanated more fully. In 1940, Richard Wright's *Native Son* revolutionized Black literature. A decade later Gwendolyn Brooks won the Pulitzer Prize for *Annie Allen*. Black writers such as James Baldwin, Amiri Baraka, Nikki Giovanni and Claude Brown informed their works with artistry, political metaphor and social commentary.

The first recorded (though never produced) Black drama was *The Escape* written in 1858 by William Wells Brown. Drama thrived during and after the Harlem Renaissance including works by Louis Peterson (*Take a Giant Step*) and Lorraine Hansberry (*A Raisin in the Sun*). The Black arts movement of the 1960s brought James Baldwin's *Amen Corner* (1964) and Lonnie Elder III's *Ceremonies in Dark Old Men* (1965). The movement also gave rise to important local theater groups including the Karamu in Cleveland and the Negro Ensemble Company in New York, which first presented Charles Fuller's Pulitzer Prize-winning *A Soldier's Play*.

When Fuller's play moved to the big screen as *A Soldier's Story* in 1984, it continued a legacy of African American involvement with film making that began as early as 1905. In early film shorts like *The Dancing Nig* (1907) and the *Rastus* series, Black performers, including whites in blackface, were stereotypical clowns and lackeys. The portrayal of Blacks in D. W. Griffith's classic *The Birth of a Nation* (1915) was so derogatory that several Black production companies were formed in response. One of the most successful producers was former Pullman-car porter Oscar Micheaux, who made so-called "race movies" from 1918 to 1940. His works include everything from Westerns to melodramas. Based on this success, the major studios also began to make these films. Most, like *Hallelujah*, starring Nina Mae McKinney in 1929, were musicals and Blacks like Stepin' Fechit and Willie Best, who landed in mainstream

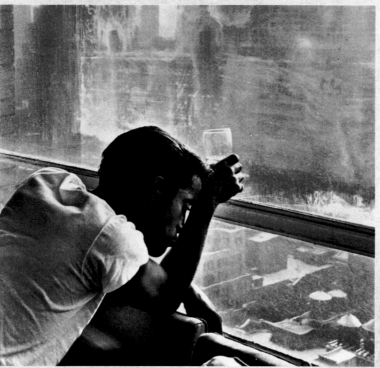

Burt Glinn/Magnum

On stage before the age of two, Sammy Davis, Jr., grew up to become one of the nation's most versatile entertainers. The song-and-dance man lent his talents to numerous political causes and was also an accomplished actor in movies such as Oceans 11 and Porgy and Bess. He aptly titled his 1966 autobiography Yes, I Can.

films, were there primarily to serve. It was a moment of real pride in the African American community when Sidney Poitier was presented with the Academy Award for best actor in 1963. Although Hattie McDaniel had won an Oscar for her supporting role in *Gone With the Wind* in 1939, Hollywood had regularly overlooked such accomplished Black actors as Ralph Cooper, Paul Robeson and Dorothy Dandridge.

The 1970s ushered in the era of the so-called "Black exploitation" films like *Super Fly*, *Shaft* and *Sweet Sweetback's Badass Song*. Serious dramas of that era included *Sounder* (with Cicely Tyson and Paul Winfield) and *Claudine*. In the 1980s, many Black actors such as Richard Pryor, Eddie Murphy and Whoopi Goldberg had comedic roots, but today, the African American presence in films cuts across all genres. While Reginald and Warrington Hudlin produce lighthearted fare like the *House Party* movies, John Singleton put himself on the map with the searing drama *Boyz 'N the Hood*. The most well-known Black film maker of this era, Spike Lee, has shown a consistent ability to focus the attention of wide audiences on African American concerns and issues.

Television parallels film in that the earliest images were of servants like "Beulah" (1950-53) or caricatures like "Amos 'n' Andy" that were first created and performed by non-African Americans on radio. Diahann Carroll's "Julia" (1968) was arguably television's first serious attempt to break the old stereotypes, although the show was criticized for white-washing political realities.

In 1980s and 1990s television, there has been a power shift behind the scenes. Bill Cosby started calling his own shots on his own show. Cosby spin-off "A Different World" is produced and directed by Debbie Allen. Thomas Carter is an Emmy Award-winning director ("Equal Justice"). "The Arsenio Hall Show" has developed a significant late-night audience. Suzanne De Passe moved from under Motown's wing to head her own production company and Avon Kirkland produced the critically acclaimed "Simple Justice."

Today in American television, and for that matter in nearly all cultural arenas, African Americans are providing a lot of well-recognized talent. And for the first time, they are beginning to control their own destiny behind the scenes as well.

\mathcal{D}uring his long career, Miles Dewey Davis, Jr., was at the forefront of practically every new movement in jazz. The man who created his dazzling sound in dark, smoke-filled clubs was the Juilliard-trained son of a prominent dental surgeon from Illinois. Davis inherited his love of music from his mother, who played keyboards and the violin. He also grew up near East St. Louis, Illinois, a regular stop for jazz practitioners such as Charlie Parker and Coleman Hawkins, who toured with Billy Eckstine's band.

Davis moved to New York after high school, attending Juilliard by day and playing jazz clubs by night. He formed his own band, an interracial group that included saxophonists Lee Konitz and Gerry Mulligan and drummer Max Roach in 1949. During this period, he spearheaded "the birth of the cool." Later, the prolific trumpeter moved from cool to be-bop and "free" jazz.

In the 1960s, Davis made a dramatic change to electronic music, enlisting young musicians Herbie Hancock, Chick Corea, Wayne Shorter and Ron Carter producing the classic albums *In a Silent Way* and *Bitches Brew.*

Throughout his life, Davis fell prey to the pitfalls of his trade, including serious drug addiction and racism. (He was once beaten by police while on a break between sets.) But Davis will always be remembered as one of the great musical innovators of his time.

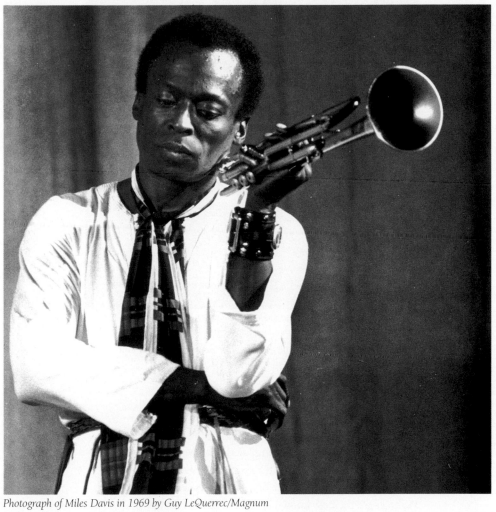

Photograph of Miles Davis in 1969 by Guy LeQuerrec/Magnum

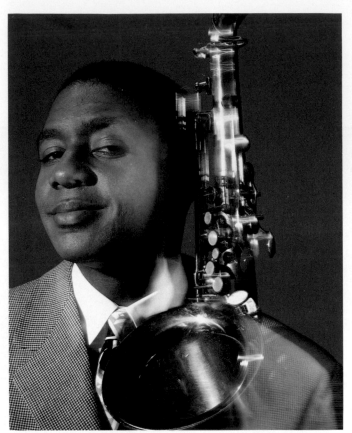

Above: Saxophonist Branford Marsalis's talents range from jazz, classical and the blues to acting roles in feature films. Photograph by Anthony Barboza

Right: Trumpeter Wynton Marsalis has won Grammy awards in both the jazz and classical categories. Photograph by Joe McNally/Sygma

*L*inked by birth and dazzling talent, the Marsalis family is making its mark on American music—"Tonight Show" saxophonist and bandleader Branford Marsalis and trumpeter Wynton are the best-known members of the family, but there is also their father, Ellis, a jazz pianist and educator, and brothers Delfeayo, a record producer, and Jason, a percussionist.

Branford's brilliance on the tenor sax finds expression in jazz and classical pieces, as well as the blues. Younger brother Wynton got his first horn at age six, and by 12, he knew that playing trumpet was his mission in life. Growing up in the restrictive atmosphere of 1960s New Orleans, jazz was his source of strength and self-esteem. Wynton went to New York to study classical music at Juilliard, began playing with Art Blakey and the Jazz Messengers and soon formed his own band with Branford. He has won Grammy awards for his jazz album *Think of One* and for his interpretations of 18th-century trumpet concertos.

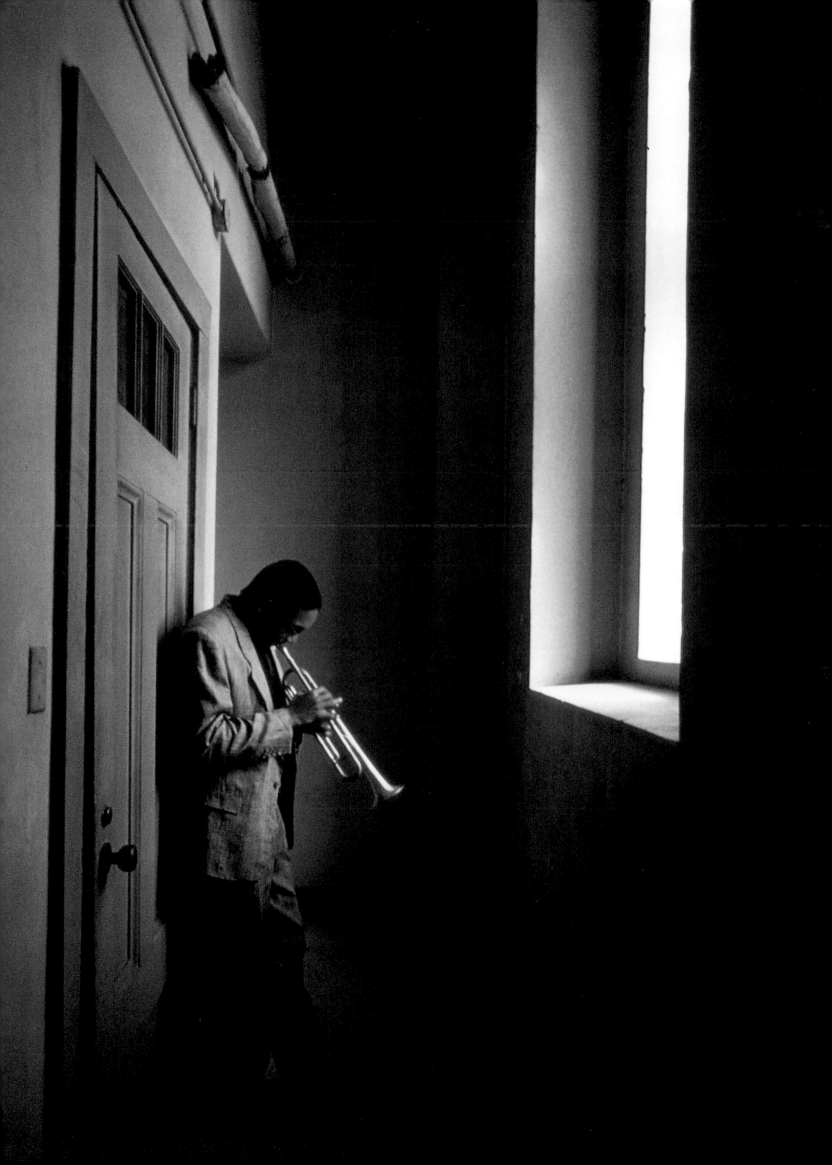

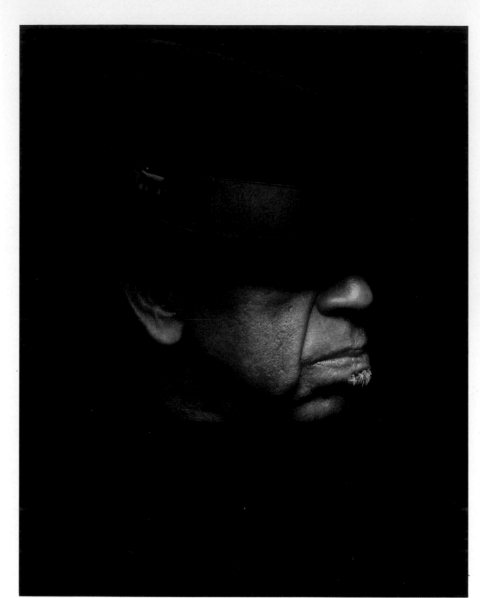

Photograph of be-bop pioneer Dizzy Gillespie by Jeff Sedlik/Outline

*J*ohn Birks (Dizzy) Gillespie was a creator of the jazz genre, be-bop and one of the greatest trumpeters in jazz history. With his outsize cheeks and trumpet bell bent upwards in a peculiar, 45-degree angle, he led jazz into new, free-form territories, accompanied by brilliant pianist Thelonious Monk and pioneering saxophonist Charlie Parker.

The seventh child of James Gillespie, a bricklayer and part-time bandleader, Gillespie was born in 1917 and taught himself to play the trumpet and trombone as a boy in Cheraw, South Carolina. By the 1940s, he was a featured soloist with big-bandleader Cab Calloway.

Gillespie helped to pioneer the unique be-bop sound and introduced his Afro-Cuban style of jazz during jam sessions at Minton's Playhouse in Harlem. For more than 50 years, he composed, performed worldwide and sought out new jazz talent until his death in 1993.

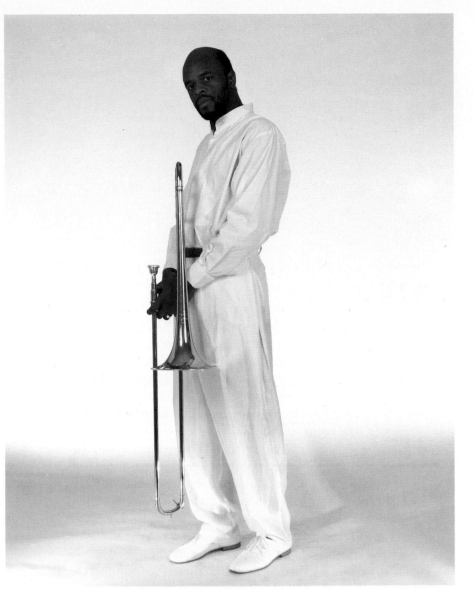

Photograph of musician Craig Harris by Anthony Barboza

\mathcal{T}oday, the horn has been passed to young artists like Harlem trombonist Craig Harris, who continue to bust the boundaries of jazz. A composer, arranger and performer, Harris blends improvisational works, electric and acoustic instruments, synthesizers and the aboriginal Australian dijiridoo.

*M*otown renamed Steveland Morris Hardaway "Little Stevie Wonder." Born blind to a single mother of five in Saginaw, Michigan, Stevie never let sightlessness hold him back. At two he was creating music with spoons; at four he could play the harmonica. He moved on to the drums and by the age of eight was composing tunes on the piano.

Discovered by Ron White, one of Smokey Robinson's Miracles, Wonder was signed by Motown when he was 12. From his first hit, "Fingertips," the young musician was a phenomenon, racking up one pop hit after another. As he matured—and dropped "Little" from his name—he adapted his music to changing times, creating the more thoughtful, intricate tunes on *Music of My Mind, Innervisions* and *Songs in the Key of Life*. Amazingly, he also scored a film, *The Secret Life of Plants*.

Wonder has lent his talent to a number of important social causes, including AIDS research, sickle cell anemia, world hunger and farm-worker relief. He has written songs criticizing apartheid (for which he was honored by the United Nations) and teenage drunk driving. One of his most popular songs, *Happy Birthday,* was part of Wonder's campaign to designate Dr. Martin Luther King, Jr.'s birthday as a national holiday. Despite his physical challenge and his involvement with so many difficult social causes, Wonder remains an optimist. "I believe this is God's island," he says, "and ultimately he will make it right."

Photograph of Stevie Wonder by Michael Grecco/Sygma

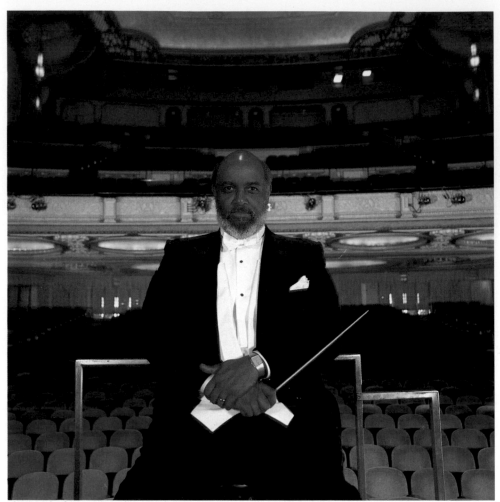

Photograph of Oregon Symphony conductor James DePriest by Anthony Barboza

*I*n 1980, James DePriest was named music director and conductor of the Oregon Symphony, which he has guided into the ranks of major United States orchestras. A Philadelphia native, DePriest studied composition at the Philadelphia Conservatory and earned bachelor's and master's degrees at the University of Pennsylvania.

In 1962, while on a state department tour in Bangkok, he contracted polio but recovered sufficiently to win a first prize in the 1964 Dimitri Mitropoulous International Conducting Competition. He was selected by the late Leonard Bernstein to be an assistant conductor of the New York Philharmonic for the 1965–66 season, becoming the first African American to hold that position.

In great demand as a guest conductor, DePriest has made appearances with scores of distinguished orchestras including the Chicago Symphony, the Juilliard Orchestra and the Netherlands Radio Philharmonic. The author of two acclaimed books of poetry, DePriest is the nephew of the legendary African American contralto Marian Anderson.

Photograph of conductor Michael Morgan, music director of the Oakland East Bay Symphony, by Tom Zimberoff

*M*ichael Morgan was one of a handful of African American conductors who followed New Jersey Symphony Orchestra leader Henry Lewis through the color barrier. Morgan has worked with two orchestras: as assistant conductor of the Chicago Symphony Orchestra and music director of the Oakland East Bay Symphony. A native of Washington, D.C., Morgan was discovered when he entered a competition sponsored by the Baltimore Symphony. He attended the Oberlin College Conservatory of Music and continued his studies at Tanglewood and in Vienna. Morgan made an auspicious debut in 1989 when he stepped in for the famed Sir Georg Solti at the Chicago Symphony. Morgan spends much of his time traveling around the country talking to students about classical music.

*In front of the scenes and behind, Michael Jackson and Quincy Jones make pop
music history. Photographs by Sam Emerson/Sygma & Mark Hanauer/Onyx*

*S*eparately they were at the top of their careers, but together they
broke all records. Michael Jackson was a musical phenomenon, a
star at the age 11 who led his four brothers to the top of the charts.

Quincy Jones, a generation older, was a trumpeter/bandleader
turned composer/producer who had worked with the best: Ray
Charles, Billie Holliday, Dinah Washington, Frank Sinatra and Count
Basie. He had scored more than three dozen movies, including *In
Cold Blood, In the Heat of the Night* and *The Color Purple.* But he was
flexible enough to change with the times, and as younger artists came
along, he added them to his stable.

So it was with Michael. Brought together on *The Wiz,* their first
major collaboration was Michael's very successful solo album *Off
the Wall.* Then Jones and Jackson made a place for themselves in
the record books when they teamed up for *Thriller,* the best-selling
record album of all time. Their next joint effort caught the world's
attention again—this time for a worthy cause. For "We Are the
World," written by Jackson and Lionel Richie, Jones assembled
some of music's superstars including Diana Ross, Stevie Wonder,
Bruce Springsteen and Ray Charles. The beneficiary was USA for
Africa, a famine-relief organization.

Jones, who went on to produce Jackson's *Bad* and his own innova-
tive album *Back on the Block,* is still reaching out to the younger gener-
ation. Perhaps the pre-eminent producer of popular music today,
he is launching new talent such as Tevin Campbell on his own label,
Qwest, producing movies and television shows like "The Fresh Prince
of Bel Air" and a magazine, *Vibe,* which focuses on hip-hop culture.

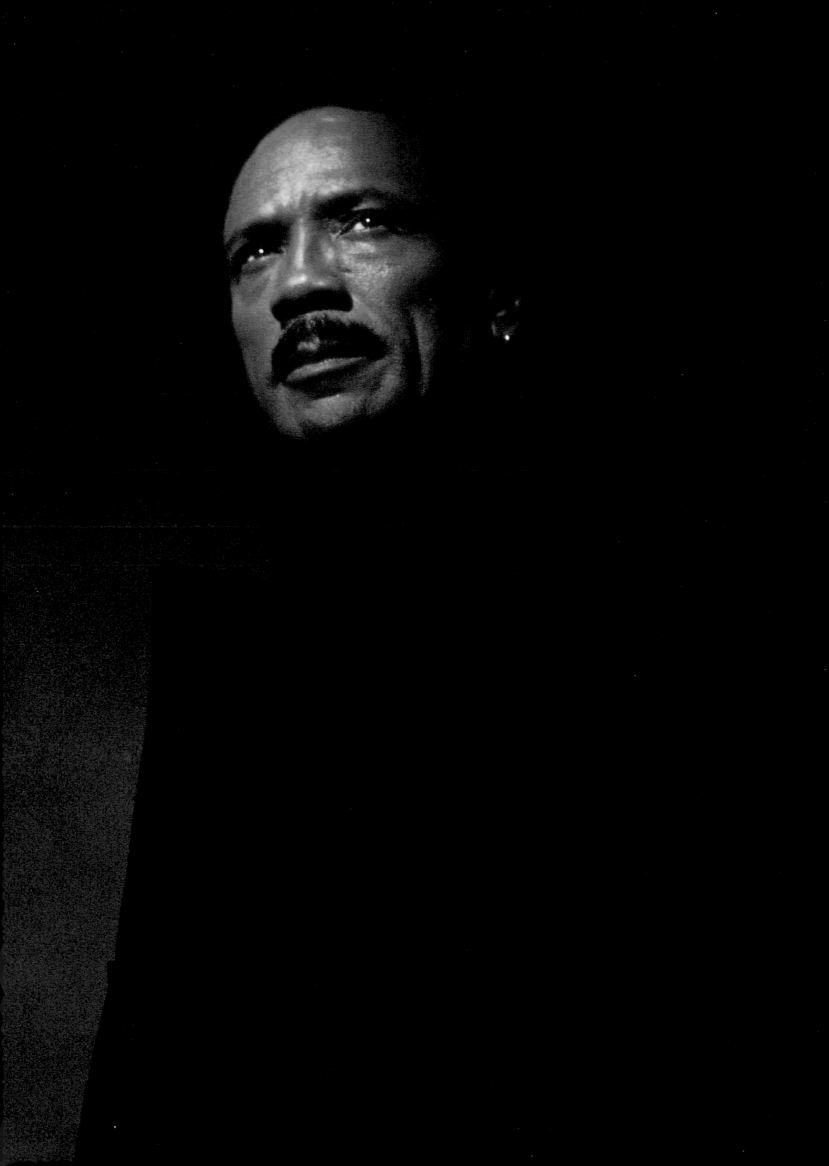

*O*pera, with all its musical complexity and drama, would seem a natural forum for the African American voice. But in the 1950s, Marian Anderson and Leontyne Price undertook long, lonely struggles to enter its ranks. Today, Jessye Norman is carrying the torch.

Norman started singing in Augusta, Georgia, at the age of two and was active in the children's choir at her local church. She did not take her first singing lesson, however, until the age of 15.

Norman and her four siblings were raised on high standards. "We were all expected to do well at everything," she has said. After earning a music degree from Howard University and doing graduate work at the Peabody Conservatory and the University of Michigan, she made the obligatory trip to Europe, and in 1969 she debuted at the Berlin Opera.

Norman made her heart-stopping initial appearance at New York's Metropolitan Opera in 1983 when she performed the role of Cassandra in Berlioz's *Les Troyens*. With her regal bearing, Norman leans toward dramatic rather than comedic roles.

Like Price and Anderson and her contemporaries, Leona Mitchell and Kathleen Battle, Norman is still contending with the isolation that comes with a stardom in an arena that requires intense concentration and constant travel. As an African American woman, Norman struggles to maintain balance. "I need to be involved in my community," she says. "I'm not interested in being sealed away from other people in a world where I exist only as a singer."

Photograph of operatic diva Jessye Norman by Bettina Rheims/Sygma

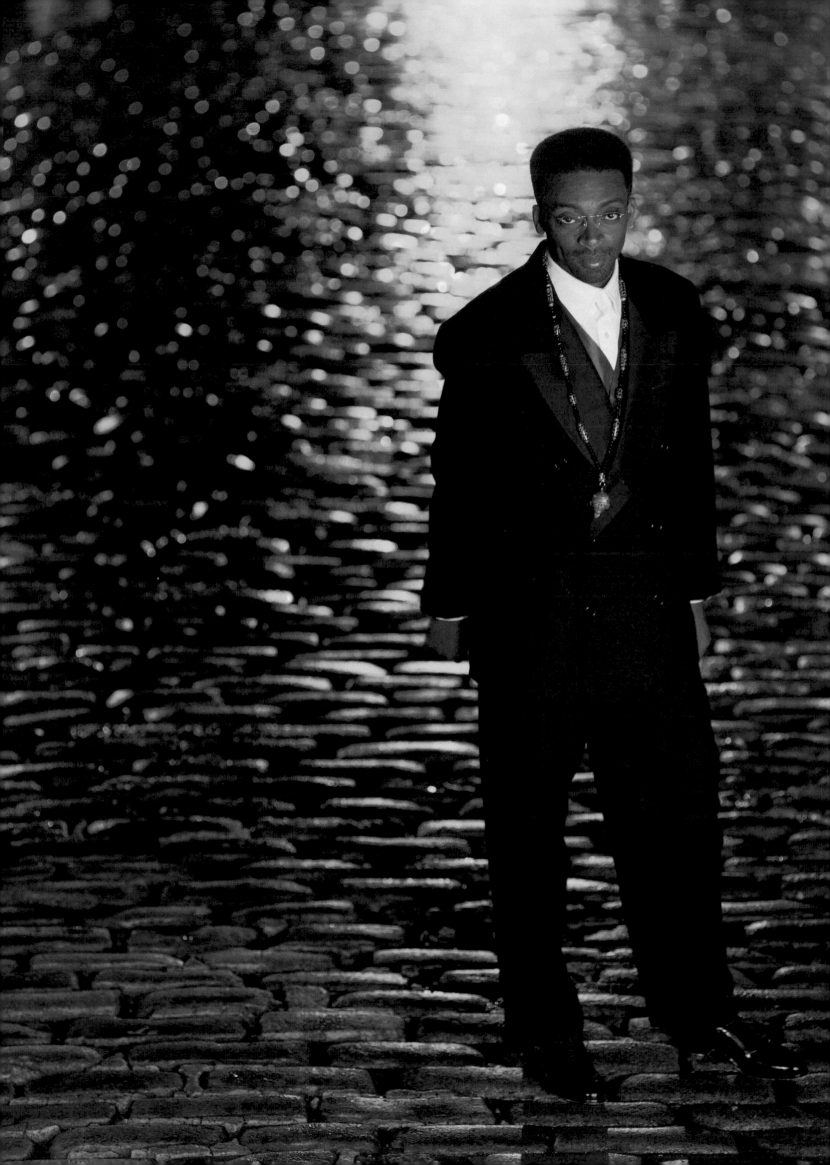

*S*pike Lee's battle cry for African American film-makers comes from Malcolm X: "Make Black films by any means necessary." These four certainly have. Not since the heyday of Oscar Micheaux in the 1920s and '30s and Hollywood's flirtation with "Black exploitation" movies of the 1970s, have so many African Americans taken their places behind the camera.

Lee, a Brooklyn native, was educated at Morehouse College and attended New York University's film school. He began his Hollywood career on a shoe-string with *She's Gotta Have It* and *School Daze.* These led to bigger-budget urban dramas such as *Do the Right Thing* and *Jungle Fever.* But perhaps Lee's greatest achievement has been to bring life to a project that had languished in Hollywood more than 20 years: a stirring film biography of Malcolm X.

Bill Duke developed his directing skills on the other side of the camera, as an actor. A veteran of movies such as *Car Wash* and *American Gigolo,* he turned to directing and won a fellowship to the American Film Institute. That led to an opportunity to direct a PBS drama, *The Killing Floor.* He also directed *A Rage in Harlem* for the big screen.

By the time he was 23, University of Southern California film-school graduate John Singleton had written and directed *Boyz 'N the Hood,* an uncompromising exploration of the life—and death—of young African American males in South Central Los Angeles. His follow-up project, *Poetic Justice,* starred Janet Jackson.

Julie Dash makes films from a woman's point of view. Dash went back in time to 1902 and the Sea Islands of South Carolina for the setting of the thoughtful, artistic drama *Daughters of the Dust.*

A new generation of filmmakers—Spike Lee (left), Bill Duke (top), John Singleton (middle) and Julie Dash (bottom)—is showing Hollywood the many sides of African American life. Photographs by Anthony Barboza, Gary Moss/Outline, Michael Grecco/Outline, and Patrick Sutton/Allford Trotman Associates.

Ruby Dee and Ossie Davis were pioneers in the post–World War II African American theater movement.
Photograph by Anthony Barboza

*R*uby Dee and Ossie Davis forged their stage careers with a devotion
to African American traditions. Davis was imbued with this sense of her-
itage at Howard University while studying under Alain Locke, a force
behind the Harlem Renaissance. He moved to New York to pursue a
career on the stage but was interrupted by a hitch in the Army, where
he wrote and produced shows for service personnel.

When he returned, Davis rejoined the Rose McClendon Players,
where he met and costarred with Ruby Dee. Dee, a Hunter College
graduate, had joined the company after a stint with the American Negro
Theatre, which numbered Harry Belafonte and Sidney Poitier among its
members. Individually they've done incredible work: Dee in *A Raisin in
the Sun* and Davis in *A Man Called Adam* and *Teacher, Teacher.* Among
their wonderful collaborations are *Purlie Victorious* (which Davis also
wrote) and Spike Lee's *Do the Right Thing* and *Jungle Fever.*

The husband-and-wife team have also devoted themselves to the
African American struggle with their involvement with the NAACP.
Davis has served as the master of ceremonies at the March on
Washington and delivered a stunning eulogy for Malcolm X. Dee has
established a scholarship in her name for Black women in the arts.

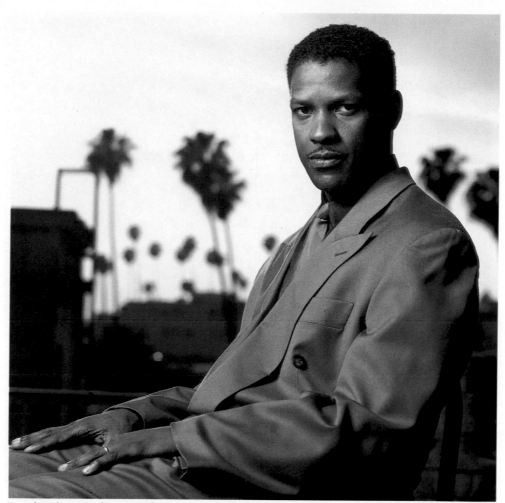

Denzel Washington is becoming a leading actor of his generation. Photograph by Jeffrey Henson Scales

*W*hen he won the Academy Award for best supporting actor in 1989 for *Glory,* Denzel Washington joined a handful of African American actors—Sidney Poitier, Hattie McDaniel, Whoopi Goldberg and Louis Gossett, Jr.—who had already been honored with an Oscar.

Washington discovered acting at Fordham University and later studied at the American Conservatory Theater in San Francisco. From there it was back to his hometown to join the New York Shakespeare Company and the Negro Ensemble Company.

Washington drew national attention on the television series "St. Elsewhere" and in movies such as *Cry Freedom* and *A Soldier's Story.* After playing Malcolm X in the stage production *When the Chickens Came Home to Roost,* Washington was told repeatedly that he was destined to play the Black Muslim leader on the big screen. Ten years later he did, in Spike Lee's biographical film. "It took that much time for me to get ready," he says. "I was growing as an actor."

Whoopi Goldberg goes undercover. Photograph by Gwendolyn Cates/Sygma
Danny Glover at the Bomani Gallery in San Francisco, run by his wife, Asake Bomani. Photograph by Michael Allen Jones

Danny Glover and Whoopi Goldberg found film fame together in *The Color Purple* in 1985. Since then Glover has balanced his career between blockbusters like the *Lethal Weapon* movies and serious fare such as the HBO movie *Mandela*, the PBS production of *A Raisin in the Sun*, the 1993 film about the aftermath of the Soweto uprisings *Bopha!* and *To Sleep With Anger* (which he also executive produced).

In spite of his busy film schedule, the actor has found time over the last few years to tour college campuses with Felix Justice reading Langston Hughes' poetry in *An Evening with Martin and Langston*.

A former drug abuser and welfare mother who has also had to overcome dyslexia, Whoopi Goldberg (born Caryn Johnson) has parlayed her comedy skills into a highly successful film career that also won her an Academy Award for the 1990 movie *Ghost*. Goldberg has bounced from comedies such as *Sister Act* and *Soap Dish* to movies dealing with crucial issues, including the civil rights film *The Long Walk Home* and the anti-apartheid musical *Sarafina*. Although she is involved in a number of political causes, including the pro-choice movement, Goldberg is probably best known for her work with Robin Williams and Billy Crystal on the annual television special "Comic Relief," which benefits the homeless.

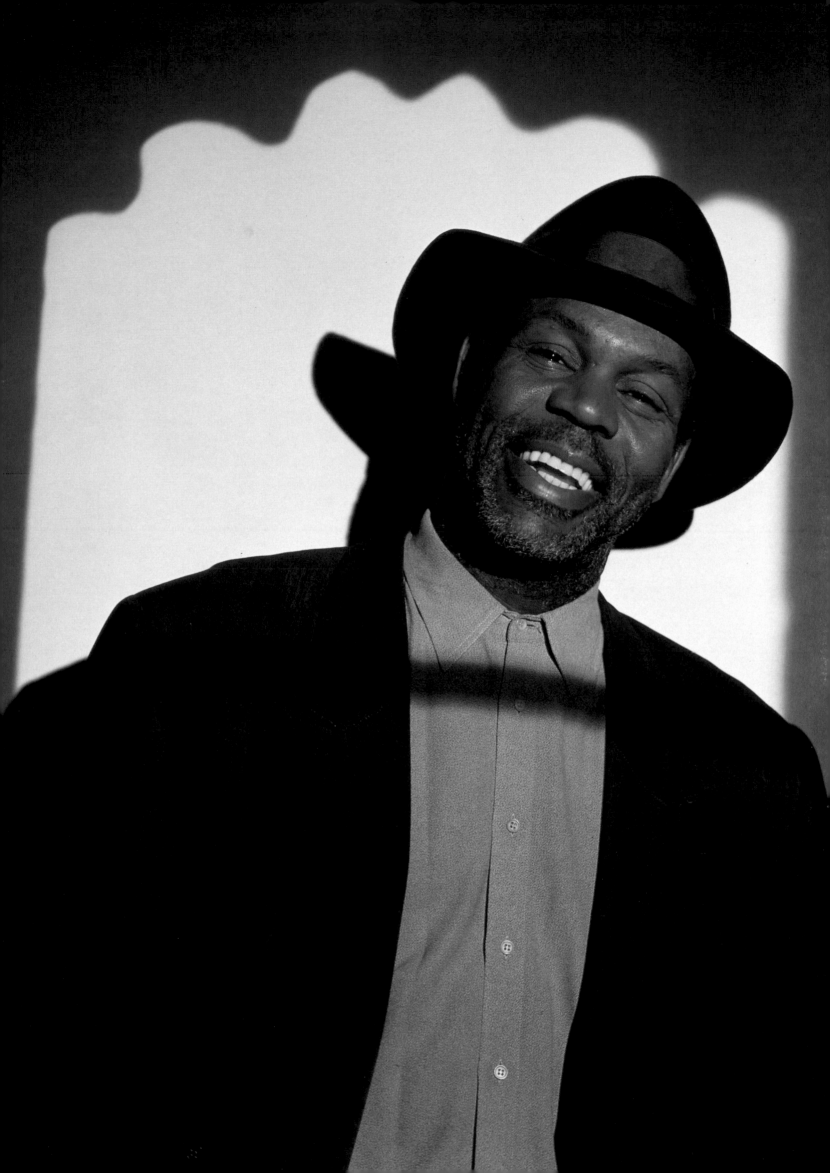

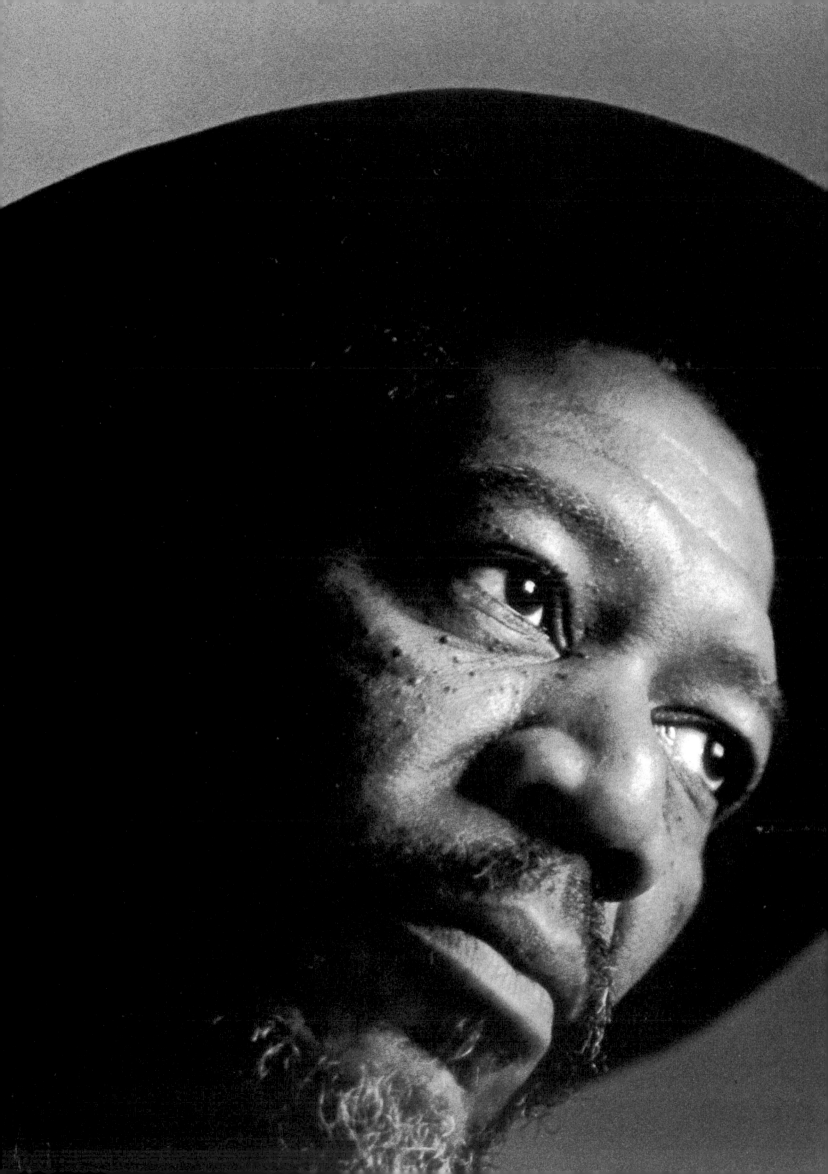

\mathcal{M}organ Freeman has proven that he can play just about whatever he chooses, from Shakespeare's *Coriolanus* to a menacing pimp in the movie *Street Smarts*. Freeman's career took a while to get started. The son of a Mississippi barber with a taste for liquor, Freeman was known for showing off. He spent time proving himself on the streets before deciding to become a fighter pilot in the Air Force—which instead gave him a job as a mechanic.

After his discharge, Freeman headed to Hollywood assuming that stardom would be waiting. Not quite. His first job in show business—as a dancer at the 1964 New York World's Fair—was a long time coming. He reluctantly found recognition as the character Easy Reader on the PBS children's show "The Electric Company." "It's like being known as Captain Kangaroo," Freeman complained. The job literally drove him to drink.

Since then, the actor has won some of the most coveted roles on stage and screen. He played Hoke, the chauffeur, in *Driving Miss Daisy,* was a slave in the film *Glory* and played hardheaded principal Joe Clark in *Lean on Me.* Freeman moved to the other side of the camera as director of *Bopha!,* a film about Soweto that starred Danny Glover.

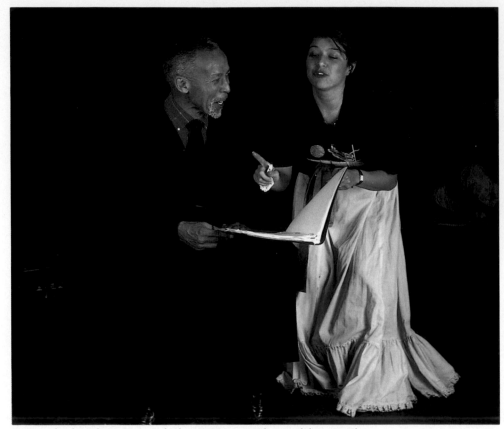

C. Bernard Jackson directs Teresa Velarde in B/C Historia. Photograph by Lester Sloan

*A*ugust Wilson has become one of the theatrical *griots* of the 20th century. The playwright won two Pulitzer Prizes for drama—for *Fences* in 1987 and *The Piano Lesson* in 1990. These two works are part of a series of five plays which also includes *Ma Rainey's Black Bottom, Joe Turner's Come and Gone* and *Two Trains Running*, all dealing with different eras of the African American experience in the 20th century.

Wilson's talent was nurtured at the Eugene O'Neill Theater Center in Connecticut by artistic director Lloyd Richards, who was also head of the Yale Drama School and the Yale Repertory Theater. Richards, who directed Lorraine Hansberry's *A Raisin in the Sun* in 1959, has handled all of Wilson's works on Broadway.

C. Bernard Jackson comes from the same theatrical heritage as Lloyd Richards. Born in the Bedford-Stuyvesant section of Brooklyn, the writer, director, composer, lyricist and musician settled in Los Angeles. There he cofounded the Inner City Cultural Center, a multicultural complex that has served as forum for writer George Wolfe, choreographer George Faison and actor Louis Gossett, Jr., among others.

August Wilson takes time out at the Crawford Bar & Grill in his hometown of Pittsburgh. Photograph by David Burnett/Contact

Director Lloyd Richards polished August Wilson's work at Yale. Photograph by Anthony Barboza

Terry McMillan, author of the best-selling novel *Waiting to Exhale,* teaches fiction writing and contemporary literature at the University of Arizona. When she was growing up, the Bible was virtually the only book read by her working-class family in Port Huron, Michigan.
Photograph of Terry McMillan by Ken Probst

In Jamaica Kincaid's case, it was isolation from her family that led her to find refuge in writing. A native of Antigua, the former Elaine Potter Richardson ran away to the United States and found herself with a literary crowd in New York. With the encouragement of the editor of *The New Yorker* magazine, she wrote a collection of short stories, *At the Bottom of the River.* Kincaid has dealt with her unreconciled anger toward her mother in her subsequent novels *Annie John* and *Lucy.*
Photograph of Jamaica Kincaid by Anthony Barboza

As a poor child in Georgia, Alice Walker was blinded in one eye by her brother's BB gun. It was then, she says, "I began really to see people and things." After leaving Spelman College for Sarah Lawrence, Walker penned her observations in *Once,* a book of poems. She then turned to fiction with *Meridian, The Color Purple*—which won the Pulitzer Prize and the American Book Award in 1983—and *Possessing the Secret of Joy*. *Photograph of Alice Walker by Anthony Barboza*

Toni Morrison's family steeped her childhood in the oral tradition of stories and folklore. Her ear for the mystical would abide with her at Howard and Cornell universities and as an editor at Random House before she turned to writing novels such as *Sula, The Bluest Eye, The Song of Solomon, Jazz* and the Pulitzer Prize-winning *Beloved*. *Photograph of Toni Morrison by Bernard Gotfryd/Woodfin Camp & Associates*

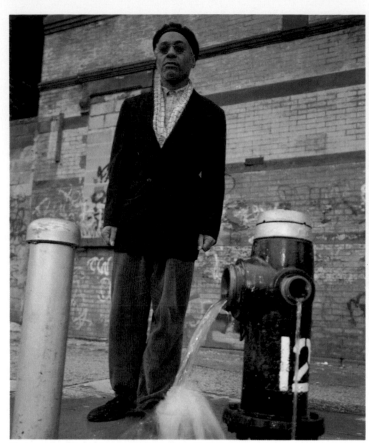

Photograph of David Hammons by Anthony Barboza

\mathcal{D}avid Hammons expands the boundaries and processes of art. Instead of paintings, for example, Hammons produces "body prints" by smearing his body with grease, pressing himself against a board then dusting the impression of himself with pigment.

Since the mid-1970s, Hammons' chosen media have been African American hair (which he glues to round rocks), urinals (which he attaches to trees outdoors), gnawed barbecue bones, Night Train wine bottles, dirt, grease and other refuse. He uses many of these found objects in mobiles, structures, sculptures, tapestry and outdoor installations in parks, urban streets and empty lots.

\mathcal{E}milio Cruz's expressive canvases hang in the collections of the New York Museum of Modern Art and the Smithsonian Institution. Cruz is also a published poet and writer. He founded and directed a multimedia theater company and has written and adapted many theater works incorporating painting, film, poetry, movement and music.

Photograph of Emilio Cruz by Anthony Barboza

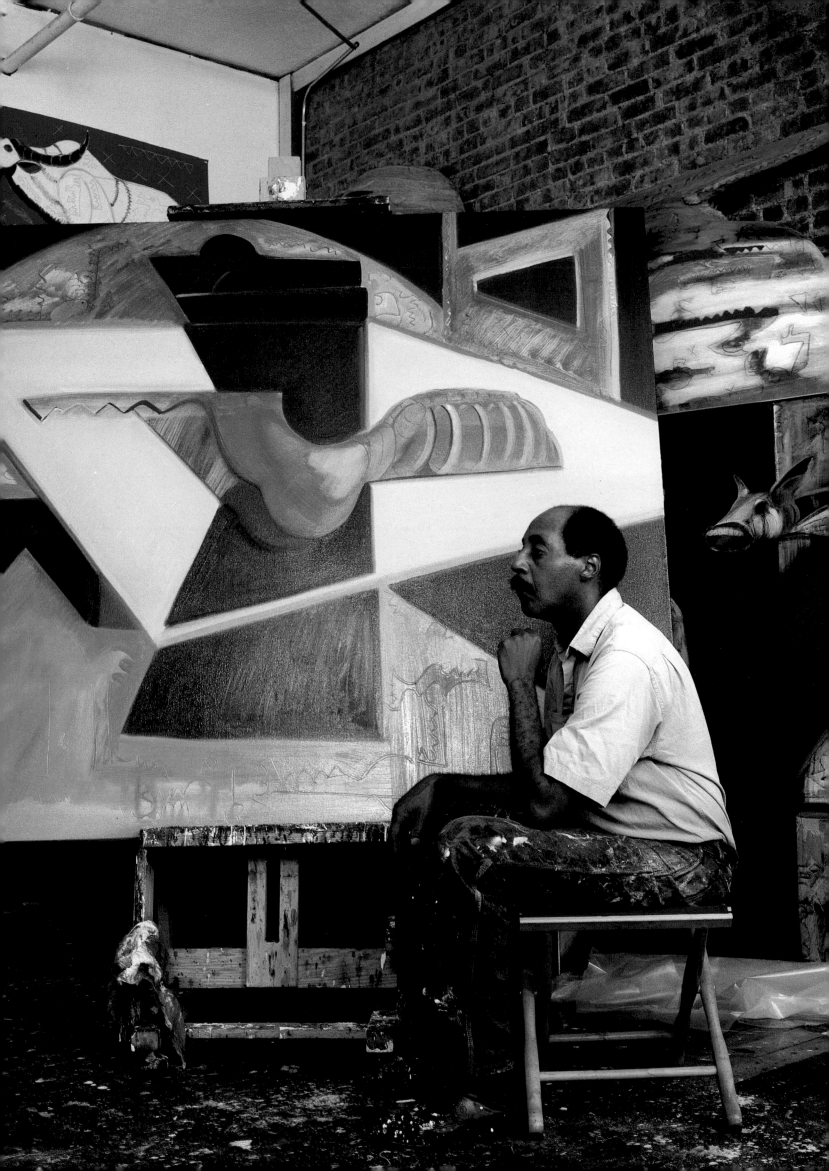

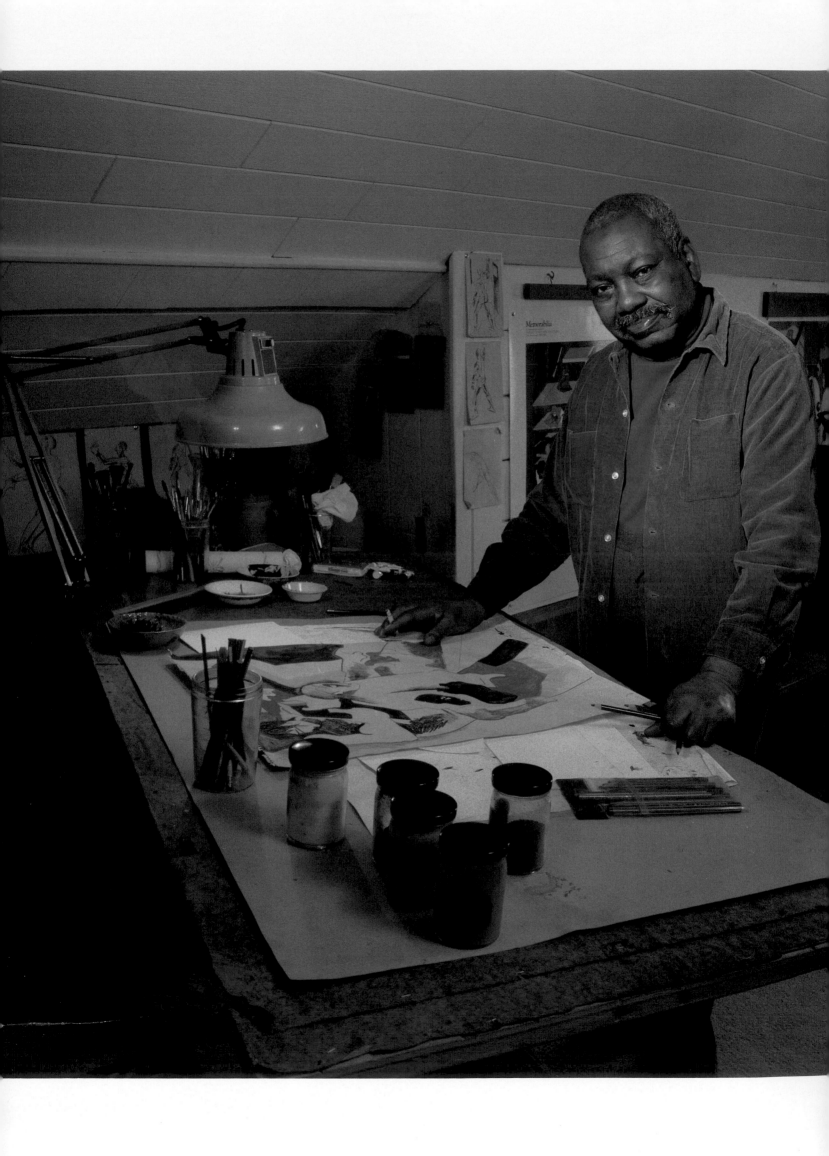

Photograph of Sam Gilliam by Anthony Barboza

In 1941, 24-year-old Jacob Lawrence was the first Black painter to be represented by a New York gallery. He won instant acclaim as one of the foremost artists of his time. Raised in Harlem in the 1930s, Lawrence draws his inspiration from African American history and daily life as well as the cultural currents of the Harlem Renaissance. Many of his major works have celebrated historical figures such as Frederick Douglass and Harriet Tubman.

Sam Gilliam's color-spattered and draped canvases carry forward the experimental work of abstract expressionists of the 1950s, such as Romare Bearden, Norman Lewis and Hale Woodruff.

Born in Louisville, Kentucky, in 1933, Gilliam moved to Washington, D.C., in the late 1950s. There he was influenced by the Washington Color School, whose teachers included Willem de Kooning, Clement Greenberg and Tom Downing. In 1969, Gilliam first earned recognition as a leading colorist painter with a major exhibition at the Corcoran Gallery of Art.

Photograph of Jacob Lawrence by Ed Lowe

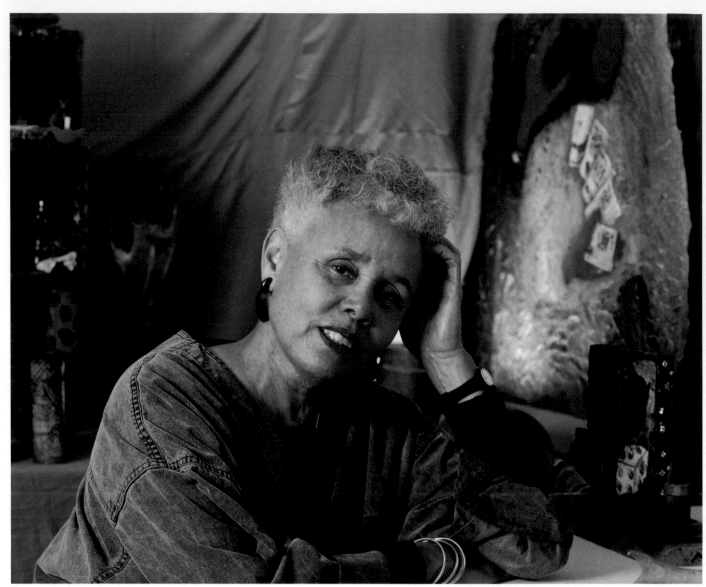

Photograph of Betye Saar by Anthony Barboza

*B*etye Saar manipulates found objects, photographs, commercial images, clothing and memorabilia into moving assemblages that express powerful spirituality, ritualism and cultural diversity.

Born in Pasadena, California, in 1926, Saar studied art at University of California at Los Angeles, California State University at Long Beach, and University of Southern California—all at a time when African Americans were not encouraged to enter university fine arts programs.

Saar believes she was psychic and clairvoyant as a child, and her work contains strong elements of mystery, dreams and the occult. She transforms symbolic found objects into allegorical boxes, shrines, altars, hanging fetishes and walk-through installations that celebrate humble objects of the African American experience.

Photograph of Alison Saar by Anthony Barboza

*B*etye's daughter, Alison Saar, has also been inspired by the ritual and spirituality of Haiti, Africa and Latin America. She combines carved and painted wood, metal, everyday objects and urban imagery into rough-hewn, poetic sculptures and large-scale installations. While Betye Saar makes her home in Los Angeles, Alison works primarily in New York.

Roy de Carava's photographs are lyrical compositions of light and shadow.
Photograph by Beuford Smith/Césaire

*R*oy de Carava was an active participant in the 1960s' Black arts movement. De Carava was known for the shading and tone of his printing as well as his haunting style of shooting pictures. He was the first African American to receive a Guggenheim grant.

Writer, photographer, filmmaker and composer—Gordon Parks, Sr., can justifiably be called a Renaissance man. Born in Kansas, the youngest of 15 children, Parks was a railroad waiter when a photography magazine inspired him to become a photographer. He bought his first camera for $12.50.

Parks was a staff photographer for *Life* magazine from 1948 to 1968. He also wrote two novels about his childhood: *A Choice of Weapons* and *The Learning Tree,* which he also made into a movie. He also composed the music for *The Learning Tree* and went on to direct several films, including the hit *Shaft.*

*P*arks could have easily been inspired by the career of the man who best captured the Harlem Renaissance on film, James Van Der Zee. Van Der Zee, who also played piano and violin, recorded the everyday experiences of Harlem's famous and not-so-famous for four decades. His work has appeared in major exhibitions such as *Harlem on My Mind.*

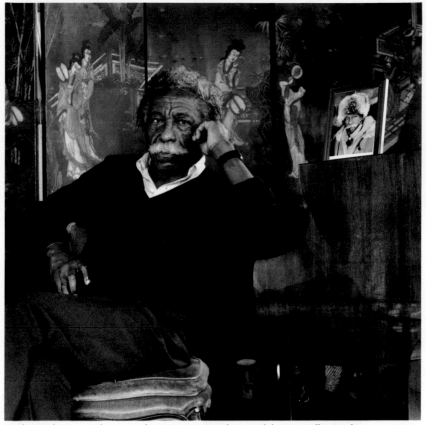

Gordon Parks, Sr., excels at several artistic pursuits. Photograph by Mary Ellen Mark

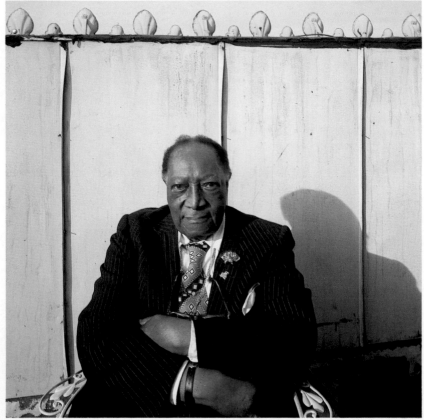

James Van Der Zee had his eye on the Harlem Renaissance. Photograph by Anthony Barboza

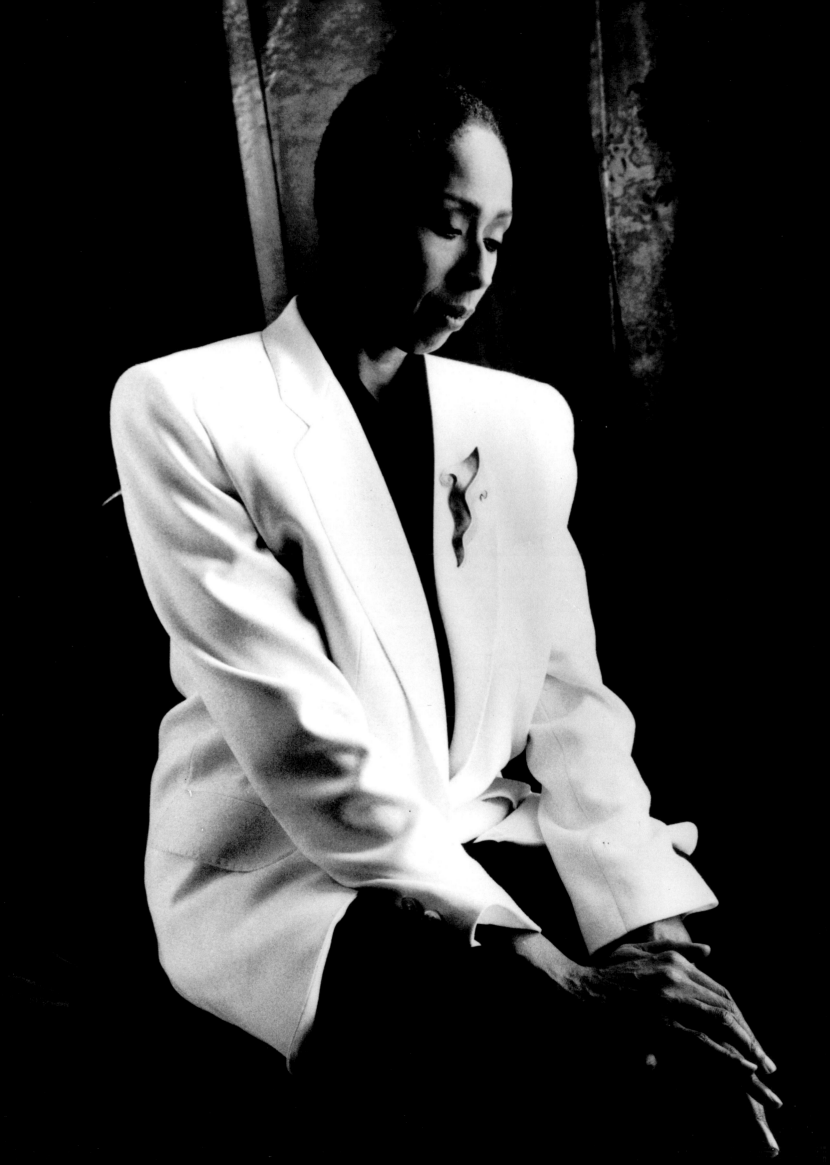

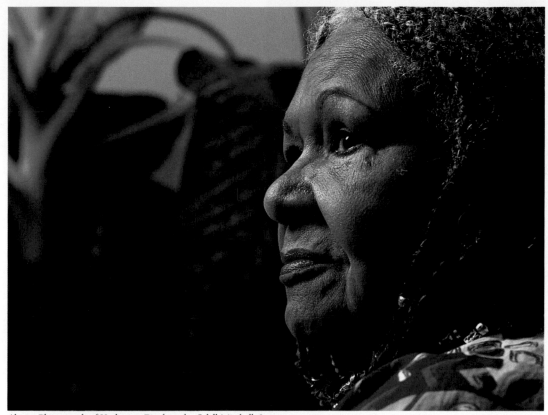

Above: Photograph of Katherine Dunham by Odell Mitchell, Jr.
Left: Photograph of Judith Jamison by Alen MacWeeney

*K*atherine Dunham and Judith Jamison are two iconoclasts of dance. Philadelphia native Judith Jamison started dancing at the age of six. After graduating from Fisk University, she trained with the Philadelphia Dance Academy and the Harkness School. Jamison's meeting with Alvin Ailey at an audition in 1965 was propitious for both. She became inextricably linked with many of his most important works, especially *Cry*. After leaving Ailey in 1980, Jamison starred on Broadway in *Sophisticated Ladies* and formed her own dance company, the Jamison Project. She became artistic director of Ailey's company after his death in 1989.

*A*t the University of Chicago, Katherine Dunham was a founder of the Ballet Négre, which specialized in African dance. Her anthropology studies also led her to examine dance in Jamaica, Martinique, Trinidad and Haiti. Upon her return, she integrated these styles into her work, creating a technique that has inspired generations of choreographers. After founding her own company in 1940, she created works for the stage (*Tropics* and *Le Jazz Hot*) and films (*Stormy Weather*).

Now located in East St. Louis, Illinois, Dunham founded the Katherine Dunham Center. An advocate for Haiti, she conducted a 47-day hunger strike to protest U.S. policy towards that country's refugees in 1992.

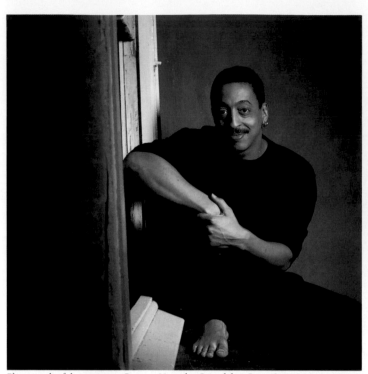

Photograph of dancer-actor Gregory Hines by Gwendolyn Cates/Sygma

*G*regory Hines has spent much of his life preserving the legacy of tap. Born in Harlem, Hines performed as a child with his brother Maurice and later with his father, a drummer. Hines went through a period of rebellion, left the family and moved to California. But by the late 1970s, tap was undergoing a revival on Broadway, and Hines returned to starring roles in the musicals *Eubie* and *Sophisticated Ladies.*

Hines has also managed to integrate tap into some of his movie roles, including *The Cotton Club* and *White Nights.* The film *Tap* is Hines's paean to dance. Sammy Davis, Jr., costarred along with Harold Nicholas, Bunny Briggs and the young tap prodigy Savion Glover. In 1992, Hines won a Tony award for *Jelly's Last Jam,* where he used tap dancing to bring to life the music of Jelly Roll Morton.

*C*hristina Johnson is a principal dancer with the Dance Theatre of Harlem. Born in Austria, Johnson studied in New York and Boston and joined the ensemble of the Boston School of Ballet. When the Dance Theatre of Harlem came to Boston, Christina asked if she could take a class. Founder Arthur Mitchell offered her an apprenticeship.

"The Dance Theatre of Harlem will always be a part of me," she says. "I believe in it and what it stands for." Johnson tells her students that "dancing is hard work. Spiritually, emotionally and physically, it's all-encompassing."

Photograph of Dance Theatre of Harlem principal dancer Christina Johnson by Jerry Valente

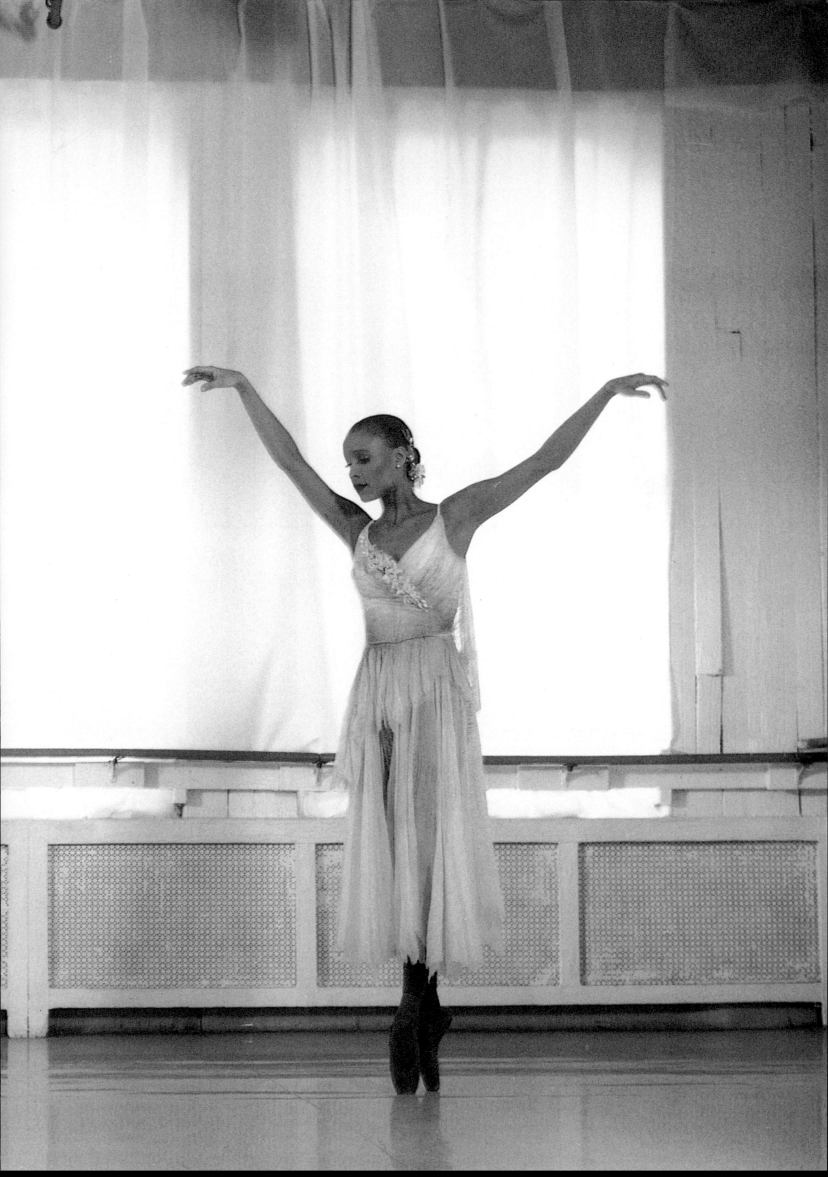

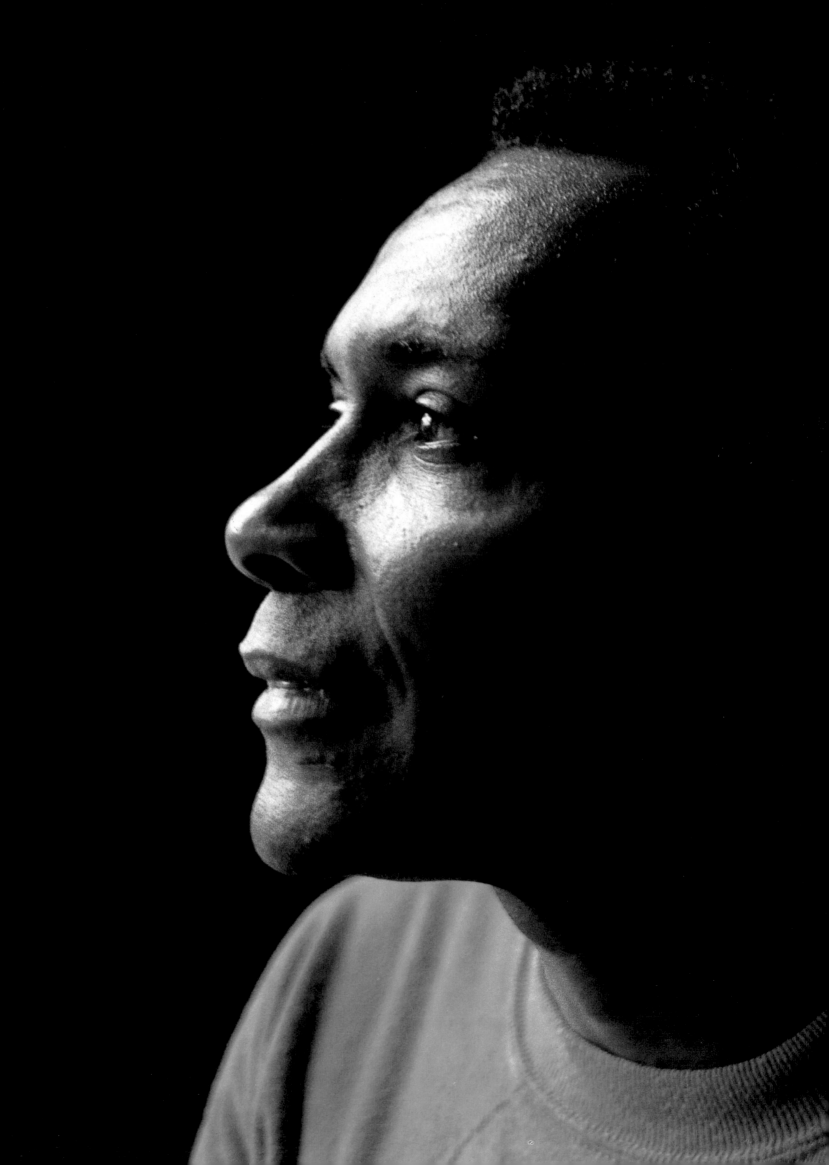

*W*hen Arthur Mitchell formed the Dance Theatre of Harlem in 1969, the prevailing wisdom was that Black people didn't dance ballet nor did they pay to see it. Mitchell knew better.

The son of a Harlem janitor, Mitchell spent time hanging out with a gang called the Hilltop Lovers until a guidance counselor who had seen him jitterbug pointed him toward the High School of Performing Arts. Mitchell won a scholarship to college, and after graduation, was offered another scholarship to the School of American Ballet. His first major role was on Broadway in *House of Flowers*.

The next year, Mitchell was invited to join the New York City Ballet under the exacting direction of George Balanchine. Although he went on to become a principal dancer of the company, Mitchell was acutely aware of the civil rights movement and he wanted to found a company for Black dancers. Mitchell got a Ford Foundation grant and founded Dance Theatre of Harlem initially as a summer program that started with 30 kids. After two months, the student body had grown to 400, and Mitchell had to move the school from a church basement into a converted garage.

Now, the Dance Theatre of Harlem has a school and a multicultural company that travels all over the globe. "My approach to solving social problems is through the arts," says the founder, president and artistic director of the company. "The arts give you a discipline and a structure."

Arthur Mitchell revolutionized ballet both as a performer and as founder of the Dance Theatre of Harlem. Photograph by Jose Azel/Contact

The misconception that African Americans could dance everything except the classics was shattered when Arthur Mitchell founded the Dance Theatre of Harlem in 1969. The company performs everything from Black-heritage works such as Geoffrey Holder's Dougla to John Taras's version of Stravinsky's Firebird. Photograph by Anthony Barboza

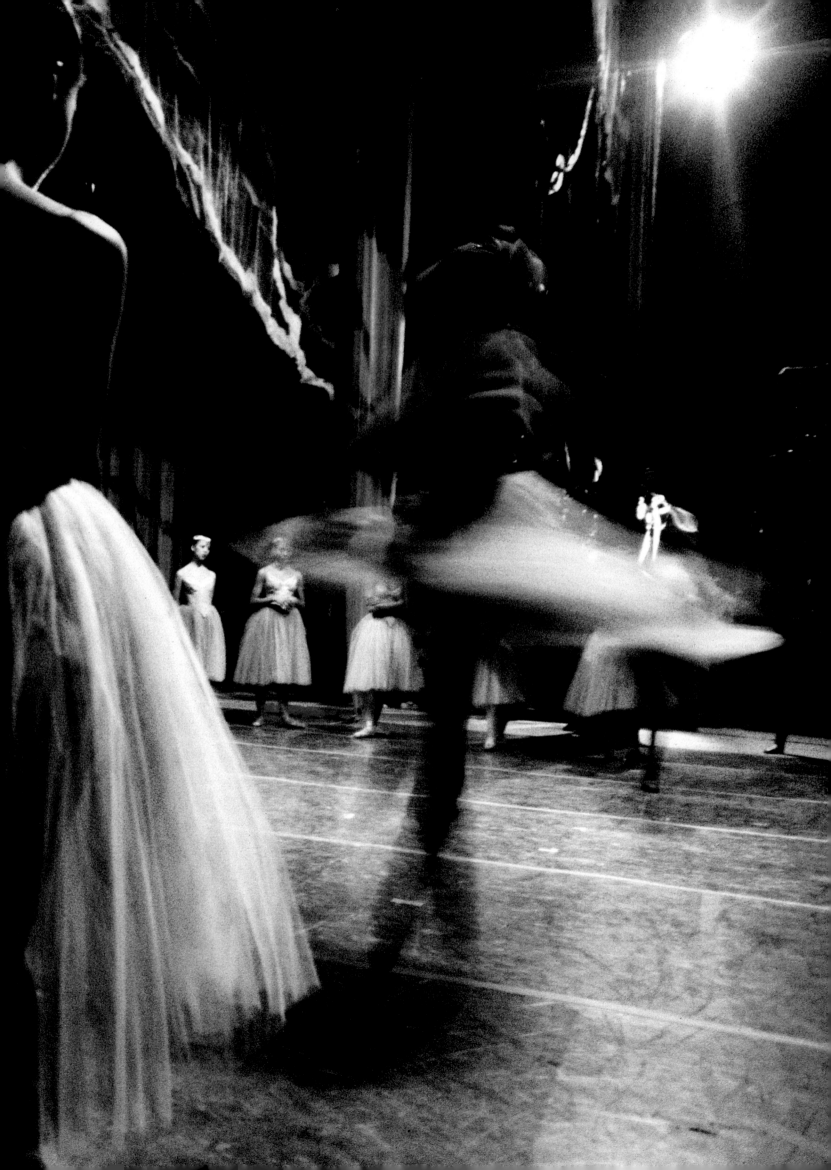

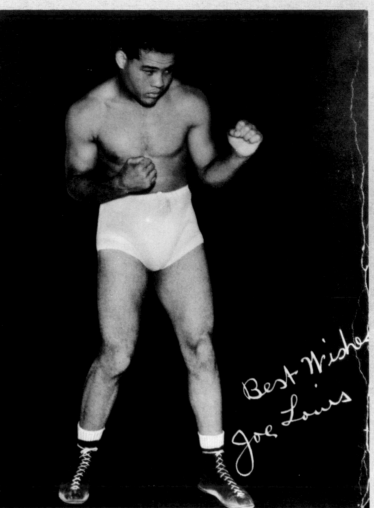

Best Wishes
Joe Louis

The Schomburg Center for Research in Black Culture, New York Public Library

The son of Alabama sharecroppers, Joe Louis won the heavyweight title in 1937 when he knocked out James J. Braddock. A mighty symbol of African American pride, the Brown Bomber was the champ for 12 years and defended his title more than 25 times before he retired in 1949. Whenever he won, Louis told reporters, "It was just another lucky night."

AMAZING GRACE

Black athletes are almost mythical characters in America. They have been glorified on one hand but had their successes discounted as the byproduct of breeding and natural gifts on the other—as if skill, concentration and assiduous practice were the sole domain of white athletes. Nevertheless, African American sports champions have always been a source of pride in their own community and beyond. Shoulders squared when Joe Louis stood triumphantly over German boxer Max Schmeling in 1938. There wasn't a dry eye in Black America when Jackie Robinson strode onto Ebbets Field for the Brooklyn Dodgers in 1947. And there were untold high-fives when quarterback Doug Williams passed his way to Super Bowl victory in 1988. It has always been this way.

Fighters were the first African Americans to be rewarded for their physical prowess. Plucked from the fields by planters, they were pitted against slaves from rival plantations. Like houseworkers who got better clothes and food than fieldworkers, those who slugged it out for the master earned tangible rewards. After emancipation, African Americans took up professional boxing, and by 1908, Jack Johnson became the first to hold the world heavyweight title.

Plantation owners also used their slaves to compete on the racetrack, which ushered in a period of dominance for African American jockeys. Fourteen of the fifteen jockeys in the first Kentucky Derby in 1875 were Black.

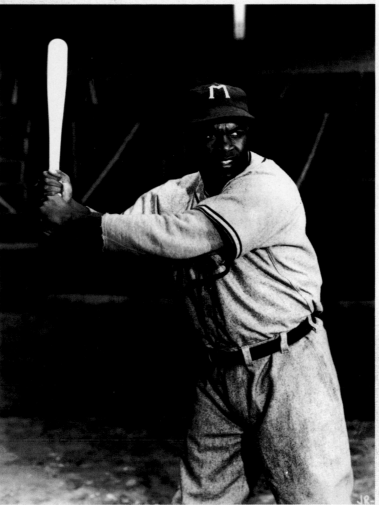

The name Jackie Robinson has become synonymous with the racial integration of professional baseball. But at UCLA, Robinson also played football, basketball and ran track. In fact, baseball was said to be his weakest sport. Robinson made baseball—and American—history when he joined the Brooklyn Dodgers in 1947. After hanging up his second-baseman's mitt, Robinson became a business executive, cochairman of Freedom National Bank in Harlem and an aide to Governor Nelson Rockefeller of New York.

The Schomburg Center for Research in Black Culture, New York Public Library

African American participation in baseball is nearly as old as the game itself. It was Andrew "Rube" Foster who initiated professional competition among Black teams when he founded the National Negro Baseball League in 1920. Nearly 30 years later, Larry Doby of the Cleveland Indians and Jackie Robinson of the Brooklyn Dodgers broke through the color barrier into the majors. And in 1974, Hank Aaron batted home run number 715, breaking Babe Ruth's lifetime record.

Jesse Owens was a sickly child, the youngest of 13 born to a sharecropper in Alabama. When his family moved to Ohio, Owens' health improved and he began his track career. Owens publicly disproved Adolf Hitler's theory of Aryan superiority—and Black inferiority— by winning four medals and setting three records at the 1936 Olympics in Berlin. This so infuriated the Fuehrer that he stormed from the stadium rather than see Owens on the victory stand.

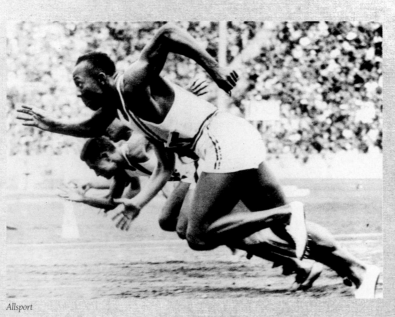

Allsport

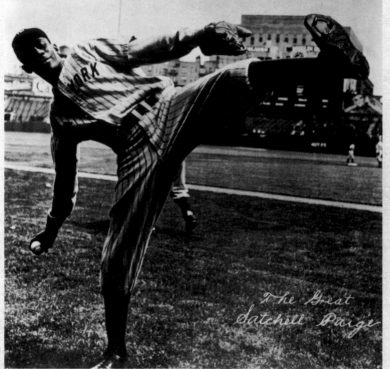

The superstar of the Negro Leagues, Leroy Robert "Satchel" Paige invented the "hesitation pitch," a throw so elusive that when he joined the American League, it was banned from play. He joined the Cleveland Indians in 1948 and was still pitching, for the Kansas City Athletics, at the age of 65.

The Schomburg Center for Research in Black Culture, New York Public Library

Today, African Americans hold a disproportionate number of track-and-field titles and records. But it was not until Jesse Owens came along in 1936 that Blacks could demonstrate their ability on the world stage. Owens' unprecedented four gold medals at the Berlin Olympics gave both Hitler and the white world of track and field new appreciation for Satchel Paige's famous quotation, "Don't look back, somebody may be gaining on you."

These days, when it seems there's a basketball court in every playground and schoolyard, it's impossible to imagine a time when there was no Black participation in the game. African Americans probably first stepped onto the court at Howard University in 1904 when basketball was incorporated into the physical education program there. Other colleges—Lincoln University, Hampton Institute, Wilberforce and Virginia Union University—soon followed with their own programs. Private clubs sprang up, and with them, rivalries and competitions.

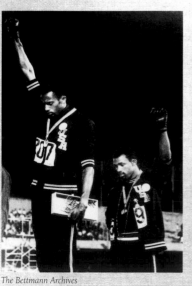

Sprinters Tommie Smith, (left), and John Carlos brought America's civil rights protests to the 1968 Mexico City Olympics when they lifted their gloved fists in a Black-power salute as the American flag was raised. Although they placed first and third in the 200-meter dash, they were expelled from the Olympic village.

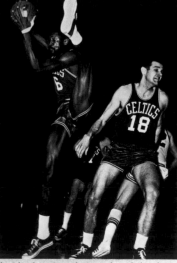

A former Olympian, Bill Russell was the National Basketball Association's Most Valuable Player five times during his first nine seasons with the Boston Celtics. In 1966, Russell was the first Black to be named head coach of an NBA team, the Celtics. He also served as coach and general manager of the Seattle Supersonics from 1973–77, worked as a sportscaster on NBA games and wrote Second Wind: Memoirs of an Opinionated Man in 1979.

The Bettmann Archives

The Schomburg Center for Research in Black Culture, New York Public Library

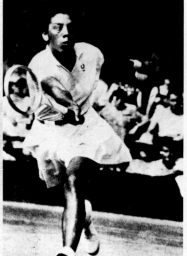

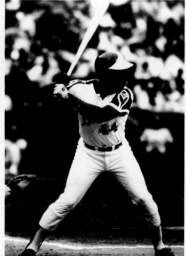

A chronic truant in high school, Althea Gibson wound up in a home run by the Society for the Prevention of Cruelty to Children. But when a friend bought her a secondhand tennis racket, she made history. The first Black—male or female—to compete and win at Forest Hills and Wimbledon, Gibson followed up with a distinguished career in golf.

The Schomburg Center for Research in Black Culture, New York Public Library

Focus on Sports

Like Jackie Robinson, Hank Aaron got his start in the Negro Leagues. And it was Robinson that Aaron honored when he hit his 715th home run in 1974, breaking Babe Ruth's record. Aaron retired from play two years later and he moved into the Braves' front office as a vice president and director of player development. Aaron is also on the Board of Directors of Turner Broadcasting, the NAACP and Big Brothers/Big Sisters of America.

In 1927, promoter Abe Saperstein turned Chicago's Savoy Big Five into the Harlem Globetrotters. Although they were remarkable athletes, the Globetrotters were more vaudeville than serious sports. They were, however, the only venue for professional Black basketball players until Chuck Cooper signed with the Boston Celtics in 1951. The Celtics were also the first National Basketball Association team to sign a Black coach, former star Bill Russell in 1966.

The great actor and bass-baritone Paul Robeson was an early Black gridiron star. A scholarship student at Rutgers University, Robeson became a football all-American (and earned letters in basketball, baseball and track). Marion Motley was the first African American to join a professional football team, playing fullback for the Cleveland Browns from 1946 to 1953. The Browns were also home to the legendary Jim Brown, who along with Walter Peyton, O. J. Simpson and Gale Sayers have redefined the role of the running back.

With wide acclaim comes wide responsibility. Black athletes such as Joe Louis, Willie Mays and Sugar Ray Robinson took their responsibility to the community seriously. This tradition is carried on today by superstars like Michael Jordan, Magic Johnson, Eagles quarterback Randall Cunningham and pitcher Dave Stewart, who give their time and money to worthy charitable and educational organizations.

When African Americans broke into professional sports, they found they were toiling in the fields of new masters. As sports sociologist Harry Edwards said in a 1989 interview with *Time* magazine, "Things have changed for the better, but the struggle is not linear. It's dynamic and ever-changing. Jesse Owens and Joe Louis struggled for the legitimacy of Black athletic talent. Later, Jackie Robinson, Bill Russell and others struggled for access. In the late '60s, athletes like Muhammad Ali, Tommie Smith, John Carlos, Arthur Ashe and Kareem [Abdul-Jabbar] fought for recognition of the dignity of the Black athlete. Now we're in the struggle for power, and that's the most difficult of all."

The challenge of the 1990s is to expand the African American presence in the front office, bargaining sessions and owners' suites where the business of sports is conducted. Only then will the journey from the old plantation boxing rings to true self-determination be completed.

\mathcal{H}is transformation from Cassius Clay, who first won the heavy-weight championship in 1964, to Muhammad Ali, the most well-recognized personality in the world, was a cultural watershed. Muhammad Ali not only changed the nature of boxing, but forced this nation to redefine its concept of African American manhood.

Clay shocked the nation when, the day after winning the heavyweight belt from Sonny Liston, he announced that he had joined the Nation of Islam and changed his name. His mentors, Ali said, were Black Muslim leaders Elijah Muhammad and Malcolm X. This announcement troubled Americans of all races. But it was Ali's refusal to be inducted into the armed services during the Vietnam War in 1967 that made the country take the man and his faith seriously.

Although he was convicted of draft evasion and lost his boxing license, his title and his passport, Ali made an unprecedented come-back. Three years after the Supreme Court reversed his conviction in 1971, he regained the belt by beating George Foreman.

Ali retired from boxing in 1981 and now suffers from Parkinson's syndrome. But he is still proving to be the greatest. "Now my life is really starting," says the champ. "Fighting injustice, fighting racism, fighting crime, fighting illiteracy, fighting poverty."

Photograph of Muhammad Ali, "The Greatest," by Neil Leifer

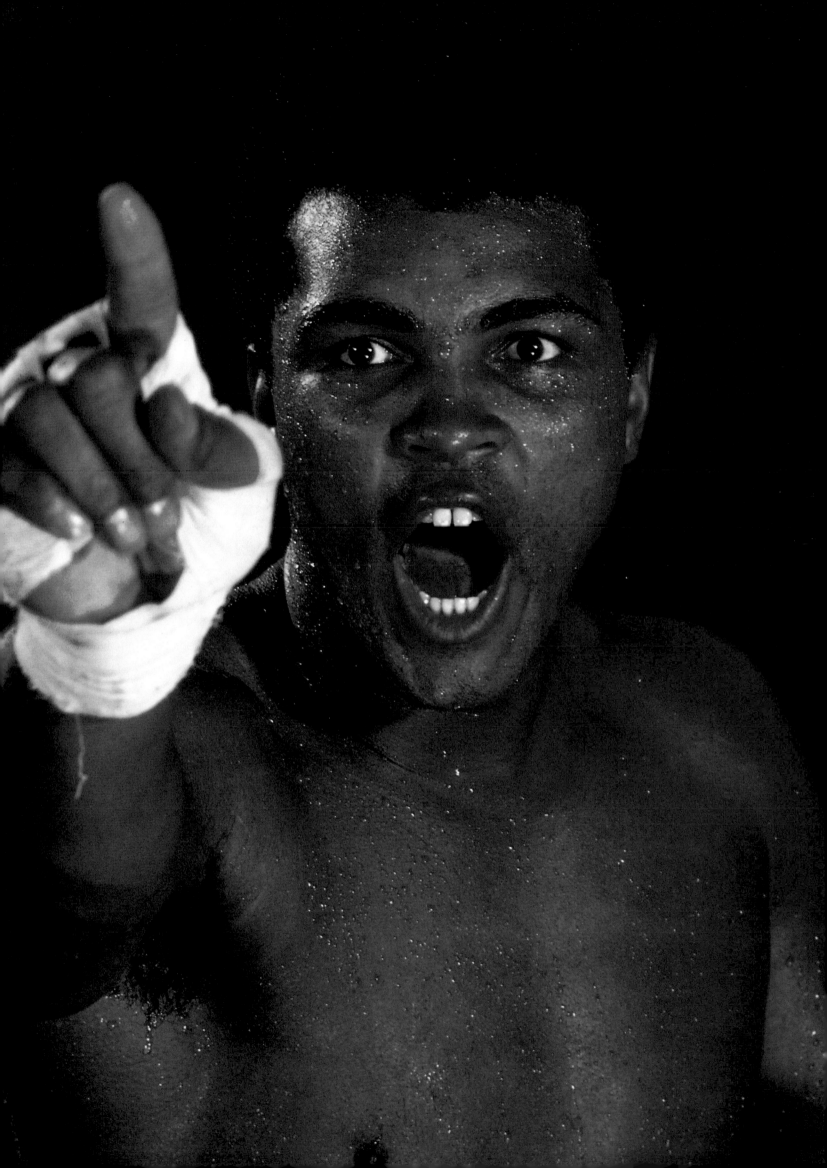

Arthur Ashe at home with daughter Camera and wife Jeanne Moutoussamy-Ashe. Self-portrait by Jeanne Moutoussamy-Ashe

*A*rthur Ashe gave the word "champion" new meaning. Raised by his father after his mother died when he was six, Ashe grew up in segregated Richmond, Virginia. He played his first game of tennis on the "colored-only" court.

With the help of his patron, Dr. Walter Johnson, Ashe became a junior national champion. He earned a scholarship to UCLA, and after graduation, he racked up a string of victories that put him in the record books: first African American man to win the United States Open, first African American man to win Wimbledon, first Black athlete to compete in South Africa.

Ashe fought effectively against apartheid and discrimination toward Haitians. He fought back from a heart attack, and after he contracted AIDS from a tainted blood transfusion, he established a foundation to fight that disease.

Yet he was a gentle soul. There is a telling story about Arthur Ashe. He always lunged for every ball, even those clearly out of bounds. When a friend asked him why, he said, "When I played against white players in the early days, the linesmen didn't always call them out. I learned that there was no use complaining, but I also learned that I could win anyway."

The last portrait of Arthur Ashe, taken at the Sleepy Hollow Country Club library by Jeanne Moutoussamy-Ashe

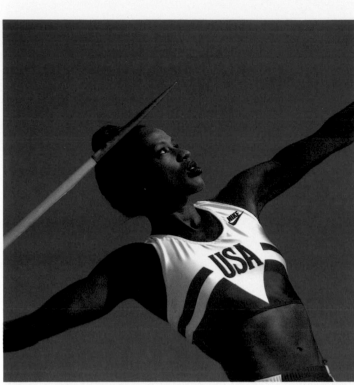

Photograph of Olympic gold-medalist Jackie Joyner-Kersee from Focus on Sports

*J*ackie Joyner-Kersee hasn't forgotten the old neighborhood. She grew up in East St. Louis, Illinois, amid poverty, violence and drug addiction. Even though she suffers from asthma and came in dead last in her first track event, she knew athletics would be her road to success. Joyner graduated in the top 10 percent of her high-school class and won a basketball scholarship to UCLA. While she was still in college, she was spotted by her future husband, Bob Kersee, who encouraged her to try the most grueling event in women's sports, the heptathlon. She won back-to-back gold medals in the event in the 1988 and the 1992 Olympics. Considered the world's greatest female athlete, Joyner-Kersee also became a champion for the kids in her hometown when she created a community foundation that raises funds to maintain recreation centers for disadvantaged youth.

*E*verybody has an obligation to give something back—I don't care who you are," says Kevin Johnson, the Phoenix Suns point guard and NBA All-Star. In 1989, Johnson returned to his hometown of Sacramento, California, and founded the St. Hope Academy to build the self-esteem of local youth. Johnson is also on the Board of Directors of the Phoenix Suns Charities and the School House Foundation, and he sponsors KJ's Readers, a reading program for local schools.

Photograph of NBA All-Star Kevin Johnson by George Olson/Woodfin Camp & Associates

\mathcal{I}t was the 1984 Los Angeles Olympics. Frederick Carlton Lewis won four gold medals and was hailed as the greatest track star since Jesse Owens. In a way, it seemed like destiny. After all, track and field is the Lewis family business.

Carl Lewis is the son of a former Tuskegee Institute football star who also ran track. Carl's mother was a hurdler who represented the United States at the Pan-American games in 1951. Together, Lewis's parents founded the Willingboro Track Club in New Jersey.

At the University of Houston, Lewis met his mentor, Tom Tellez, who revolutionized his long-jump style. Lewis qualified for the 1980 Olympic team, but was disappointed when the U.S. boycotted the Moscow games. He honed his skills to a razor's edge for the 1984 games in Los Angeles, setting two world's records and winning gold medals for the 100- and 200-meter dashes, the long jump and the 400-meter relay. Lewis won two more gold medals at the 1988 games in Seoul and struck gold again in the 1992 Barcelona games, making his one of the longest, most successful careers in track-and-field history.

With eight gold medals to his credit, Carl Lewis was once considered the fastest man on the planet. Photograph by Gregory Heisler

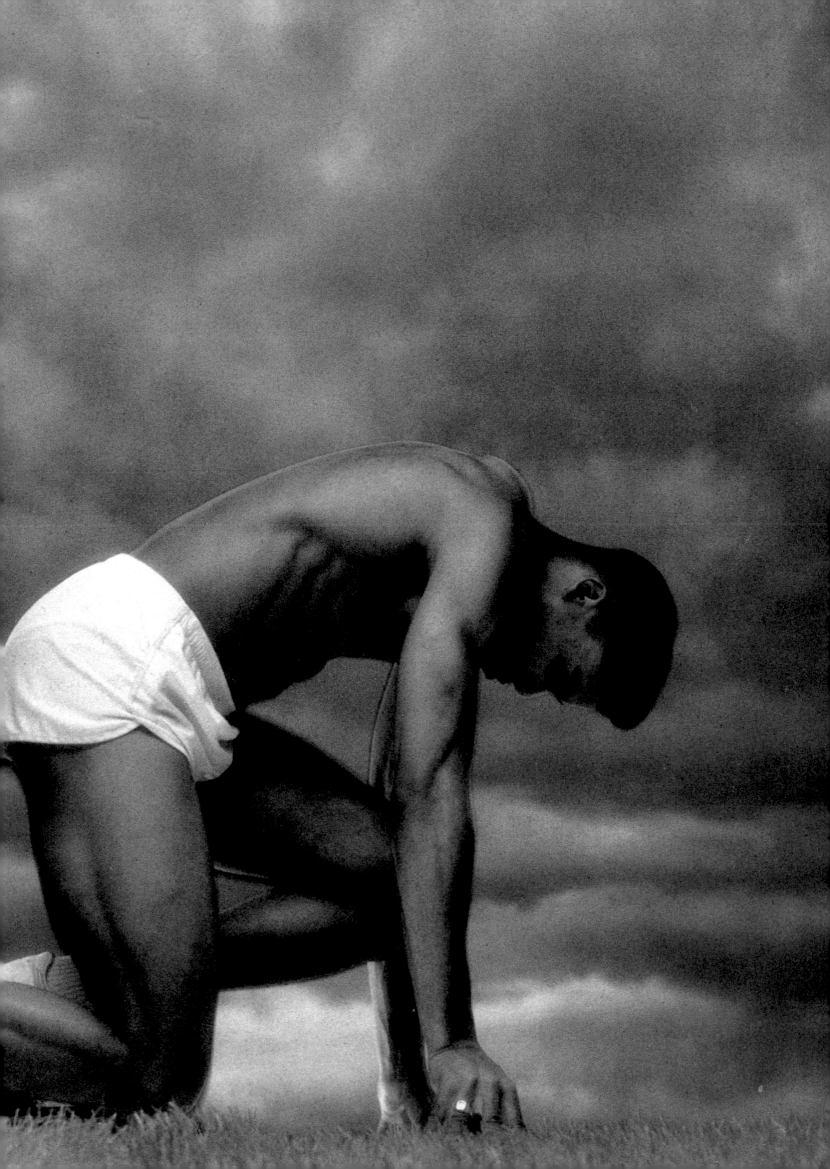

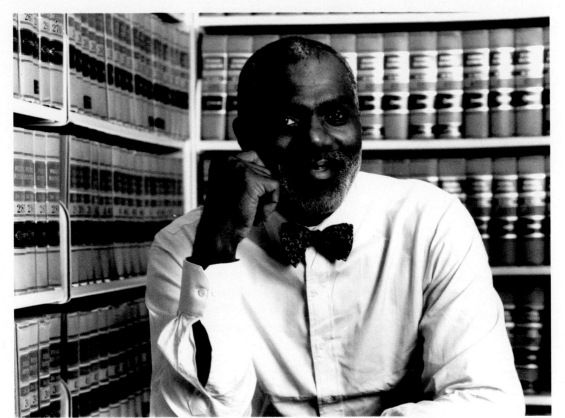

Above: Photograph of football Hall of Famer-turned-Minnesota Supreme Court Justice Alan Page by James Schnepf
Left: Photograph of track champion-turned-businessman Edwin Moses by Alon Reininger/Contact Press Images

The career of a professional athlete is usually short, and too few prepare for the life after the cleats have been hung up. Not so for Alan Page and Edwin Moses.

Page was a ten-time all-pro defensive tackle for the Minnesota Vikings who made it to the Hall of Fame. But he knew that was not enough. The Notre Dame graduate studied law at the University of Minnesota and practiced in the off-season before retiring from the game in 1981. In 1992, after serving in the state's attorney general's office, Page was elected overwhelmingly as the first African American to serve on the Minnesota Supreme Court.

Edwin Moses also shored up his athletic achievement with a sound education. A former physics and engineering major at Morehouse College, Moses is considered one of the best 400-meter hurdlers of all time. He won two Olympic gold medals and a bronze. After retiring from competition, Moses studied for an M.B.A. and became a partner in the Platinum Group, which manages track-and-field athletes. He credits his success off the field to his parents, who were both educators, and to his alma mater. "Going to Morehouse had an impact," he says. "I wish more of these young Black guys would go to Black colleges."

\mathcal{A}lthough he was a basketball star at San Jose State University, Harry Edwards' most important contributions to athletics have been off the court. As an undergraduate, Edwards joined the Black Panther Party and helped convince African American athletes to boycott sporting events, including the 1968 Olympics in Mexico City.

He was earning his doctorate at Cornell University when African American students took over the administration building, and Edwards was asked to intervene.

Still the racial conscience of the sports world, Dr. Edwards is a sports sociology professor at the University of California at Berkeley, and has served as a consultant to Major League Baseball, the San Francisco 49ers, the Golden State Warriors and other professional teams. "We must teach our children to dream with their eyes open," says Edwards. "The chance of your becoming a Jerry Rice or a Magic Johnson are so slim as to be negligible."

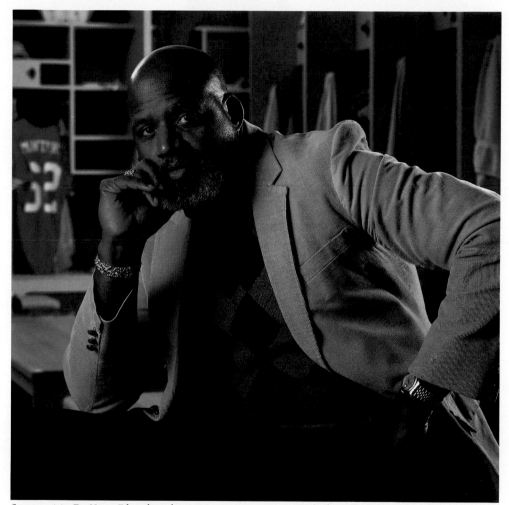

Sports activist Dr. Harry Edwards works to put minority executives into the front offices of professional sports. Photograph by Roger Ressmeyer/Starlight

Photograph of hoop star Jason Kidd by Andy Freeberg.

*A*lthough studies show that a good high-school basketball player had about one chance in 12,000 of making it into the NBA, Jason Kidd beat those odds and now plays for the Dallas Mavericks. Kidd was named national high school player of the year in 1991 by *USA Today* and *Parade* magazine. Formerly a point guard for the University of California Golden Bears, Kidd was courted by every top basketball college in the country. Still, the budding superstar didn't overlook academics. "I realized, in the end, books are more important than basketball," he says.

*D*eion Sanders helped to usher in a new era in sports in 1992 when he had successful seasons as an outfielder for the Atlanta Braves and cornerback for the Atlanta Falcons. Like Bo Jackson, who also doubled up sports, Sanders is an all-around athlete who played high-school basketball in Fort Myers, Florida, and ran track at Florida State University. He also sponsors an annual charity basketball game to raise money for the homeless.

Sanders may be aspiring to the kind of football career that San Francisco 49er Jerry Rice has achieved. Rice is probably the best receiver in the game's history. Rice got into football when an assistant principal caught him running through high school while cutting class. Impressed by the speed of Rice's retreat, the principal encouraged him to take up football. Rice was noticed by scouts at Mississippi Valley State College and became the 49er' top draft choice in 1985. His incredible speed helped the 49ers win three Super Bowls.

Along with Bo Jackson, Deion Sanders is one of only two modern players who have starred simultaneously in both pro baseball and pro football. Photograph from the Sports Illustrated Picture Collection

Jerry Rice may be the greatest wide receiver of all time. Photograph by Otto Greule, Jr./Allsport

\mathcal{J}ohn Lucas's life is a testament to the powers of redemption. When he broke into professional basketball in 1976, he was the first college player selected in the National Basketball Association draft. He seemed to have a lock on fame and fortune. Instead, Lucas moved through nine teams in the league and failed two drug tests.

The turnaround came in March 1986, when Lucas missed practice with the Houston Rockets, failed a drug test and was released by the team. He immediately went on a cocaine binge that left him shoeless and soaked with urine on the streets of Houston. Days later, Lucas checked himself in for treatment for the fifth time.

This time it worked. Within two months he founded John H. Lucas Enterprises, a multifaceted company that serves recovering substance abusers and includes a prominent treatment and rehabilitation center in Houston. He founded Students Taking Action Not Drugs (STAND) and Basketball Congress International, which organizes tournaments for local youth.

Lucas also bought a United States Basketball League team, the Miami Tropics, to give recovering ballplayers an opportunity to pick up their shattered careers. In December 1992, Lucas was hired as head coach of the San Antonio Spurs.

Lucas, who still keeps the red and white Pumas he forgot to wear on his last night of drug binging, does not like to be called a role model. Yet for many talented athletes who have fallen into the abyss of drug abuse, he is a hero, someone who climbed back out. Lucas is a role model, but only for one day at a time.

For San Antonio Spurs coach John Lucas, there is life after recovery in the NBA.
Photograph by John O'Hara/The San Francisco Chronicle

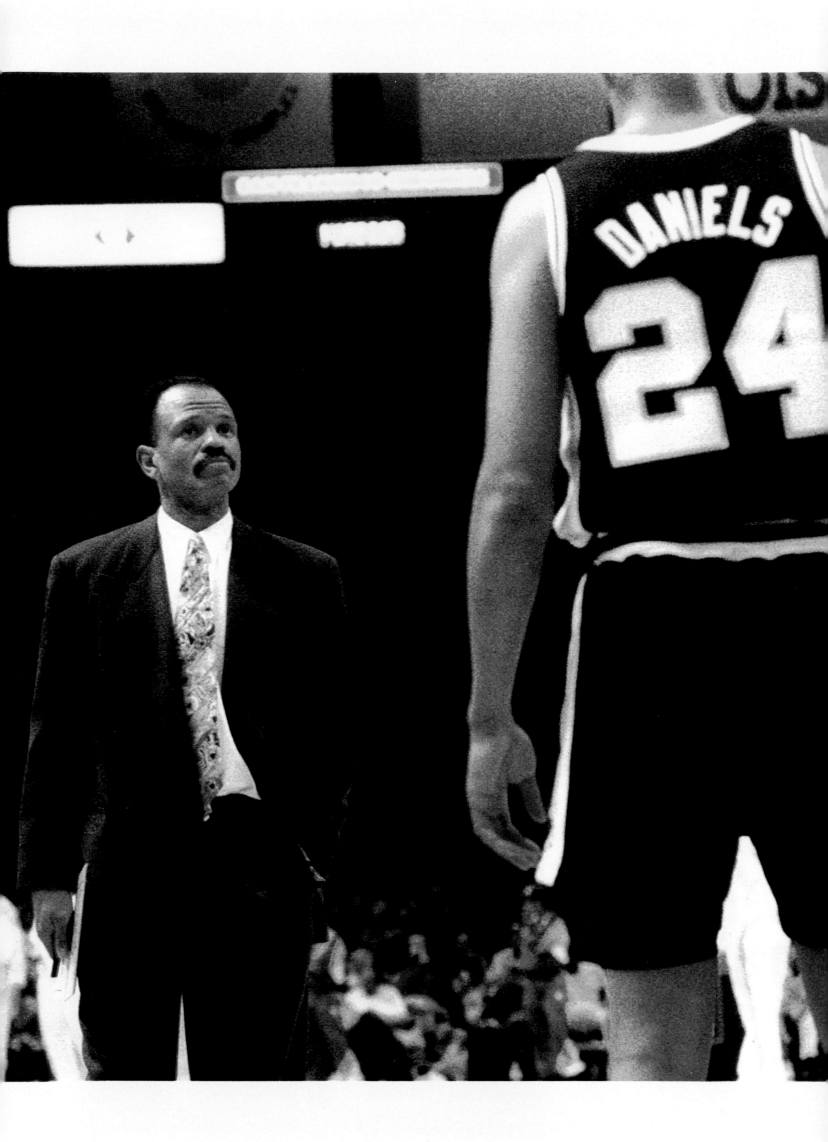

In Philadelphia, two boys shoot hoops at Girard College, a
free boarding school for needy, inner-city kids.
Photograph by David H. Wells/JB Pictures

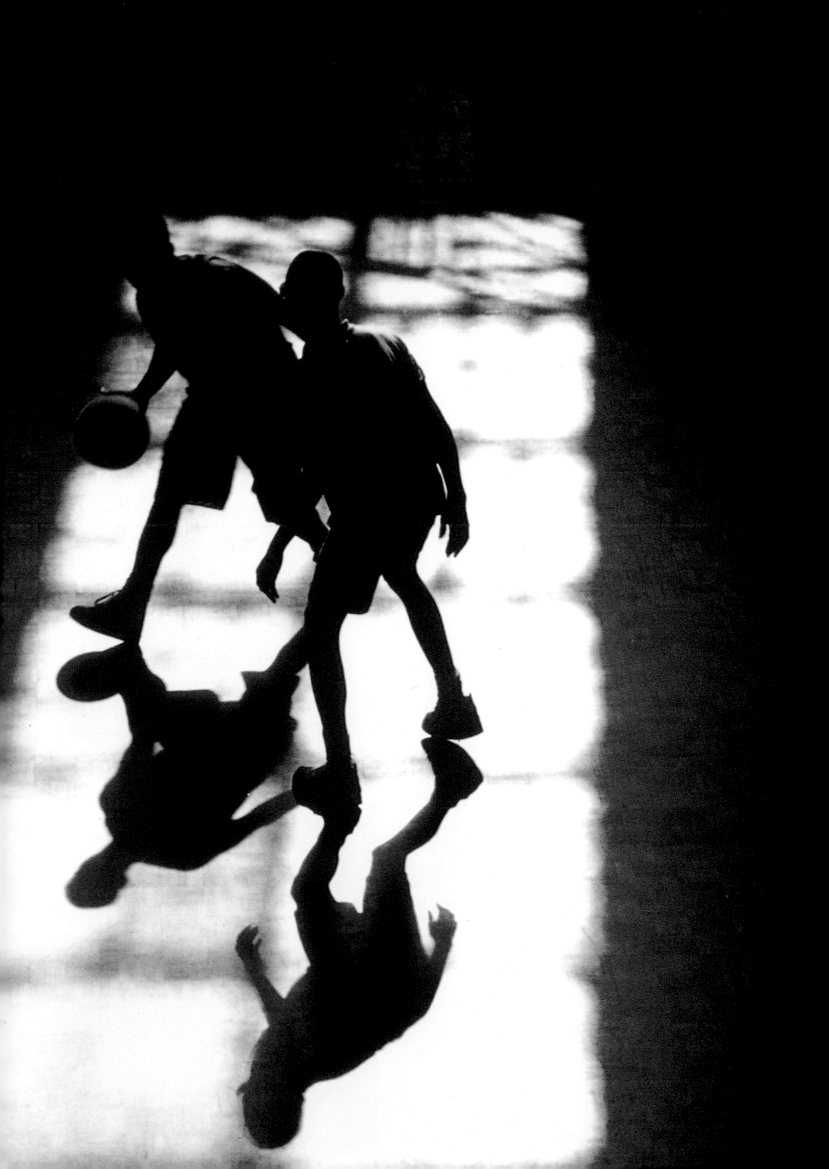

EVERYDAY HEROES

Tiny, physically impaired and in almost constant pain, Fanniedell Peeples, 72, is a mighty hero to the staff, families and young patients at Detroit's Children's Hospital. Since 1983, Peeples, or "Peep," as she likes to call herself, has been a tireless volunteer at the hospital, logging many thousands of dedicated hours without pay.

Peep is there in the surgical waiting room, offering support and information to worried parents. She is in the nursery, holding sick and dying infants who have no one else to cuddle them. She is with pediatric patients, cheering children and parents with wide smiles and acrobatics. She hands out library books, gives tours and holds prayer sessions. And for all her good work, day in, day out, she gets a free meal in the hospital cafeteria.

Born with acute scoliosis, Peep realized at a young age that what she couldn't accomplish with good looks and physical abilities she could achieve with a powerful spirit. Although she was raised in foster homes from the time she entered grade school, Peep was an honor student, received a scholarship to Lincoln University in Missouri, was named the student "Most Likely to Succeed" and graduated as valedictorian of her class.

In her teenage years, her luck turned bad. Peep underwent 15 major operations, was confined in a body cast and then, with no money or family, spent ten years in her home alone. Finally, despite her disabling back pain, kidney, lung and heart problems, arthritis and countless other ailments, she decided just to get on with life. She found a way to help herself by helping others, and her generosity of spirit has earned her a share of fame. Articles about her have appeared in national magazines, and she received two personal commendations at the White House. In the evening, Peep returns home to her apartment, paid for with her small, monthly Social Security check. Her spirit and strength have propelled her through another day, and every day she makes a difference.

Hospital volunteer Fanniedell Peeples. Photo essay by Scott Thode

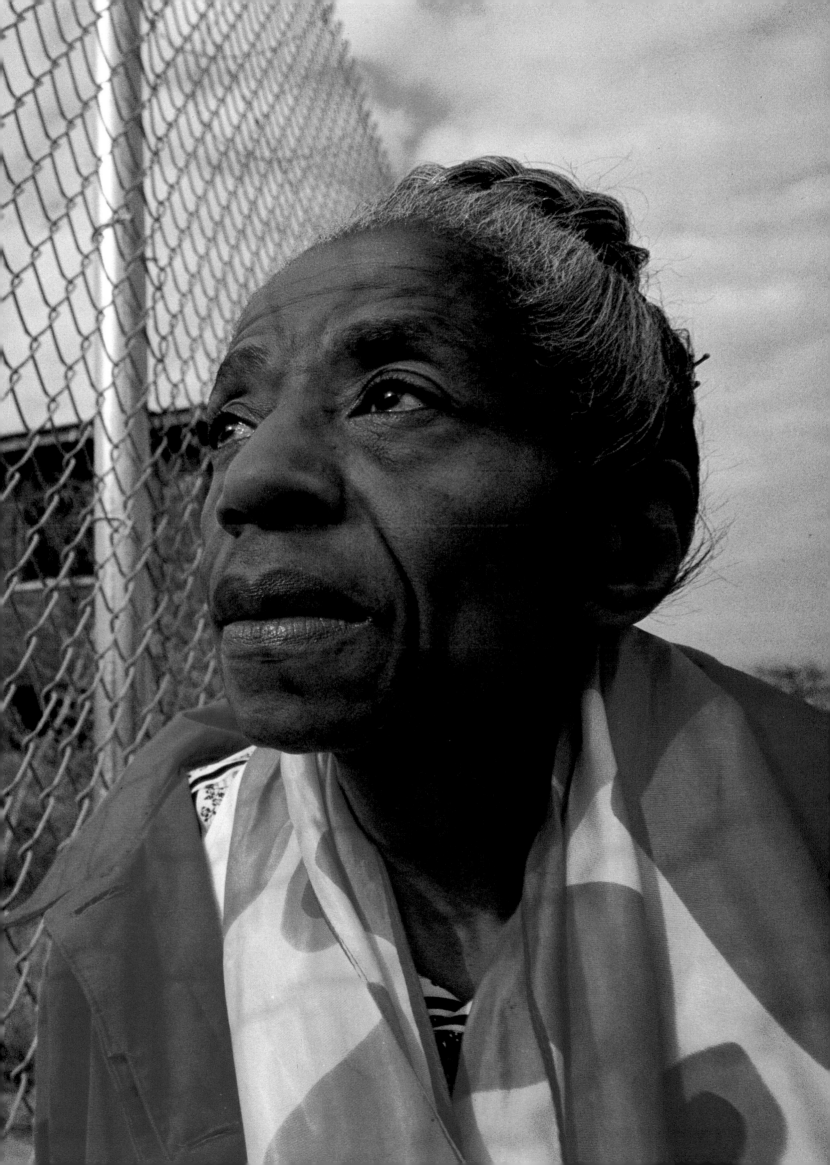

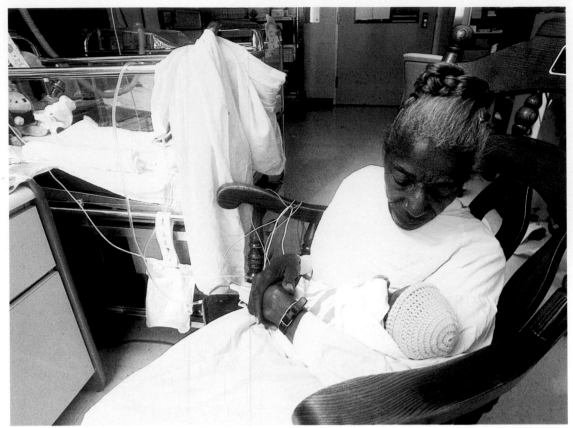

Peeples loves babies the best, she says, because they respond instinctively to love and care.

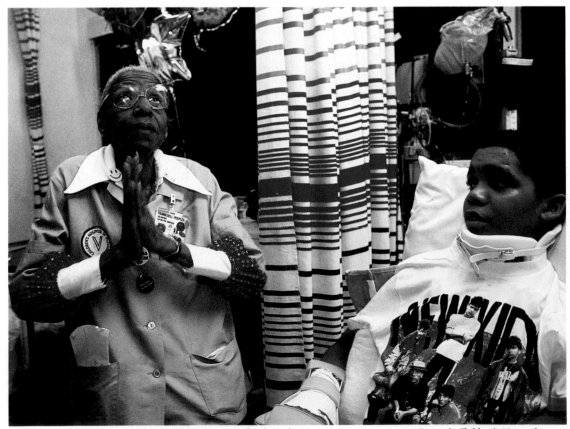

With her tireless good humor and steely strength, Peeples has been the answer to many a prayer at Detroit's Children's Hospital.

Fanniedell Peeples cheers a young patient with her surprising acrobatics.

On a rare break, Peeples rests her painful body in a hospital hallway.

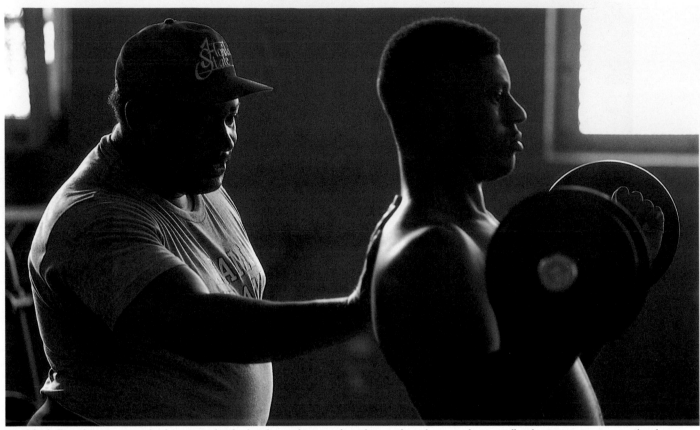

*Head football coach at Miami Norland Senior High School, Osborne also counsels students and is a deacon at the New Fellowship Missionary Baptist Church.
Photo essay by Jeffery Allan Salter*

*B*eing there for others isn't always easy. "You can get stressed out," says high-school coach John Osborne, "and as anyone can tell you, you sure don't make much money." But, he says, the benefits are worth it: confidence in his children's future, the admiration of his football players and Sunday-school students and the satisfaction of helping his community.

For Osborne, being involved is more than a full-time job. He is head football coach and counsels students at Miami Norland Senior High School. He is also a Sunday-school teacher and deacon of his church. But his most important job, Osborne says, is being a good father and role model for his daughter, Erica, and son, Taurian John.

"I have to be there for my kids," he says. "The way things are today, with drugs and immorality, it would be easy for my kids to become statistics."

Osborne could have been a statistic himself. When he was 14, he watched his stepfather murder his mother. But instead of losing his way, he immersed himself in sports. He won a football scholarship to Bethune-Cookman College, made All-American, played in the World Football League and had a short stint with the Cleveland Browns.

Sports saved him, says Osborne, and so did loving friends, neighbors and especially his wife. "My wife has really been my strength. We both came from broken homes. We were determined to make our relationship work. My wife is a strong Christian. She's supportive, understanding. As they say, 'Behind every good man, there is a good woman.' That is definitely the case here."

Osborne has the same dedication to his kids, his players and his church. "So many kids are like diamonds in the rough," he says. "They just need some encouragement and genuine concern."

John Osborne is not rich or famous or unusual. He is just an ordinary man doing extraordinary things in his community. And he is just like thousands of other African Americans who make exceptional contributions every day. Grandparents who raise their children's children, teachers who mold their students, mothers and fathers who make the time to be involved in their children's lives—all are part of a rich tradition of self-help and involvement that has bound and nurtured the African American community.

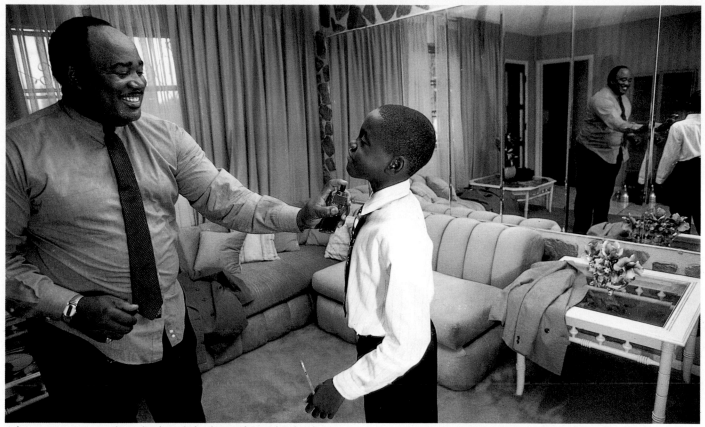

Osborne sprays Taurian John with cologne before leaving for Sunday church services.

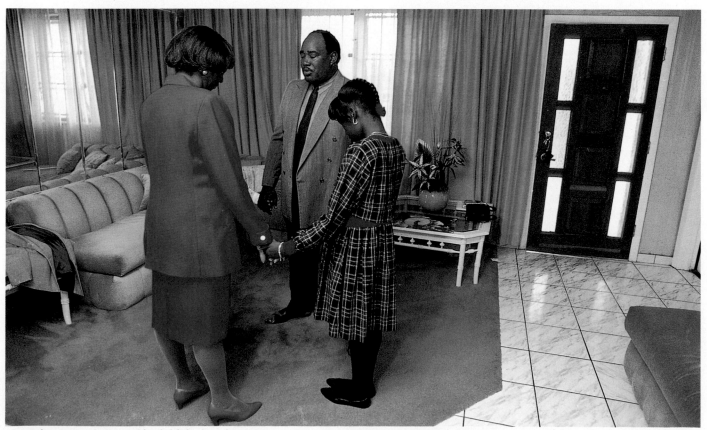

Love and prayer are the heart of family life for the Osbornes.

John Osborne helps his son, Taurian John, with math homework, while his daughter, Erica, cuddles up for a kiss.

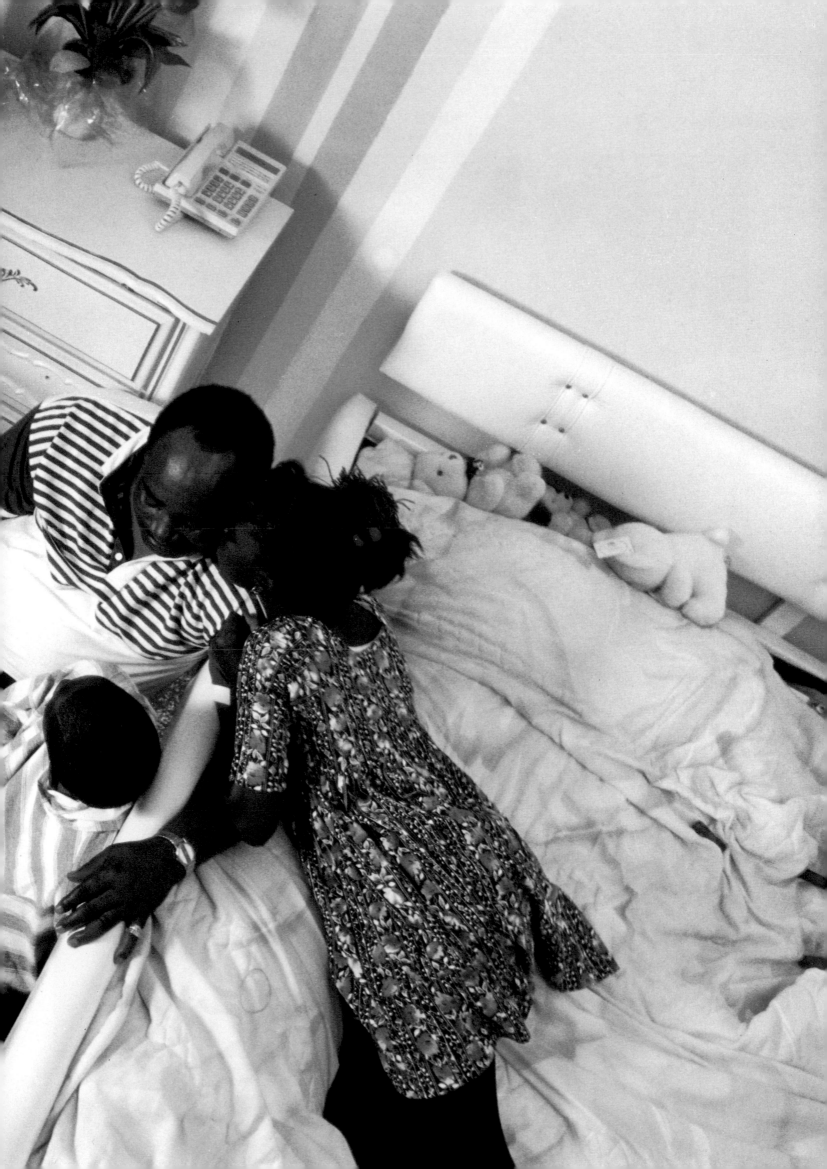

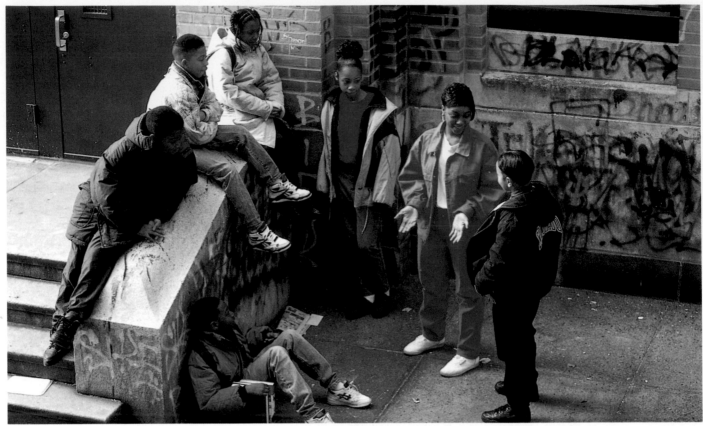

Karesha Lowe talks with friends outside her old school. She's determined to get good grades, even if she's sometimes teased for being smart.

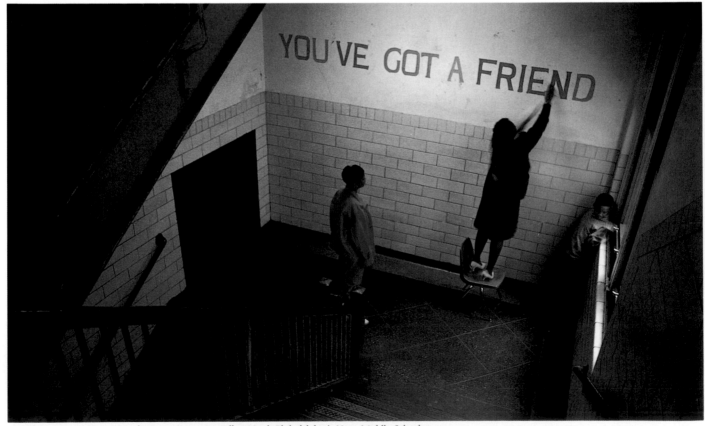

Karesha passes an inspirational message in a stairwell at North Philadelphia's Vaux Middle School.

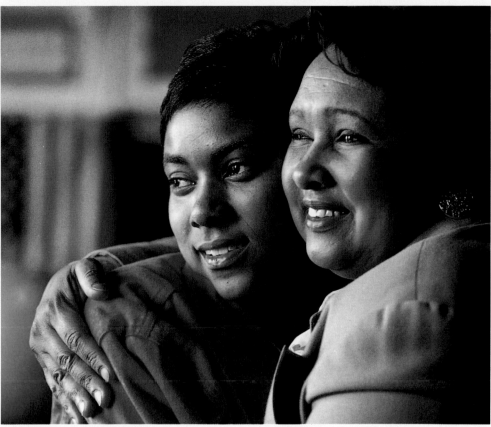

On a return visit to Vaux Middle School in Philadelphia, straight-A student Karesha Lowe gets a hug from former teacher Lynne Johnson. Photo essay by Nick Kelsh

*E*very day, children are beaten down by poverty, crime and desertion. And then there is Karesha Lowe.

Karesha's life has been a prescription for disaster. Her father was murdered when she was ten. Her mother was sentenced to life in prison for another killing when Karesha was 12. At 14, Karesha was living with her stepsister and six other children in a crowded rowhouse in a litter-strewn North Philadelphia neighborhood.

But somehow Karesha is beating all the odds. She earned straight A's at Vaux Middle School, where she graduated from eighth grade at the top of her class. She was accepted to the best public high schools in the city, and now attends the exclusive George School in Newtown, Pennsylvania. She loves math, has served as a member of the student council and has tutored seventh graders after school.

Throughout middle school, Karesha's strengths have been nurtured by caring teachers, such as her mentors, Florence Johnson and Lynne Johnson. And Karesha's outstanding performance has been rewarded. After an article about her appeared in the *Philadelphia Inquirer,* offers of scholarships and financial support poured in. The National Organization for the Professional Advancement of Black Chemists and Chemical Engineers awarded her a four-year, $50,000 college scholarship. Hahnemann Hospital offered her a paid staff position through high school and college. Talk show host Tony Brown established a fund at United Bank of Philadelphia to pay for housing, food and clothes for Karesha and her younger brother, Chris.

Her success is baffling to some, but it's a matter of common sense to Karesha. Her misfortunes, she told the *Inquirer,* are "nothing I can really do anything about, and there's no sense in me doing badly. There's no sense in me failing, too."

Karesha Lowe walks through her old North Philadelphia neighborhood to visit her sister and brother.

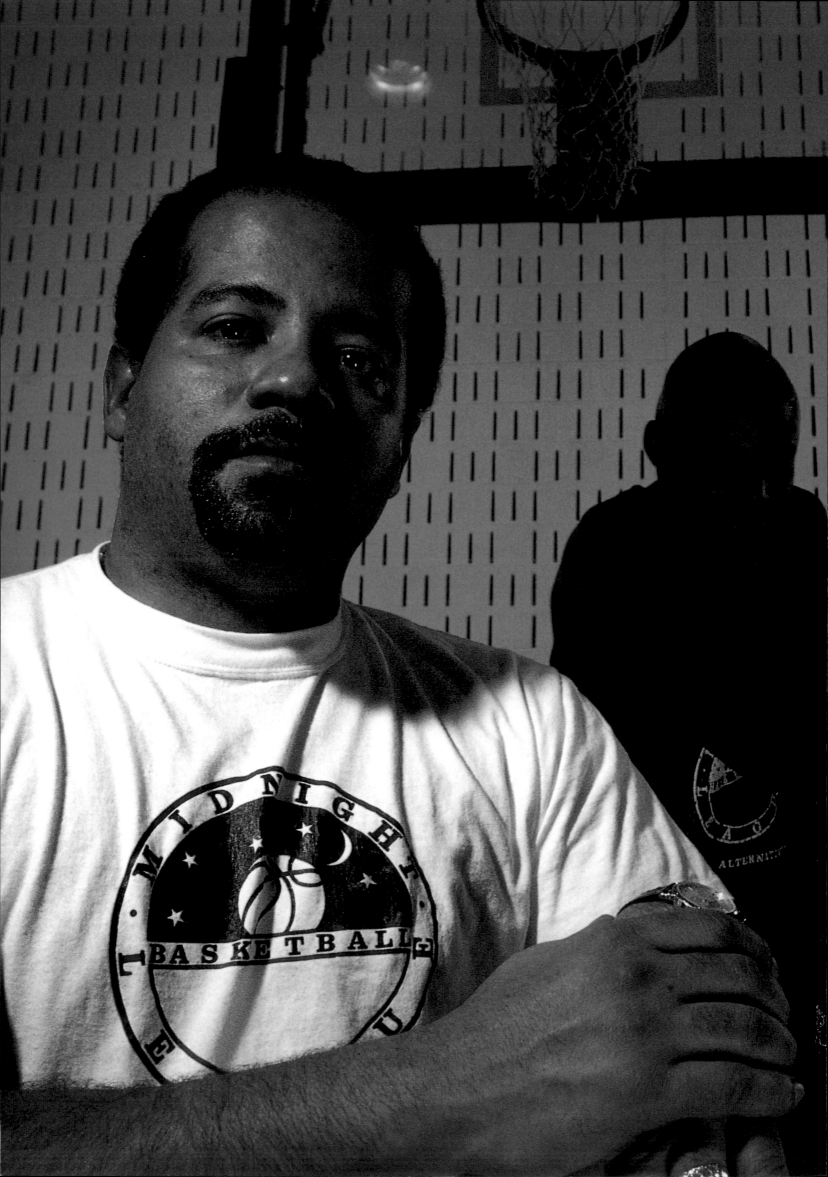

Nelson Standifer holds a portrait of his late father, G. Van Standifer, founder of the Midnight Basketball League. Photographs by C. W. Griffin

The idea was simple. There was no great plan, nor any reason to think that it would be so effective. In 1986, G. Van Standifer, town manager for Glenarden, Maryland, just wanted some way to get older teens and young men off the street during the dangerous hours between 10 p.m. and 2 a.m., when most violent crimes take place.

He came up with the idea for a Midnight Basketball League (MBL), open to young men ages 17 to 21. The night of the first game, Standifer was not sure whether any players would show up. But before the night had ended, two MBL teams had faced off while 150 spectators watched the action.

Today, Standifer's Midnight Basketball League has succeeded in getting young men off the streets and into the gyms in 41 cities across the country. In addition to slick uniforms and fast-paced games, the MBL offers family counseling, academic workshops, vocational seminars, advice about financial aid, drug counseling and career planning in between the games. Players who do not go to the seminars are dropped from the league. And the system works. When Standifer launched the MBL in Glenarden, crime in the town dropped 60 percent, and communities across the country have seen the MBL perform for them.

Standifer died in September 1992, but the MBL carries on with the help of his son, Nelson. A lot of good has come out of a simple idea for stemming local crime. "I took it personally," Standifer once said, "and decided to do something about it."

Midnight Basketball players Kevin Jackson and Michael Reed play one-on-one behind Nelson Standifer, who runs Midnight Basketball in Prince George's County, Maryland.

\mathcal{L}ife can be surprising. Dianne Ritchie, raised in Manhattan's Washington Heights, signed up to work for the National Health Service for three years in exchange for medical school loans. Instead of being assigned to a low-income area as she expected, Ritchie was sent far afield: to the Pine Ridge Indian reservation in South Dakota.

It was a far cry from the University of Chicago where Ritchie earned her medical degree. There, she decided not to specialize in the lucrative practice of surgery, but rather to become a family physician who would help meet the need for primary care in low-income communities.

In the often chaotic environment of the Public Health Service Indian Hospital at Pine Ridge, Ritchie and eight other physicians cared for Oglala Lakota Sioux patients. The experience was far from ideal—inadequate staffing at the hospital, widespread poverty and sorrow and a public health system that she found to be chronically unresponsive. Still, Ritchie was inspired by the spirit of her patients, the beauty of the Black Hills and Badlands of South Dakota and the opportunity to reach out and help.

Dr. Dianne Ritchie enjoys a quiet moment in her house on the Pine Ridge reservation. Photo essay by Andy Levin

212

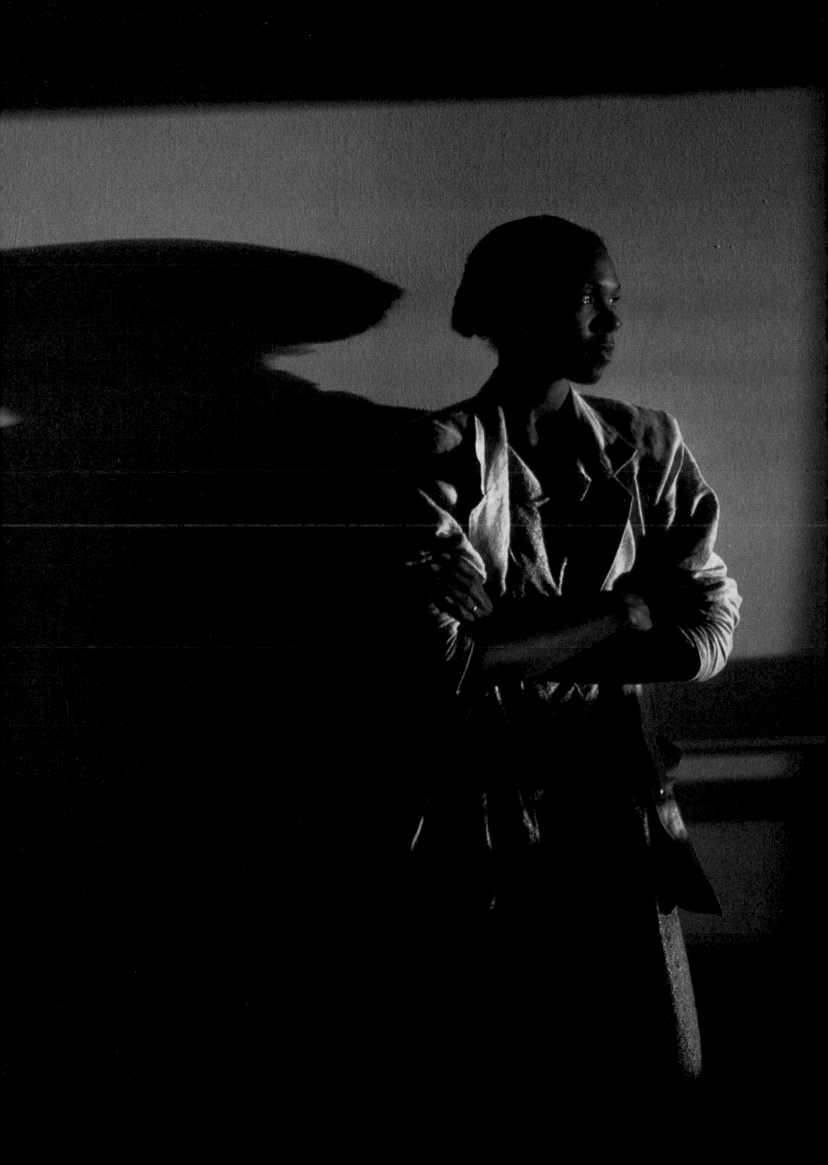

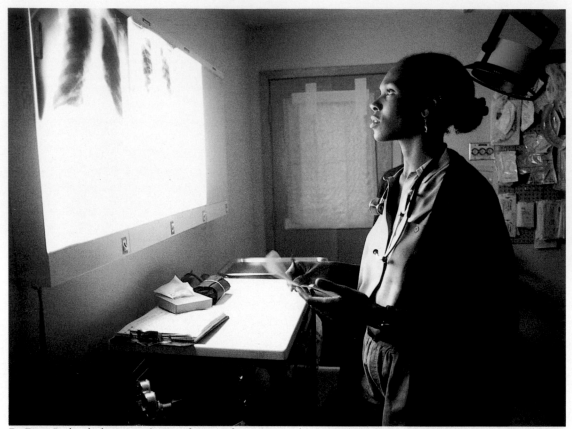

Dr. Diane Ritchie checks a patient's X-rays for signs of pneumonia and congestive heart disease.

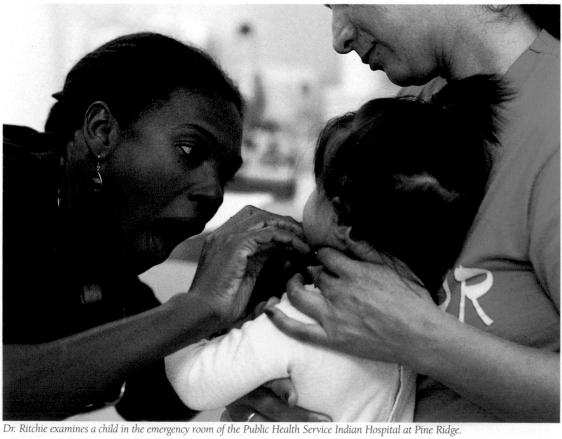

Dr. Ritchie examines a child in the emergency room of the Public Health Service Indian Hospital at Pine Ridge.

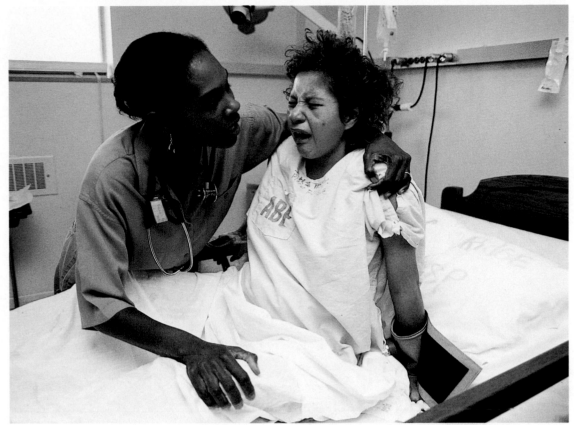

On the reservation hospital's busy maternity ward, Ritchie coaches a Pine Ridge woman in labor.

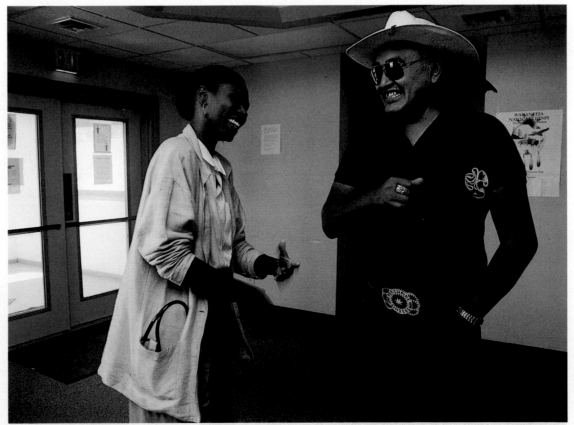

The clinic in the Pine Ridge village of Porcupine doubles as a community center. Ritchie jokes with an Oglala Lakota Sioux village leader.

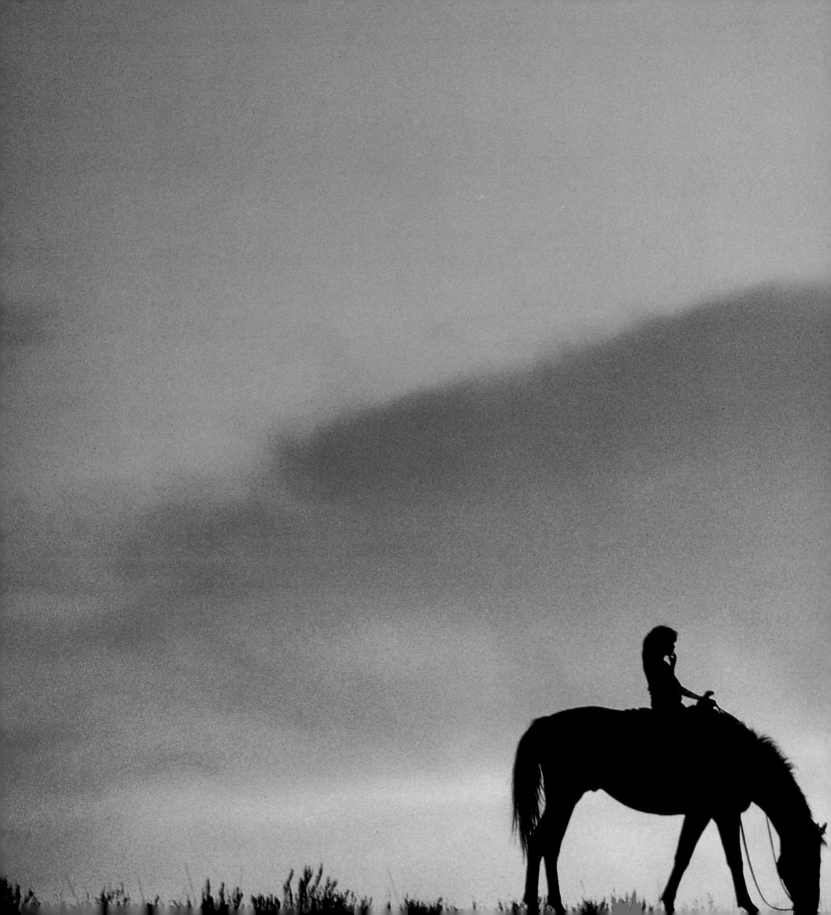

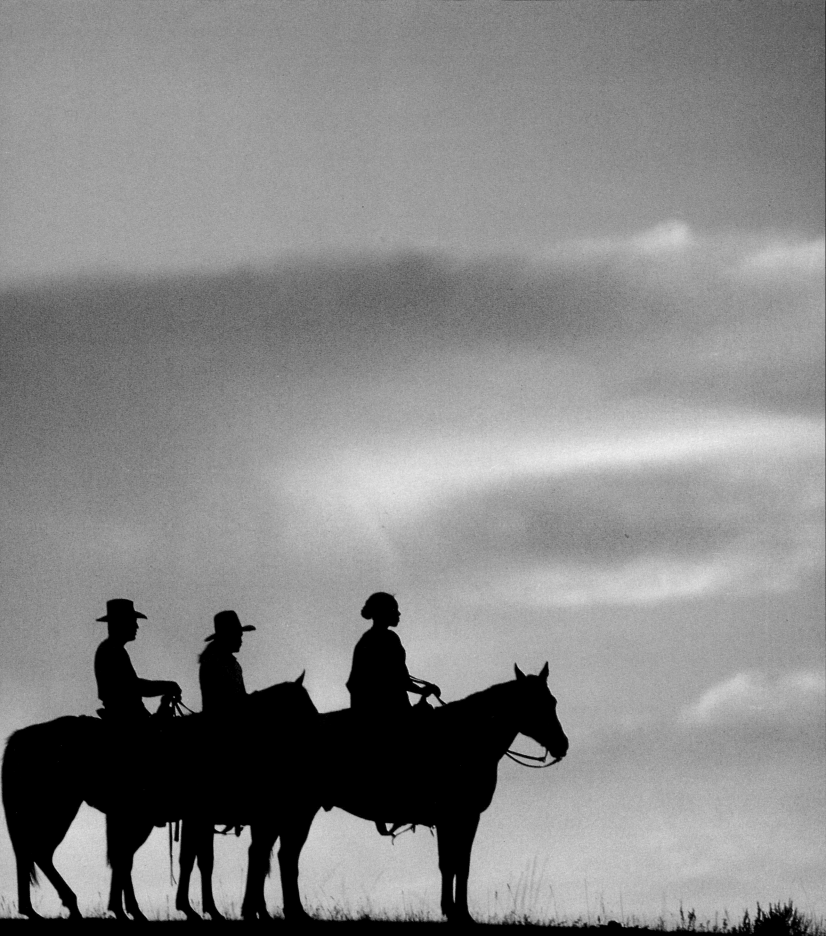

HOPE FOR THE FUTURE

For 15-year-old LaToya Hunter, coming of age in New York has meant more than discovering boys, arguing with her parents and staying out of trouble in a tough Bronx neighborhood. In LaToya's case, it has also meant the start of a writing career.

In 1992, Crown Publishers published the journal that she wrote as a 12-year-old entering her first year of junior high school. Called *The Diary of LaToya Hunter: My First Year in Junior High,* the book has received wide attention for its insights into adolescence and urban pressures.

Born in Jamaica, LaToya spent her first eight years in the small, rural district of Irons Mountain before moving to New York with her parents, Linneth and Linton. LaToya has always loved reading and writing, and when she was in sixth grade, she won a school award as best writer. On her report card, her teacher wrote, "The world is waiting for LaToya Hunter!"

As it turns out, the teacher was right. An editor at Crown Publishers read about LaToya and her class in a *New York Times* article. He contacted LaToya and suggested that she keep a diary about her first year in junior high. It was an eventful year: LaToya witnessed a murder, took part in her brother's wedding and became an aunt when her unwed teenage sister had a baby. Writing was a way for LaToya to express her feelings and make sense of the confusing and sometimes painful world around her.

LaToya now attends high school in Mt. Vernon, New York, and looks forward to continuing her writing career and becoming a psychologist. "It's a struggle in the world today," she says. "There are so many things that can try to pull you away from achieving. The violence and drug dealing seem to be everywhere. But you can't let what's going on affect you. You have to know what you want—and just go out and get it. I feel positive about my future. When I read books like *Jane Eyre*, about people who have a tough time in life but don't let anything get them down, it inspires me to be like them and make a good life for myself."

Photograph of LaToya Hunter and her parents by Nicole Bengiveno

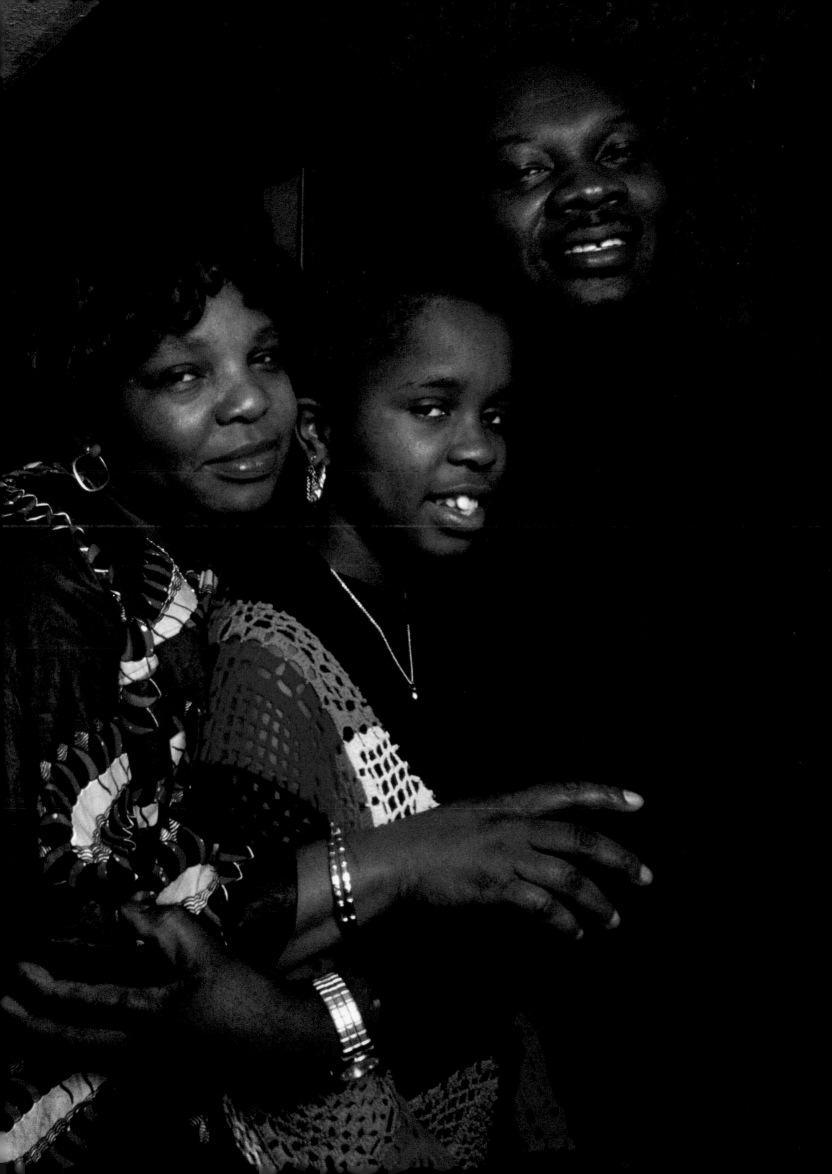

Photograph of cartoonist Barbara Brandon by Carol Halebian/Gamma-Liaison

Cartoonist Barbara Brandon is the first African American woman to be internationally, as well as nationally syndicated in mainstream publications. Her weekly strip, "Where I'm Coming From," chronicles the thoughts and conversations of nine Black women talking about life. It appears in 65 publications, including *The Detroit Free Press, The Atlanta Constitution and Journal* and *The Chicago Sun-Times.*

Since Reconstruction, when African American slaves were first allowed to read and write, education has always been the key to advancement. Today, at England's Oxford University, these four young African Americans have reached the pinnacle of academic excellence as Rhodes scholars earning advanced degrees in math, education, political philosophy, economics and theology.

In Los Angeles, the community service group 100 Black Men is preparing college graduates and Rhodes scholars of the future. The group's Young Black Scholars program aims to increase the number of academically prepared African American high-school graduates in Los Angeles County. The program was developed to counter an alarming trend. In 1983, a full third of African American high-school graduates in California finished with less than a C average. Young Black Scholars seeks to have at least 1,000 African American students in Los Angeles graduate from high school with a 3.3 grade-point average in college preparatory subjects, starting in 1994.

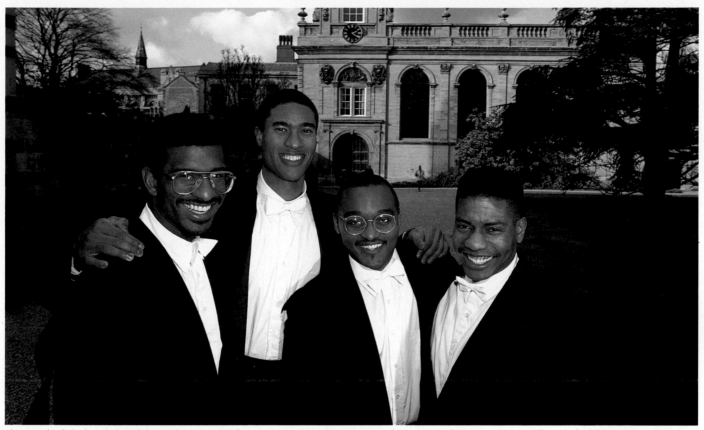

Photograph of Rhodes scholars (left to right) Darcy Prather, Peter Henry, Brad R. Braxton and Marcus A. Christian at Trinity College, Oxford, by Barry Lewis

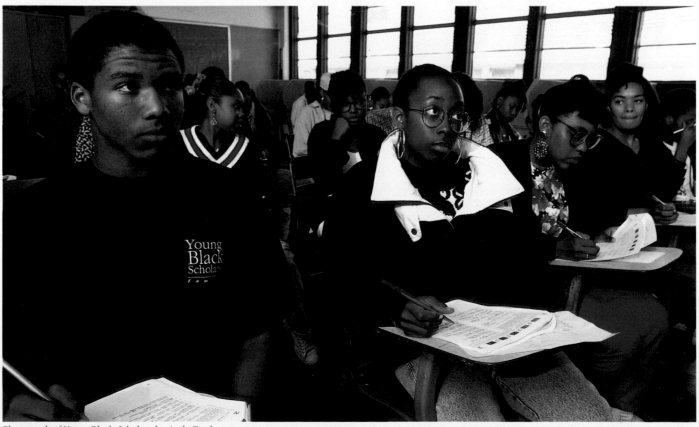

Photograph of Young Black Scholars by Andy Freeberg

Margie S. Word, R.N., is head of the Chi Child Care Center's boarder baby program. Photographs by Douglas Vann

\mathcal{I}n a program called "Our First Love" at the Chi Eta Phi Child Care Center in Washington, D.C., African American volunteers, from grandmothers to teenage boys, care for infants who have been abandoned in hospitals.

The center was established under the auspices of Howard University Hospital in 1992 by the Alpha chapter of the Chi Eta Phi nursing sorority, with support from the Washington-based Coalition of 100 Black Women. The center's goal is to provide abandoned children with a healthy, nurturing environment until they can be reunited with their parents, adopted or placed in a loving foster home.

Banneker High students Larry Overton and Michael Korona cuddle an abandoned baby at the Howard University Hospital Department of Pediatrics in Washington, D.C.

223

Photograph of student leader Charlie Ward by Jeffery Allan Salter

Charlie Ward, a junior at Florida State University in Tallahassee, is a football and basketball star and student-body vice president. The son of a librarian and a schoolteacher in Thomasville, Georgia, Ward studies hard and plans to work with physically and mentally disabled children after graduation. In his off time, he speaks to community and youth groups about the dangers of drug abuse and the importance of education. "You have to rely on education—it's the key," says Ward. "Without an education today, it's very hard to find a job or to make it on any level."

Photograph of tennis prodigy Venus Williams by Peter Read Miller/Sports Illustrated

*A*t 15, Venus Ebonistarr Williams is already being hailed as the next Althea Gibson. Venus learned to play on public tennis courts in the tough Los Angeles neighborhoods of Watts and Compton. She was instructed by her father, Richard, the owner of a private security company, who had taught himself the game. By age ten, Venus was turning down offers from agents and teaching pros, who were awed by her size, speed and skill.

Venus is being carefully coached at Rick Macci's International Tennis Academy in Delray Beach, Florida. She is an A student and dreams of becoming an astronaut or archaeologist after her time on the court.

Trumpeter Aaron Flagg and violist Lisa Whitfield are gifted classical musicians with spirit, skill and star quality. Photograph by Anthony Barboza

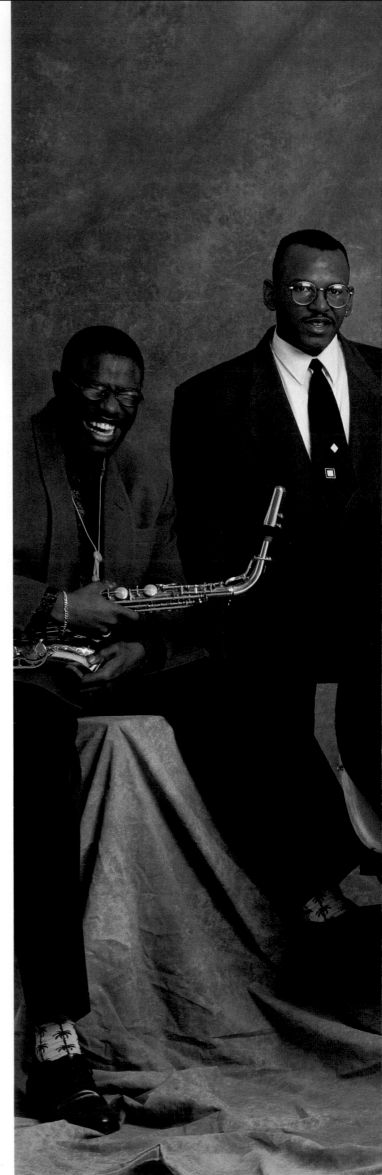

\mathcal{F}or generations, African American musicians have been at the heart and soul of the American music scene. If the up-and-coming generation of Black artists is any indication, there is a wealth of passion, skill and inspiration yet to come.

Classical musicians Lisa Whitfield, a violist, and Aaron Flagg, a trumpeter who also plays jazz, are two young artists who are already amazing audiences at New York's Juilliard School, where both are enrolled in the master's program.

Another crop of outstanding young artists is creating a renaissance in traditional jazz. These "young lions of jazz"—saxophonist Antonio Hart, pianist Stephen Scott, contrabassist Christian McBride, vocalist Cassandra Wilson, trumpeter Roy Hargrove and drummer Winard Harper—are winning major record contracts and regalvanizing jazz audiences that drifted away in the 1970s and 1980s.

The outstanding "young lions of jazz" (left to right) Antonio Hart, Stephen Scott, Christian McBride, Roy Hargrove, Cassandra Wilson and Winard Harper, are inspiring a new generation of traditional jazz audiences. Photograph by Anthony Barboza

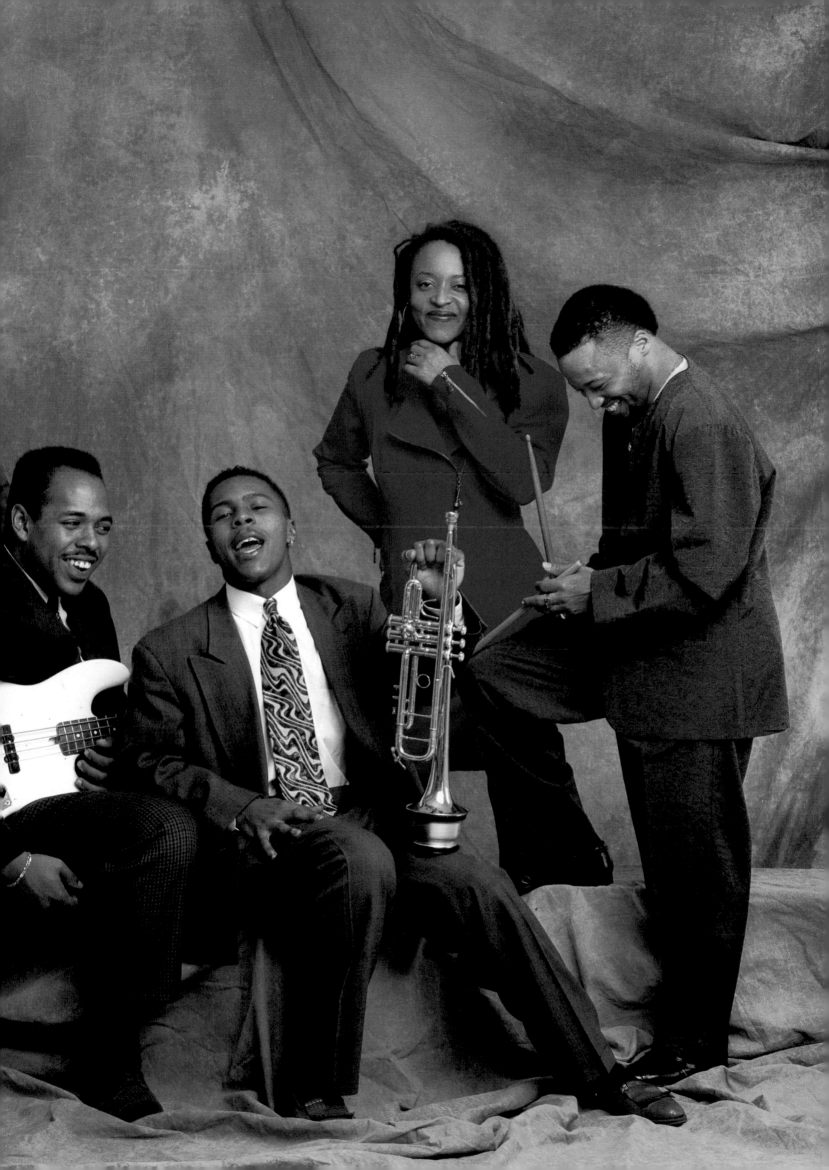

THE AFRICAN AMERICANS
BIBLIOGRAPHY

Asante, Molefi K., and Mattson, Mark T. *Historical and Cultural Atlas of African Americans*. New York: Macmillan Publishing Company, 1992.

Ashe, Arthur. "45 Years in Sports." *Ebony* (November 1990): 100–108.

Ashe, Arthur. "Seize The Day." *People* (June 8, 1992): 42–44.

Astor, Gerald. *The National Baseball Hall of Fame 50th Anniversary Book*. New York: Prentice Hall Press, 1988.

Bennett, Lerone, Jr. *Beyond the Mayflower*. New York: Penguin, 1988.

Bergman, Peter. *The Chronological History of the Negro in America*. New York: The New American Library, 1969.

Bogle, Donald. *Blacks in American Films and Television, An Encyclopedia*. New York: Penguin, Garland Publishing, Inc., 1988.

Bradley, Mark. "The Slugger Speaks." *Philip Morris* (May-June 1990): 25–27.

Branch, Shelly. "America's Most Powerful Black Executives." *Black Enterprise* (February 1993): 78–96.

Brelin, Christa, ed. *Who's Who Among Black Americans*. Detroit: Gale Research, Inc., 1992.

Brown, Chip. "The Light in August." *Esquire* (April 1989): 116–127.

Brown, Tony. "For $1,000.00 You Can Save Two Black Geniuses." *Philadelphia Observer* (April 22, 1992).

Chambers, Veronica. "Kwanzaa With the Karengas." *Essence* (December 1992): 96–98.

Charles Ethan Porter. Marlborough, Conn.: The Connecticut Gallery, Inc., 1987.

Clark, Caroline V. "Management Dynasties." *Black Enterprise* (June 1992): 305–310.

Colson, Kenneth, and Watson, Lola A., eds. *1992 African American Black Book International Reference Guide*. Chicago: National Publications Sales Agency, Inc. 1992.

Crawley, James W. "Hard work is Lloyd's secret." *San Diego Tribune* (March 25, 1991).

Curiel, Jonathan. "Lucas, Spurs–Winners Again." *San Francisco Chronicle* (February 17, 1993).

Curry, Dale. "Louisiana Oysters." *New Orleans Times-Picayune* (February 4, 1993).

David Hammons, Rousing the Rubble. New York: The Institute for Contemporary Art, 1991.

Davis, Thulani. *Malcolm X: The Great Photographs*. New York: Stewart, Tabori & Chang, 1993.

Dedford, Frank. "Arthur Ashe's Secret." *Newsweek* (April 20, 1992): 62–63.

Drake, Sylvie. "An Academic 'Historia' at L.A. Theater." *Los Angeles Times* (February 27, 1993): F-5.

Driskell, David C. *Hidden Heritage: Afro-American Art, 1800–1950*. Bellevue, Wash.: Bellevue Art Museum, 1985.

Easter, Eric; Cheers, D. Michael; and Brooks, Dudley M. *Songs of My People*. Boston: Little, Brown and Company, 1992.

Edwards, Audrey. "Jamaica Kincaid, Writes of Passage." *Essence* (May 1991): 87–90.

Edwards, Audrey, and Polite, Craig K. *Children of the Dream, The Psychology of Black Success*. New York: Doubleday, 1992.

Edwards, Harry. *The Revolt of the Black Athlete*. New York: The Free Press, 1970.

"Exploring Venus." *Tennis* (October 1992).

Fabrikant, Geraldine. "Black Cable Channel's Wild Ride." *New York Times* (June 1, 1992).

Fishel, Leslie H., Jr., and Quarles, Benjamin. *Negro American, A Documentary History*. Glenview, Illinois: Scott, Foresman and Company, 1967.

Fleming, Robert. "Arthur Mitchell and his Harlem Crusade." *American Visions* (April/May 1992): 48–50.

Franklin, John Hope. *From Slavery to Freedom, A History of Negro Americans*. New York: Alfred A. Knopf, 1974.

Franklin, John Hope. *Reconstruction After the Civil War*. Chicago: The Chicago Press, 1961.

Franklin, John Hope. "A Personal Memoir." *The Massachusetts Review* (Autumn 1990).

Franklin, John Hope. *The Color Line: Legacy for the Twenty-First Century*. Columbia, Missouri: University of Missouri Press, 1993.

Franklin, John Hope. *The Emancipation Proclamation*. Garden City, New York: Anchor Books, 1963.

Franklin, John Hope, and Meier, August, eds. *Black Leaders of the Twentieth Century*. Chicago: University of Illinois Press, 1982.

Fullwood III, Sam. "Primed For a New Era." *Emerge* (February 1993): 46–49.

Gladstone, Pennie. "Alice's Wonderland." *Image* (July 19, 1992): 6–12.

Grier, Roosevelt. *Rosey Grier's All-American Heroes, Multicultural Success Stories*. New York: MasterMedia Limited.

Griffin, Noah. "The Man of our Redemption." *Image* (February 7, 1993): 10–11.

Hampton, Henry; Fayer, Steve; and Flynn, Sarah. *Voices of Freedom, An Oral History of the Civil Rights Movement from the 1950's Through the 1980's*. . New York: Bantam Books, 1990.

Harrington, Walt. "So This Is What a Saint Looks Like…." *Life* (September 1990): 52–60.

Haskins, James. *Black Music in America*. New York: HarperTrophy.

Hawkins, Walter L. *African American Biographies*. Jefferson, N.C.: MacFarland & Company, 1992.

Haynes, Karima. "The Women of Spelman." *Ebony* (March 1993): 40–50.

Hearty, Kitty Bowe. "An Everyman called Danny." *Premiere* (February 1992): 72–74.

Heron, Liz. "Shades of Black." *New Statesman* (February 5, 1988).

Higgenbotham, A. Leon, Jr. *In the Matter of Color, Race and the American Legal Process–The Colonial Period*. New York: Oxford University Press, 1978.

Higgins, Chester, Jr.,. and Coombs, Orde. *Some Time Ago, A Historical Portrait of Black Americans, 1850–1950*. Garden City, New York: Anchor Press/Doubleday, 1980.

Hine, Darlene Clark, ed. *Black Women in America, An Historical Encyclopedia*. New York: Carlson Publishing, Inc., 1993.

Hirschberg, Lynn. "King Rap." *Vanity Fair* (July 1992): 113–141.

Hoover, Gary; Campbell, Alta; Chai, Alan; and Spain, Patrick. *Hoover's Handbook of World Business 1992*. Austin, Texas: The Reference Press, Inc., 1992.

Hruska, Bronwen, and Rayman, Graham, "On the Outside, Looking In." *New York Times* (February 21, 1993): 17–27.

Hughes, Langston; Meltzer, Milton; and Lincoln, C. Eric. *A Pictorial History of the Negro in America*. New York: Crown Publishers, Inc.

Hunter, LaToya. *The Diary of LaToya Hunter, My First Year in Junior High*. New York: Crown Publishers, Inc., 1992.

Infusino, Divina. "Toni Morrison, This Novelist Challenges the Roles of Language, Race, and Gender." *Vis a Vis* (July 1992): 54.

Joffe, Phyllis. *In the Shadow of the Great White Way: Images from the Black Theater*. Hartford, Conn.: Aetna Corporate Affairs, 1992.

Johnson, John H. "Succeeding Against The Odds." *Ebony* (November 1992): 34–61.

Johnson, Pamela. "Wynton Marsalis." *Essence* (October, 1987): 52.

Joseph, James A. *Black Philanthropy: The Potential and Limits of Private Generosity in a Civil Society.* Washington, D.C.: Association of Black Foundation Executives/Smithsonian Institution, 1991.

Kahn, Eve. "Black Designers Build Momentum."*Santa Rosa Press Democrat* (April 18, 1992).

Kastre, Michael F. "1993 Black Engineer of the Year Award." *U.S. Black Engineer* (Conference 1993): 25–26.

Katznelson, Ira. *Black Men, White Cities.* London: Oxford University Press, 1973.

Kaufman, Michael T. "Portrait of the Artist as a Bronx Girl." *New York Times* (September 19, 1992).

Kram, Mark. "Edwin Moses, A Hurdler in Inner Space." *Esquire* (June 1988): 127–131.

Lanker, Brian. *I Dream A World: Portraits of Black Women Who Changed America.* New York: Stewart, Tabori & Chang, 1989.

Lee, George L. *Interesting People: Black American History Makers.* New York: Ballantine Books, 1989.

Lincoln, Eric C., and Mamiya, Lawrence H. *The Black Church in the African American Experience.* Durham, N.C.: Duke University Press, 1990.

Lippard, Lucy R. *Mixed Blessings, New Art in a Multicultural America.* New York: Pantheon Books, 1990.

Litwack, Leon F. "Lincoln's Legacy." *Image* (February 7, 1993): 6–9.

Locke, Alain, ed. *The Negro in Art, A Pictorial Record of the Negro Artist and of the Negro Theme in Art.* New York: Harker Art Books, 1979.

Locke, Alain, ed. *The New Negro.* New York: Atheneum, 1992.

Lomax, Sarah M., ed. *Coca Cola 1992 African American Heritage Calendar.* Philadelphia: Entracom, Inc., 1992.

Long, Richard A. *The Black Tradition in American Dance.* New York: Rizzoli.

Low, W. Augustus, and Clift, Virgil A. *Encyclopedia of Black America.* Baltimore: Da Capo Press, 1981.

"Man of Grace in Glory" *People* (June 22, 1993).

Marx, Jeffrey. "Catching Up with the World's Fastest Human." *Runner's World* (August 1992): 62–69.

McElroy, Guy C.; Powell, Richard J.; and Patton, Sharon F. *African-American Artists, 1880–1987.* Seattle: University of Washington Press, 1989.

McLarin, Kimberly J. "A Child Shines Amid the Shambles." *Philadelphia Inquirer* (April 13, 1992).

McLarin, Kimberly J. "The Offers Come Pouring In." *Philadelphia Inquirer* (April 21, 1992).

Milkowski, Bill. "Craig Harris." *Downbeat* (February 1991): 24–25.

Mills, Kay. "This Little Light of Mine." *Image* (February 21, 1993): 12–17.

Morcos, Amal E., ed. "Dr. Walter E. Massey, Frontiers of Science." *A Mind is a Terrible Thing to Waste* (Winter 1992).

Morice, Laura. "Jesse Jackson." *US* (February 7, 1991): 37–40.

Muwshaw, Michael. "Exploring Venus." *Tennis* (October 1992).

O'Connor, Ian. "Straight Shooters." *New York Daily News* (June 21, 1991): 58–59.

Palmer, Robert. "The Man Who Changed Music, Remembering Miles." *Rolling Stone* (November 14, 1991).

Perry, Regina A. *Free Within Ourselves, African American Artists in the Collection of the National Museum of American Art.* Washington, D.C.: Smithsonian Institution, 1992.

Pick, Grant. "Race Against Time." *Chicago Tribune Magazine* (October 4, 1992): 12–19.

Pooley, Eric. "The Education of Reverend Butts." *New York Daily News* (June 26, 1989): 43–49.

Posnick, Phyllis, ed. "Norman Conquest." *Vogue* (March 1993).

Randall, Dudley, ed. *The Black Poets.* New York: Bantam Books, 1988.

Roessing, Walter. "Football's Miracle Receiver." *Boy's Life* (November 1989): 35–36.

Salley, Columbus. *The Black 100, A Ranking of the Most Influential African-Americans, Past and Present.* Citadel Press.

Scherman, Tony. "Fingers to the 'Bone." *Musician* (September 1990): 20–21.

Schoener, Allon, ed. *Harlem On My Mind.* New York: Random House, 1968.

Scott, Matthew S. "109 Years Old and Going Strong." *Black Enterprise* (June 1982): 142–150.

Simpson, Janice C. "Carrying On the Legacy." *Time* (July 15, 1991): 67.

"Sinking a Long Shot." *Newsweek* (March 1, 1993): 65–67.

Smith, Dinitia. "Jelly on a Roll." *New York* (June 8, 1992): 44–52.

Smith, Franklin. "For Harlem Thrift, Housing Spells Success." *American Banker* (May 6, 1992): 1–8.

Smith, Jessie Carney, ed. *Epic Lives: One Hundred Black Women Who Made a Difference.* Detroit: Visible Ink Press, 1993.

Stewart, Mark. "Midnight League Goes National." *Prince George Journal* (October 26, 1990).

Tate, Greg. "Burn Baby Burn." *Premiere* (August 1989).

Terry, Wallace. "Love Is The Key." *Parade* (June 28, 1992): 4–5.

Terry, Wallace. "Make Things Better For Somebody." *Parade* (February 14, 1993): 4–5.

The Negro in American History. New York: The Board of Education of the City of New York, 1964.

The New Electronic Encyclopedia. Grolier Electronic Publishing, 1991.

Thomas, Ron. "NBA's KJ Provides Hope in His Hometown." *San Francisco Chronicle* (February 12, 1993).

Tucker, Ken. "Beyond The Pale." *Entertainment Weekly* (February 26, 1993): 16–21.

Vidal, Gore. "Lincoln Up Close." *Image* (February 7, 1993): 12–14.

Ward, Charles. "Conductor Takes Music to Community." *Houston Chronicle.*

Watkins, Mel, and Appelo, Tim. "Straight Out of Brooklyn." *Entertainment Weekly* (May 15, 1992): 32–37.

Weisbrot, Robert. *Freedom Bound, A History of America's Civil Rights Movement.* Plume.

Wheat, Ellen Harkins. *Jacob Lawrence, American Painter.* Seattle: University of Washington Press, Seattle Art Museum, 1986.

White, Evelyn C., ed. *The Black Women's Health Book: Speaking for Ourselves.* Seattle: Seal Press, 1990.

Whitehead, Kevin. "Ellis Marsalis, His Kids Play, Too." *Downbeat* (April 1992): 23–25.

Wilbron, Michael. "Midnight Basketball Turns On the Lights for a Lot of Inner-City Minds." *Washington Post* (April 13, 1991): G1.

Williams, Marjorie. "Clinton's Mr. Inside." *Vanity Fair* (March 1993): 142–150.

Woods, Paula, and Liddell, Felix H. *I Too, Sing America.* New York: Workman Publishing, 1992.

Woodson, Carter G. *The Mis-Education of the Negro.* Washington, D.C.: Africa World Press, Inc., 1990.

INDEX OF SUBJECTS

CORPORATIONS WITH A COMMITMENT
TO THE AFRICAN AMERICAN COMMUNITY

ANHEUSER-BUSCH COMPANIES

Anheuser-Busch Companies, as one of America's leading corporations, has made significant contributions to the social, economic and cultural fabric of the African American community. The company's involvement reflects its continuing partnership with organizations and institutions that are working for positive change.

Each year, Anheuser-Busch assists a number of local, regional and national organizations to achieve their goals and objectives. By doing so, the St. Louis-based company is serving as a catalyst for community self-direction.

Through partnerships with leading civil rights groups such as the National Urban League and the National Association for the Advancement of Colored People (NAACP), innovative programs to help African Americans gain valuable job skills have been formed.

Cooperative efforts with these groups and many others also have led to unique educational initiatives, including special programs to educate single-adult heads of households, and incentive programs to encourage students to stay in school and to achieve to the best of their ability.

To help prepare future leaders in the African American community, Anheuser-Busch is a strong supporter of historically Black colleges and universities. As the national and founding sponsor of the annual "Lou Rawls Parade of Stars" telethon, the company in the past 13 years has helped to raise more than $100 million for the United Negro College Fund (UNCF). Proceeds from the "Parade of Stars" help some 53,000 students who attend UNCF's 41 colleges and universities.

The company's "Partners In Economic Progress" program is an example of its commitment to minority economic development. Designed to ensure that minority business owners have an equal opportunity to do business with Anheuser-Busch and its subsidiaries, the "Partners" program is credited with expanding the number of Black-owned firms that supply Anheuser-Busch with goods and services.

Currently, more than 1,800 minority-owned firms do business with Anheuser-Busch, and in 1992 the company purchased more than $100 million in goods and services from these firms.

To help improve the quality of life in the African American community—and to perpetuate an awareness of the significant contributions African Americans have made to this and other cultures—Anheuser-Busch also supports and sponsors a number of cultural activities in cities across the country. These programs—such as art exhibits, tributes to civil rights heroes and heroines, and salutes to everyday citizens who are helping to make a difference in their community—help to provide a better understanding and appreciation of the African American experience.

Anheuser-Busch is prepared to continue its commitment to the African American community, and to reaffirm its commitment to improve the quality of life for all Americans.

AT&T

It is with great pride that we present THE AFRICAN AMERICANS, a visual celebration of the African American experience.

For more than a century, AT&T has been committed to addressing important human needs. Knowledge is one such need.

THE AFRICAN AMERICANS communicates the vibrant heritage of the African diaspora and the unique contributions of peoples of color in making this country what it is today. As we seek to develop ways to enhance the quality of life for all Americans, AT&T recognizes that ethnic diversity is crucial to America's future. And, we realize that no investment in the future is more urgent than education.

The AT&T Foundation donates substantially to educational programs. But, we know that it takes more than money to turn knowledge into power. Educators have long recognized that achievement must be fueled by the will to succeed. AT&T has thousands of employees who work with faculty and students to share their experience or work as mentors.

As a company with a reputation for bringing people together, AT&T is constantly reaching out to the communities we serve. In the African American community, we've shared a powerful partnership for many years.

From Atlanta to Los Angeles, Newark to Chicago and countless counties in between, AT&T has become increasingly involved with helping to improve the quality of life. We work with the Black community to improve education and health care; to support the family and to celebrate the arts; to foster a diverse work force and to provide opportunities for Black-owned businesses to grow and prosper.

THE COCA-COLA COMPANY

The Coca-Cola Company knows that the cost of what Langston Hughes called "a dream deferred" is beyond calculation for society as well as the dreamer—for society will never know the dreams or the reality they might have wrought.

As we stand on the doorstep of the 21st century, America's demographic landscape is changing before our eyes—an already diverse population growing more so each day, blossoming into the bouquet of multiculturalism that is our unique heritage and destiny.

More than ever, America is a microcosm of the world—a marvelous multicultural mosaic of people from within our borders and beyond. Without question, we are a much stronger society today thanks to our diversity and the contributions of people of color such as those celebrated in this special publication.

If our nation is to build an effective 21st century work force, American business and American society must fully embrace diversity and ensure equal economic and educational opportunity for all.

That is why The Coca-Cola Company has encouraged diversity in the workplace and marketplace for many years.

That is why The Coca-Cola Company's headquarters in Atlanta, Georgia—reflecting the business that we conduct every day in more than 195 countries—sometimes resembles the United Nations.

That is why The Coca-Cola Company is a longstanding supporter of the National Urban League, historically black colleges and universities, and other institutions serving the African American community.

That is why The Coca-Cola Company committed $50 million through The Coca-Cola Foundation to encourage excellence in education during the 1990s—with particular emphasis on helping minority students meet the unique challenges they face.

That is why The Coca-Cola Company expanded its commitment to businesses owned by minorities and women with a five-year pledge to purchase $1 billion in goods and services from such firms.

And that is why America must fling open the doors of opportunity, shatter glass ceilings everywhere—and finally realize our full potential as the vibrant, dynamic and diverse society that we are.

HILTON HOTELS CORPORATION

One of hospitality's most recognized and respected names, Hilton has provided excellent service and first-class accommodations to the traveling public since 1919. Through the years, the company has placed an increasing emphasis on creating a more balanced workplace. Hilton's commitment to the minority community is evidenced in several ways, including its aggressive college recruiting campaign, innovative internship program for inner-city youth and participation in the industry's foremost minority organizations.

With more than 70,000 employees, Hilton constantly seeks the best talent to operate its growing network of hotels. The company has initiated an aggressive recruiting program among the nation's coalition of historically and predominantly Black colleges and universities. In 1992, for example, Hilton's recruiters visited six schools recognized for their excellent hotel- and restaurant-management programs, seeking highly qualified participants for the Hilton Professional Development Program. Program trainees spend several months at different Hilton properties learning real-world applications of hotel-management principles previously covered in college. Successful trainees go on to become managers at the company's hotels.

Hilton also conducts an internship program for high-school students at the Palmer House Hilton in Chicago and at the New Orleans Hilton and Towers. Designed to train inner-city minority youth for careers in hospitality management, the program includes work in sales and marketing departments, front-office operations and the executive office of each property. Since its inception in 1980, more than 300 students have participated in this program.

In addition, Hilton is a member of both the National Urban League and the National Coalition of Black Meeting Planners, two of the pre-eminent minority organizations within the $3 billion Black travel market. The company also participates in the minority Hotel Student Association's national conference, held at Cornell University.

THE EDITORS WISH TO THANK THE FOLLOWING

ORGANIZATIONS

100 Black Men Organizations
100 Black Women Organizations
Abyssinian Baptist Church
Afro-American Newspapers
American Postal Workers Union
Ancient Egyptian Arabic Order,
 Nobles of the Mystic Shrine of
 North and South America and
 Its Jurisdictions, Inc. (PHA)
Anheuser-Busch Companies
A.R.T. Lab
Aspen Graphics
AT&T
AT&T Bell Laboratories
Baltimore City College High School
Bay City Marine
Bethel A. M. E. Church
Black Entertainment Television
Bomani Gallery
The Boys Choir of Harlem
Call-A-Granni
Carrie Productions
Carver Federal Savings Bank
Chi Eta Phi Nursing Sorority,
 Alpha Chapter
Church for the Fellowship of
 All Peoples
The Church of God in Christ
Clark Atlanta University
Coca-Cola Company
Collins Publishers,
 San Francisco
Congressional Black Caucus
The Conrad Hotel, Hong Kong
The Council on Foundations
Cross Colours Clothing Company
The Dance Theatre of Harlem
Def Jam Recordings
Detroit Medical Center
Detroit's Children's Hospital
Dewey School
Ebenezer Baptist Church
Flint's Barbeque, Oakland
Florida A & M Marching Band
Florida State University
Fortune magazine
Gamma Photographic Labs, Inc.
The Garden Project
George School
Golin/Harris
Grambling University
 Marching Band
Granite Broadcasting Corporation
Greater Victory Temple

Hale House
Harlem Chess Academy
Harlem Hospital
Harpo, Inc.
Hilton Hotels Corporation
Hilton Hotel & Towers, Atlanta
Howard University
Howard University Hospital
Inner City Broadcasting
Inner City Cultural Center
Joffrey Ballet School American
 Ballet Center
Johnson Communications, Inc.
Johnson Publishing Company
The Juilliard School
King World
Kinko's Copy Centers
La Rabida Children's Hospital
Library of the
 Atlanta-Constitution Journal
Louisiana Seafood Promotion &
 Marketing Board
Malcolm X Academy
Marie Brown Associates
Marin Community Foundation
Marymount School, Manhattan
McDonald's Corporation
Michigan Department of
 Social Services
Midnight Basketball League, Inc.
Mill Valley (California) Library
Modern Effects
Morehouse College
Mount Vernon High School
NAACP
National Pan Hellenic Council
National Science Foundation
National Urban League, Inc.
New Fellowship Missionary
 Baptist Church
The New York Public Library
The Omega Boys Club
Outtakes magazine
Paine College
Penguin USA
The School District of Philadelphia
Rapid Design Services
Rogers & Cowan Public Relations
Rush Communications
Rutgers University
San Francisco African American
 Historical and Cultural Society
San Francisco Glide Memorial
 United Methodist Church
San Francisco 49ers

The San Francisco Chronicle
 library staff
San Francisco Hilton
San Francisco Public Library,
 Information Services Division
San Quentin Prison
The Schomburg Center for
 Research in Black Culture
Spelman College
Sylvia's Soul Food Restaurant
Temple Church of God in Christ
Howard Thurman Education Trust
The Thylaxis Society
Tony Brown Productions
Toppan Printing Co.
 (America), Inc.
Trans-Africa
U.S. Army–Fort Belvoir
United Airlines
University of Chicago
Urban League of Greater Miami
Urban League of New Orleans
Urban League of Washington, D.C.
Vaux Middle School
Office of the Vice President of
 the United States
Viking Studio Books
The Waldorf Astoria, New York
Wajumbe Cultural Institution
Watts Labor Community
 Action Community
Westside Distributors, Los Angeles
The White House
William Penn Foundation
Williams College
Yale University Child Study Center

FRIENDS AND ADVISORS

Joseph Abrams
Addo Afiemoh
Faye Alpert
John Altberg
Bob Ambriano
Gail Anderson
Lois Anderson
Rene Anderson
Roger & Christie Anderson
Tamika Anderson
Mary Andry
Tom & Marilyn Angelo
Hamman Ansari
Margaret Anzinger
Rogelio Q. Aranzanso
Brian Argrett

The Asai family
Herbert & Dorothy Ascherman
Maurice Ashley
Andrea Ashmore
Cynthia Atterberry
Julayne Austin
Roni Axelrod
Jennean Bailey
Michael L. Baker
L. E. Bannock
Ken Barboza
Robin L. Barlow
Jennifer Barner
LeRoy Barnes & Denise Conley
Clarence Barney
Jennifer Barry
Michele Barry
Hallie Beacham
William Beacham
Robin Beaman
Derrick Joshua Beard
Angela Bell
Derrick Bell
Jennifer Bell
Sister Gilda Marie Bell, S.B.S.
Andy & Sam Belt
Makita Best
Bipin & Bharti Bhayani
Carole Bidnick
David Biehn
William Bigelow
Andrew & Amy Billingsley
Elaine & Hy Binger
Adassa Birthwright
Angela Blackwell
Reverend Dorsey Blake
Herb Bleiweiss
Azwad Isaiah Bligen-Smith
Carolyn Block
Susan Bloom
Eugene Bloomberg
Keith Boas
Roderick Boddie
Asake Bomani
Joseph Boudreaux
Reginald K. Brack, Jr.
Patricia Bradbury
Craig Braithwaite
Walter Brame
Bob Brauner
Mary Braxton
Barry & Andrea Breaux
Barbara & Stewart Brenner
Kristina Broadhurst

Dudley Brooks
Corey Broussard
Brian Browdie
Dr. Gerald & Lois Browdie
Tina Brower
Brian Brown
Bryanne Brown
Ethel Brown
Frank Dexter Brown
Marie D. Brown
Ronald Brown & Schyleen Qualls
Susanne Brown
Rev. & Mrs. Wilfred Brown, Jr.
John Bryan
Kevin T. Bryan
Heather & Sam Bryant
Olivia Bryce
Homer Buchanan
Ivory M. Buck, Jr.
John Bull
Christopher Burnett
Tom Burns
Jonnie Burroughs
William Burrus
Troy Butler
Jean Buttner
Liz Byas
Pam Byers
David John Bynum
Thomas Byrnes
Pedro Cabral
Tino & Ivan Calabuig
Michael Calhoun
Robert Cameron
Woodfin Camp
Diane Camper
Cynthia Cannady & Bob Woods
Jane Cano
Pat Canterbury
Cornell Capa
Dulce Capadocia
Bascar Carlos
Clayton Carlson
Dr. Ben Carson
Lori Carter
Max T. Catt
Robert Cave-Rogers
Nontsizi Cayou
Shannon N. Celestine
Mike Cerre
Ani Chamichian
Marvin & Portia Chandler
Zeb Chaney
Tom Chapman
Howard Chapnick
Donna Chazen
Marion Cheatham
Michael Cheers

Gurumayi Chidvilasana
Saul & Jean Chosky
Marcus A. Christian
Arta Christiansen
Dale & June Christiansen
Shirley Christine
Narva J. Christopher
John & Addie Clark
Andrew Clark
Dr. Constance E. Clayton
Beth & Robin Clements
Valencia Hollins Coar
Dr. Price M. Cobb
William Coblentz
Carolyn Coch
Aaron Cohen
Daniel & Stacy Cohen
Ellyn & Steven Cohen
Kara Cohen
Norman & Hannah Cohen
William G. K. Cohen
Steve Colding
Arthur & Rene Coleman
Beverly Coleman
Clinton Coleman
Rhonda Coleman
Sheila Coleman-Matute
Atif Collins
Chip Collins
Craig Collins
Dan Collins Jr.
Daniel & DeReath Collins
Edward Collins
Essie Collins
Hilary Collins
Julia Collins
Paula Collins
Penelope Brown Collins
Sara Collins
Ted Collins
Sharon Combs
Karen A. Comeaux
Angela Conrow
Maya Rudy Cook
Norman Cook
Thelma Cook
Walter Cook
Dave Cooke
Maya Cooke
Ann Cook Jordan
Guy Cooper
Maudine Cooper
Harry Cox
George Craig
Vernell Crittendon
George Crockett & Harriett Clark
William F. Crockett
Patricia Cruz

Ayana Cuevas
Mary Ellen Curley
Clarence Dalcoon
Fay Daley
Lu Dandelet
Jack & Maureen Daniel
Lee Daniels
Paige Darlington
Peggy Darlington
Edward B. Darnell
Belva Davis
Bob Davis
Brant Davis
Mike Davis
Lydia Davis Eady
Frieda Dawson
Silvia de Alba
Sherry de Carava
Tony De Young
Michael A. Deas
Jan DeChabert
Cliff Deeds
Mary Ellen Del Andro
Martin Delaney
Raymond DeMoulin
Jim Dennis & Barbara Rodgers
John Denniston
Reginald Denny
Daphne Derven
Jason DeSousa
David DeVoss
Marina Devoulin
Rana Diallo
Gene & Bob Dickman
Jody Dickman
Chickie Diogardi
Anthea Disney
Walter Dods, Jr.
Lisa Doerries
Sheila Donnelly
Larry Dorfman
Michael & Brenda,
 Chris & Sean Drake

Valzora Draper
Arnold Drapkin
Joel Dreyfus
Gene & Gayle Driskell
Dan Dry
Lakisha Duckett
Ed Dugger & Liz Harris
Linda Dukette
Dick Duncan
Judy Dunn
John Durniak
Charles & Edith Duval
Oscar Dystel
Lois & Mark Eagleton
Mary Dawn Earley
Chris Eden
Anne Edmonson Kerr
Patrice Edwards
Will & Liz Edwards
Ronald Sterling Egherman
Dr. & Mrs. Richard Eisenberg
Roy Eisenhardt
Sandra Eisert
Wanda M. P. Elum
Jeffrey & Susan Epstein
Jennifer Erwitt
Mike Etchison
Steve Ettlinger
Ella Evans
Rev. Clay Evans
T. Willard Fair
Jeanne Fairfax
Bill & Candy Falik
David & Eleanor Fax
Phillip, Lisa, Hope &
 Hannah Feldman
L. A. Felries
Linda Ferrer
Mary Fetsch
Jeff Finci
Mary Fiori
Diane & John Fisher
Margaret Fitzsimmons

Photographer Michael Jones and his subjects. Photograph by Tom Levy

Peter Fitzsimmons
Judge Charles W. F. Fleming
Dr. Walter Fluker
H. Welton Flynn
Lorrie Fogarty
Kathy Fong & Andy McInnis
Amy & Billy McInnis
Betty Ford
J. Patrick Forden
Badi Foster
Betty Fountain
James Fox
Ken Fox
Michael Fragnito
Christopher Franceschelli
Adam Frank
Hans Israelson & Janet Frank
Jeffrey Frank
Jeffrey Frankel
Scott Frankum
Anthony Frederick
Lynn French
Sheldon Frisby
Charles Fruit
Holger B. Gantz
Herb Gardener
Anabel Garth
Wendy Gaspard
Skip Gates
Victoria Gee
Alice George
Hans Gerhardt
Louis Gerstner
Stefano & Giovanna Gianni
Jarobin Gilbert
Bill Giordano

Mark Godfrey
Jim Goetz
Penny Goff
Philip & Lauren Goldblum
Raymond & Betty Jean Goldblum
Tracy Goldblum
Thelma Golden
Susan Goodwin
Jackie & Zoo Goosby
Alayna Gougis
Rod Goya
Mary Grabler
Tom Grady
Nan Graham
Chris Grant
Jeff Grant
John F. Grant
Pat & Mary Grant
William & Mary Agnes Grant
Naomi Gray
CeCe Green
Richard Green
Carolyn Greene
Lynn, Clarence &
 Kimberly Greene
Gabrielle Michael &
 Savannah Greene
George Greenfield
Dustin Griffin
Noah Griffin
Melanie Griffith
Michelle L. Grimes
Lonnie Gross
Ruth Gulley
Patty Gulyas
Heidi Gurian

Keith Hadley
David Hagerman
Emily & Casey Hagerman
Lois Crozier Hogle
Barbara Hairston
Charles W. Hales
Alinda Hall
Terri N. Hall
Pam Hamilton
Rod & Bonnie Hamilton
Chas & Samuel Hamilton
Chuck Hamilton & Pam Carlton
Evelynn M. Hammonds
John Hanley
Vincent Harding
Bill, Robie, Ben & David Harris
Dudleasa Stacie Harris
Kadar Harris
Melanie Harris
Nettie Harris
Ché Hashim
Andrew Hathaway
Tom Haugen
Fannie Haughton
Lee & Linda Hawke-Gerrans
Nicole Haynes
Maureen Healy & Greg Luecke
Francois Hebel
Jason Hedley
Robyn, Peter, Marta
 & Sarah Heilbrun
Andrew Heineman
Cathy Hemming
Janaka Henderson
Lyle Henderson
Ray Henze

Alan Hermish
Aileen Hernandez
Otilia Hernandez
Cleo Herne
Caroline Herter
Jim & Barbara Herwitz
Bill Hickman
Lasina Hicks
Nuam Hicks
James Higa
Judge A. Leon Higgenbothom
Bill, Terri, Tyler, Morgan &
 Baby Henry Higgins
Chester Higgins
Lisa Highton
Duane Hill
Rosalyn Hines
Russell Hinton
Suzanne Hodgart
Bettie Ruth Hodges
Nadine, Marc,
 Noah & Jared Hoffman
Pat Holt
Nick & Nancy Hoppe
Richard Horowitz
Mike Horton
Chris Howard
Jeff Howard
Diane Howell
Fred Huber
Karen Hudson
Jim Huffman
Burld Hughes
Emerson Hunter
Dwight Huntsman, Jr.
Bill Hutton
John Hyde
David Inocencio
Esther Isaac
Herman Isidore
Dianne Dash Island
France Israel
Kevin Jackson
Sharon Jackson
Tania Jackson
John & Barbara Jacob
Jeff Jacobs
Michael Jacobs
Anise Jacoby
Marc Jaffe
Momodou B. Jallow
Maggie James
Sara James
Sheila James
Stephanie James
Charles & Lucia Jean James
 & Family
Charles James III

Every picture tells a story: (clockwise from left) Picture editor Michel duCille, coeditor David Cohen, picture editor and research director Peter Howe, coeditor Charles M. Collins, picture editor Rosalind Williams, senior project consultant Charles Ward, picture editor Melvin Scott. Photograph by Barry Sundermeier

Evelyn Jamison
Schatzie & Jim Jefferson
Rev. Theodore Jemison, Jr.
Hope Gladney & Ted Jessop
Sherry Jester
Marie Johns
Belma Johnson
Channing Johnson
Charles E. M. Johnson
Dave Johnson
Charles & Glenda Johnson
 and Family
John H. Johnson
Larsh & Sue Johnson
Mark Johnson
Nancy & David Johnson
Terry, Lunell, Christina
 & Bradley Johnson
Linda Johnson Rice
Eugene Johnson, Jr.
Christopher L. Jones
Denise M. & Thomas Jones
Monique Jones
Thelonious & Tiye Jones
Andrea Jones & Evelio Grillo
Ann Jordan
Vernon E. Jordan
Janie Joseland Bennett
Margaret Kadoyama
Anna Kamdar
Devyani Kamdar
Family Kamdar
Pete Kamdar
Pravin & Caroline Kamdar
Vinu & Chitra Kamdar
Mira Kamdar & Michael Claes
Craig & Susan Kammerer
Ibrahim Kante
Alexander Karanikas
Tiamoyo Karenga
Leslie Katz
Che Keens-Douglas
Rachel & Tom Kellerman
Sharon Pratt Kelley
Kate Kelly
Tipton Kendel
Jonas & Odette Kennedy
Willie B. Kennedy
Donald Keough
Red Kernan
Tony Kiernan
Daniel & Andrew Kilduff
Marshall Kilduff & Pat Schultz
Dr. Alexandra King
Rodney King
Avon, Evelyn & Avery Kirkland
Arthur Kirk & Family
Harriet Kirk

Douglas Kirkland
Francois Kirkland
Robert Kirschenbaum
Judy & Sandy Kivowitz
Gia Marie Knight
Hiroko Koff
Rick A. Kolodziej
Ken Kragan
David, Michael & Caroline Kremer
Michael Kressbach
Emily Kretchmar
Jeffrey F. Kriendler
Evan Kriss
Teri Kula
Linda Kulik
Joseph H. Kushner
Angie Kwon
Roy LaCuesta
Florence Ladd
Eliane & Jean-Pierre Laffont
Robert Laffont
Marc LaFrance
Troy LaFrance
Linda Lamb
Sonia Land
Donneter and John Lane
Jack Lane
Orelia Langston
Heidi Larson
Bill LaRue
Ken Lassiter
Gail Laughlin
Gwendolyn Lawrence
Quentin Lawson
Patricia Leasure
Billie Jeanne Lebda
Johnny Ledbetter
Syble A. Ledet
Terry LeGoubin
Richard & Sharon Levick
Aaron Levinson
Bonnie Levinson
Dr. & Mrs. Peter Levinson
James & Lynn Levinson
Liz Levy & George Vickers
Craig & Mary Lewis
Danielle M. Lewis
Robin Lewis
Shantrelle P. Lewis
Drs. Brian Lewis & Bobbie Head
William & Cissy Lieberman
Jodi & Rick Lindner
Heather & Mark Lindquist
Grant Lindsey
Vickie Livingston
Ann Lloyd
Tom & Susan Lloyd
Susan Lloyd & John Karrel

Nikishua Lodge
Janet Long
Richard LoPinto
Barbara Loren
Miriam Lorentzen
Terry & Ursula Loucks
Mildred Love
John & Gloria Lowrey
Henry Lucas
Leonard Lueras
Mari & Walter Lurie
Michael Lynton
Otis Lyons, Jr.
Peter Macchia
Diana & John Mack
John Mackie & Kate Ecker
J. Mark Magee
Kanika A. M. Magee
Lekecia Magee
Nathaniel Magee
Reema Mahamood
Bill Maher
Brian Mand
Roderick, Laura, Annais
 & Christopher Marcoux
David Marcus
Michael Marion
Hodge Markgraf
Brenda Marsh
Ian Martin
Matthew Martin
Sue Martin
Angelle Mason
Bill Mason
Brandon Mason
Danyelle Mason
Francine Massey
Bernard Matias, Jr.
Aki Matsuura
Peter Matthiessen
Claudine Maugendre
Art & Pam May
Dr. Arthur Mayo
Gwen Mazer
Vern & Frankie McCalla
Holloway McCandless
Derilene McCloud
James McCray
Riley McCray
Eugene McCullers
Janelle McDowell
Jemmel Dominique McDuffie
Willie McDuffie, Jr.
Maria McFarlane
Doug McHenry
Myles McKinley
Pam McKoin
James McLain

Mary Lou & John McLaughlin
Jason McManus
Alfred & Elaine McMichaels
Michele McNally
Norma McNamara
Robert McNeely
Broule Men
Bob Mendelsohn
Doug, Theresa &
 Big Paolo Menuez
Adrienne Mercadel
Monica Mercurius
Dr. Lisa Merritt
Mary Metcalf
Pedro Meyer
Isabella Michon
Troy Miles
Gary Miller
Marla Miller
Jonathan Mills
Manita Mills
Hassan, Linda & Kallie Minor
Ida Mintz
Sra. Maria Pia Miraglia
Celeste Mitchell
Pat Mitchell
Martha & Dean Miyamoto
Roger Miyamoto
Phillip Moffitt
Gail Marcus & William
 Monaghan
Art Mont
Ave Montaque
Jane Bond Moore
Robert Moore
Sandy Moore
Mark Morelli
Masaaki Morita
Lisa Morris
Larry Morse & Pam McKoin
Ann Moscicki
LaVicki Moss
Drs. Evelyn & Donald Motzkin
 and Family
Fade Moussa
Craig Muckel
Yasin A. Muhaimin
Kimberly Munn
Francis Murphy
Mattie Myers
Sondra Myvette
Tammi Nace
Pat Nacey
Betsy Nachbaur
Joan Nagano
Tanya Narath
Jean Jacques Naudet
Dr. Michael Naumann

Matthew Naythons
Claude Nederovique
Dave Nelson
Kenya Nolden
Anthony L. Nolen
Al Norris
Christy Norsworthy
Amanda North
George Norwood
Molly Norwood
Silvio, Valeria, Camilla, Ludovica
 & Clelia Notarbartolo
Sra. Enza Notarbartolo
Frank & Claire Ann Oakley
Bernard Ohenian
Daniella Olibrice
Steve Oliver
John H. Osborne & family
Lionel Oubichon
Carol & Bill Ouchi
John Owen & Dawn Low
Mary Owsley
Kent E. Pafford
Hope Page
Matt Painter
Bill Pakela
Barbara Palazzolo
Rusty Pallas
Steve Palley
Rick Pappas
J. P. Pappis
Jack & Gertrude Parker
Tom Parker
Donald R. Parks
Jayvonce Parks
John Parks
Eva Patterson
Alice Patterson & Darryl Joyce
Larry Payne
Lisle & Roz Payne
Richard & Roberta Pearl
Leland Pease
Roger, Carmen, Ramona
 & Anita Pedersen
Linda Peek
Nancy Corrine Pelosi
Dr. Margaret Penn
Pilar Perez
Gabe & Pat Perle
Liz Perle
Ann & Alec Peters
Nolan J. Peters
Trish Peters
Sam Petersen
Steve Peterson
Tom Peterson
Dr. Muriel Petioni
Juris Petricêks

Lyn Koya Marie Pfister
Judy Phillips
Don & Jan Pickett
Drummond Pike
Ina Pinkney
Vincent Pinkney
Mike Pinney
Catherine Pledge
Robert Pledge
Veronica Pollard
Bernard Porter
Catherine Porter
J. B. Porter
Robin Powell
William T. Pratt
Kurt & Terri Preising
Asha Prevost
George Price
JoAnn Price
Earl Prone
Pat & Faye Prout
Jeff Prowda
Barbara Puff
Joan Purkiss
Jemaray Pyatt
Cherise Pyatt-Antonio
Ricky Quarles
Virginia Quental
Deanna Quinones
Dr. Robert Rabkin
Linda Raglan Cunningham
J. Lee Rambert
Jorge Ramos
Michael Rand
John Randolph
Viola Rankins
Israel Raphael
Myriam Rashada
Sylvie Rebbot
Ray Reddell
Gilbert S. Reddings
Barry & Ann Reder
Carl Reed
Eli Reed
Michael Reed
John Reens
Little John Reeves
Susan S. Reich
Karl J. Reid
Spencer Reiss & Ann Day
Roger & Jain Ressmeyer
William Hari Rhodes
Ron Rhody
Daniel Richard
Patti Richards
Ingrid Richardson
Keija Ricks
Miguel Ridgley

Steve Riggio
Susan & Cornel Riklin
Vincent Riley
Mary Risley
Barry Robinson
Diane Stevens Robinson
Doris & Aubrey Robinson
Edward G. Robinson
Gertrude Robinson
Gregory Robinson
Lisa Robinson
Sharon Robinson & Family
Sheryl Robinson
Spencer Robinson
Yolanda & Charles Robinson
Buckle Rod
Manuel J. Rodriguez
Ann Rogers
Carla Romash
Ellen Rose
Pat Rose
Noah Rosen
Sue & Bruce Rosen
Joan Rosenberg
Mike & Mindy Rosenberg
Bonnie Rosenblum
Andy Roth
Daniel Roth & Bonnie Solow
Ginny Rubin
Keith Rucker
Abraham Rudolph, M.D.
Marcy Rumsfeld
Deborah Rush
Pam Ruggiero
Kathy Ryan
Elaine Ryeff
Mark Rykoff
Barbara Sadick
Nola Safro
Denise Salvant
Shanda Salvant
Tim, Toby & Molly Salz
Marianne Samenko
Richard Samson
Tunde Samuel
Michael A. Samuels
Curt Sanburn
Will & Marta Sanburn
Lucienne Sanchez
Ruben Sanchez
Ellen Sanger
Ellen, Kate & John Sanger
Ingrid Saunders Jones
Charles C. Savitt
Meg Coco Henson Scales
Dick Schaap
Charlie & Joanna Scheidt
Bernard Scheier

Mary Schendel
Aaron Schindler
David Schneider
Dr. Alan Schulman
Kary Schulman
Mr. & Mrs. William Schultz
Dr. Leonard & Millie Schwartz
Dr. Julius Scott
Eldridge J. Scott
Robb Scott
Dave Scypinski
Mary Margaret Scypinski
Rob Scypinski
Robin Seaman
Brian Seaton
Gina Sedillo
Paul & Lynn Sedway
Dr. Arthur T. Shack
Ira Shapiro
Mrs. Belle Shapiro
Terri L. Sharpe
David Shaw
Harold Shaw
Marji Shaw
Mike Shaw
Norman Sheinman
Stephanie Sherman
Steven, Danan, Caitlin
 & Alex Sherman
Mary & Art Shields
Charlie Shorter &
 Suzanne Randolph
Chuck Shorter
Eric Shorter
Randy Shorter
Toby Shorter
Al Shreck
Grandpa David Siegel
Eve Grace, Stan, Reva, Fred
 & Laura Siegel
Minette Siegel
Jocelyn Sigue
George & Stephanie Sigue
Steve Silberman
Hayden & Jessica Simmons
Joe & Susan Hirsch Simmons
Lemroy Simon
Penny Simon
Bill Simpkins
Lowery Sims
George L. Sinks
Diane Sinnott
Jo Anne Sinnott
Andres Sipliadias
Sylvia Sleight
Paul Slovak
Bob, Becce & Andy Small
Aki Smith

Brenda Smith
Bud Smith
Christina J. Smith
Cindy Smith
Debbie Smith
Diane Smith
Dietrich Smith
James Smith
Johnny Smith
Marva Smith
Michelle Smith
Mylischa S. Smith
Preston Smith
Sandra Smith
Susan R. Smith
Phillip, Winnie, Alexis &
 Phillip Gregory Smith
William & Carolyn Smith
 & family
Leslie Smolan
Marvin & Gloria Smolan
Rick Smolan
Sandy Smolan
Cathy Sneed
Neil Soffman
Eva Solovay
Dr. Brenda Spriggs
Randy Starkweather
Venetta Stathis
Sheryl Stebbins
Bob Stein
Erik & Lisa Steinberg
Linda Steinberg
Dieter Steiner
Beth Steinhorn
Michele Stephenson
David Stern
Michael Stevens
Dennis Stevenson
Andy Stewart
Christopher Stewart
James & Virginia Stewart
Timothy Stewart
Jim Steyer
Jim Stockton
M. Jack Stone
Dave Strauss
Blanche Streeter
Michelle Stubblefield
Hazel E. Stuick
Nancy Stuke
John & Pauline Sundermeier
Terence C. Sullivan
Andrew Sun
Gene Suttle
Shannon Swartz
Cissie Swig
Sharon Swingle

Brandis K. Sylve
Lena Tabori
Bruce Talamon
Catherine Talton
Lori Tambara
Jon Tandler
Elzbieta Tarke
Graham, Nancy, Alysha
 & Jonathan Taylor
Monica Taylor
Allen Thomas
Darla Thomas
Doris Thomas
Doug Thomas
Kola Akintola Thomas
Peter Thompson
Robert E. Thompson
William Thompson
Jordan Thorn
Vicki Thornton
Anne Spencer Thurman
Judith Thurman
Sue Bailey Thurman
Billy Tidwell
Marie Timell
Claudette W. Tolbert
Janet Tolbert
Tameka Tolbert
Kathy Trapani
Frank Trapper
Gina Trask
Dr. Reynold Trowers
Bert Tucker
Martha Tucker
Veronica Tuckerson
Edith Turner
Karl Turner
Keisha Tyler
Vaisigago Upexesa, Jr.
Caroline van Gelderen
Julia Van Haaften
Neil Vanderdussen
Melanie Varin
Taja Varnado
Ignacio Vasallo
Kenny Vaughan
Carl Vedro
Peter Vedro
LeRoy Votto
Kailey Walczak
Lukas Walczak
Anne Walker
Edward Walker
Mertie & Jay Walker
Joseph Walkes, Jr.
Lilla Waltch
Cheryl Ward
Doris Ward

Oscar Warren
Bert Washington
Jackie Washington
Oliver Washington, Jr.
Ted Watkins
Dr. Clifford Watson
Herbert Watson
Lou Watts
Astril Webb
Sharon Weiner
Hymen & Freda Weiss
Carl & Candy Weissensee
Conrad Weissensee
Stephen H. Weitzen
Kevin Weldon
Darlene Wells
Marguerite Wels
Dianne Wesley
Gerald & Bonnie West
Gerald I. West, Jr.
Janie Westenfelder
Lakeisha Weston
Eric & Janet Weyenberg
Ralph Wheeler
Alan White
Davene White
Dione R. White
Dr. Michael G. White
Julian White
Margaret White
John B. White, Jr.
Carol & Bruce Wicklund
Ed Wieger
Linda Wight
Gabrielle Samantha Bates Wiley
Zealous Wiley, Jr.
Doug Wilkins
Fred Wilkinson
Angela Williams
Barbara Williams
Barry Lawson Williams
Carla Williams
Denise Williams
Dwain Williams
Elynor Williams
Eric Williams
Hilton Williams
Jamie L. Williams
Lakeshia Williams
Lauri Williams
Lloyd Williams
Lori Williams
Luins Williams
Marcia Williams
Ricky, Becky & Remi Williams
Rosalind Williams
Zelma Williams
Reginald D. Williams, Sr.

Chara Willis
Curtis Willis
Deborah Willis
Kimberly R. Willis
Patricia Willis
Pete & Michele Willmott
Scarlette & Charles Wilson
Earl Wilson
Harold Wilson
Sondra Wilson
Sue L. Wong
Rene S. Woo
Henri Wood
Jamaica Wood
James Wood
Jim & Robin Wood
Portia Wood
Savannah Wood
Bob Woods
Robin James Woods
Sylvia Woods
Van Woods
Bette Woody
Margie S. Word
Frank L. Workman
Peter Workman
Becky Wriggle
Deborah Wright
Nadine Wynter
Eric Yopes & Amelia Kamens
Winifred Younge Smith
Trisha Ziff
Ernst Zimmermann
Eugene Zykov
Betty & Carl Zlatchin

THE AFRICAN AMERICANS
PHOTOGRAPHERS AND STAFF

PROJECT PHOTOGRAPHERS

Anthony Barboza
Nicole Bengiveno
Bob Black
W. A. Bridges, Jr.
C. W. Griffin
Durell Hall, Jr.
Kevin Horan
Keith Jenkins
Michael Allen Jones
Ed Kashi
Nick Kelsh
Douglas Kirkland
Andy Levin
Barry Lewis
Ed Lowe
Doug Menuez
Odell Mitchell, Jr.
Jeanne Moutoussamy-Ashe
Larry Price
Jeffery Allan Salter
Jeffrey Henson Scales
Lester Sloan
Beuford Smith
Jerry Valente
Douglas Vann
Tom Zimberoff

PROJECT STAFF

Project Directors
David Cohen
Charles M. Collins

Assignment Editor
Barry Sundermeier

Finance Manager
Devyani Kamdar

Editorial Coordinator
Teri Stewart

Picture Research by
Peter Howe, director
Evan Kriss
Jane Lusaka

Introduction by
John Hope Franklin, Ph.D.,
Professor of History,
Duke University

Text by
Cheryl Everette,
The New York Daily News
Susan Wels
Evelyn C. White,
The San Francisco Chronicle

Copy Editors
Naomi Lucks
Amy Wheeler

Editorial Researcher
David Carriere

Index by
William Klein

Editorial Consultants
Dennis Dickerson, Ph.D.,
Professor of History,
Williams College
Reginald F. Hildebrand, Ph.D.,
Associate Professor of History,
Williams College

Senior Project Consultant
Charles Ward

Picture Editors
Michel duCille, *The Washington Post*
Peter Howe
Melvin L. Scott
Rosalind Williams

Art Director
David Cohen

Electronic Production
Rick Binger,
Lisa Motzkin,
Rick Binger Design

Decorative Artist
Peggy Del Rosario

Advisors
Marie C. Brown,
Marie Brown Associates

Justice Allen E. Broussard, partner,
Coblenz, Cahan, McCabe & Breyer,
former associate justice, California
Supreme Court

Daniel A. Collins, D.D.S.,
former president,
Division of Urban Education,
Harcourt Brace Jovanovich

John E. Jacob, president and chief
executive officer, The National
Urban League

Vernon E. Jordan, Jr., managing
partner, Akin, Gump, Strauss,
Hauer and Feld

Attorneys
Philip Feldman
E. Gabriel Perle

Literary Agent
Carol Mann, Carol Mann Agency

Accountant
Joseph Abrams